Conceptual Art and Painting

Conceptual Art and Painting

Further Essays on Art & Language

Charles Harrison

The MIT Press
Cambridge, Massachusetts
London, England

This book was set in Sabon by Graphic Composition, Inc., Athens, Georgia, using QuarkXPress, and was printed and bound in the United States of America.

Photo Credits: Michael Goodman, New York: figs. 27, 30, 31, 35; Charles Harrison: figs. 6, 7, 13 a, b, 15 a, b, c, d, e, f, 17, 18, 33, 46, 47, 54, 55 a, b, 56, 76, 77 a, b, 82, 85; Konstantinos Ignatiadis, Paris: figs. 61, 70; Réunion des musées nationaux, Paris: fig. 28; John Riddy, London: fig. 5; Andrew Whittuck, London: fig. 86; Gareth Winters, London: figs. 19, 37, 40, 41, 42, 48, 50, 51, 53, 58, 59, 64, 65, 66, 68, 69.

Library of Congress Cataloging-in-Publication Data

Harrison, Charles, 1942– .
 Conceptual art and painting : further essays on Art & Language / Charles Harrison.
 p. cm.
 Companion v. to: Essays on Art & Language. 2001.
 Includes bibliographical references and index.
 ISBN 0-262-08302-7 (hc : alk. paper)
 1. Conceptual art – England. 2. Painting – Philosophy. 3. Art & Language
(Group). I. Harrison, Charles, 1942– . Essays on Art & Language. II. Title.
N6768.5.C63 H368 2001
709′.04′075 – dc21

2001030260

Contents

List of Illustrations

Foreword

Since my *Essays on Art & Language* was first published in 1991, I have
had it in mind to publish a sequel. My reasons for doing so were prin-
cipally of two kinds. On the one hand I wished to continue with an
analysis of art since the 1960s and of the puzzles and problems it at-
tracts. On the other I wished to continue my contribution to the de-
scription and criticism of Art & Language itself, of its concerns, its
various enterprises, and its art. The two projects have been and remain
inseparable. It may be thought that my involvement in the practice of
Art & Language must compromise all claim to objectivity in an ac-
count of the wider history and preoccupations of modern art. I might
respond to any such objection by arguing against the feasibility of any
Archimedean point from which the controversies of recent and current
art could be dispassionately surveyed. In fact I take the alternative
course and embrace the risks involved in overt engagement, if only for
those advantages that must follow from observing the conditions of
practice at first hand, from participating in the attendant conversation,
and from contributing to publications issued in Art & Language's name.
Throughout the following essays, therefore, the practice of Art & Lan-
guage forms a central case study for thought about the recent and cur-
rent conditions of art as a whole. Some readers will come to this book
with established views about the extent to which the work of Art &
Language can justly be taken as representative, while others may start
from a position of unfamiliarity with the work in question. I hope that
all will take my accounts and arguments on their merits, and that they
will at least consider instances and generalizations together to see for
themselves how they fit.

On the larger questions this book is intended to address, I am confi-
dent that the material must be of some relevance to any serious discus-
sion of the art of the past forty years. The first part deals with the
art-historical significance and critical implications of the Conceptual
Art movement; the second and third parts, on landscapes and nudes re-
spectively, are concerned with the present possibilities for some kind of
figuration or picturing, and the third specifically with the vexed issues

surrounding the representation of the female body; the final section addresses the question of art's recent and current relation to its audience. Though the argument of the book follows a sequence of sorts, the individual essays are written so that they can be read as freestanding discussions.

Preliminary versions of much of this material have been tried out in the form of lectures, conference papers, articles and catalog essays, and in teaching. I am grateful to all those who have provided the relevant opportunities and to those friends and colleagues who have offered critical feedback in one form or another. I would like particularly to thank Manuel Borja-Villel, Noemí Cohen, Thomas Crow, Catherine David, Nuria Enguita Mayo, Aleš Erjavec, Trish Evans, Carles Guerra, Christian Mattheissen, W. J. T. Mitchell, Philip Peters, Clara Plasència, Christian Schlatter, Jill Silverman van Coenegrachts, and Peter Weibel. I have drawn much support from my working relationship with Paul Wood and Jason Gaiger, developed in the course of the *Art in Theory* project, and from the continuing conversation and criticism they have provided. I owe a considerable debt to graduate students in the department of art at the University of Chicago and in the department of art and art history at the University of Texas at Austin, with whom I discussed issues and problems in the interpretation of art since the 1960s in 1996 and 1997 respectively. My thanks are due to Roger Conover of MIT Press, for the welcome he extended both to this publication and to its predecessor. I should also acknowledge the support I have received from the Research Committee of the Open University's Faculty of Arts.

My principal thanks, of course, go to Michael Baldwin and Mel Ramsden, with whom I have been associated since I first became involved with Art & Language in 1970, and in whose hands alone the artistic work of Art & Language has been pursued since 1977. They have been the close companions of the enterprise this book represents, as they were of its predecessor. In the manner in which our working relations have been represented, however, the two volumes are intentionally distinct. In the writing of *Essays on Art & Language* I tried to make a virtue of that limited degree of intellectual distance that my employment as a historian of art seemed to impose. Michael and Mel in their turn exercised a self-denying ordinance as to the kinds of revision and correction they would offer. The essays composing the present volume all similarly have their origins and basic forms in work done in the solitude of the study. But that work has been done with the aim that our changing but continuing conversation of some thirty years' standing should be more faithfully represented in the final outcome, and that this second volume should be more truly a work *of* as well as *on* Art & Language.

Accordingly my preliminary versions have all been taken into the work of the studio and extensively revised in the light of ensuing exchanges. It is in the nature of those exchanges that they draw on a wide range of practical and intellectual concerns, and that they variously

inflect and are inflected by the kinds of production for which we are severally and jointly responsible. On a standard view, these kinds of production might be seen as bounded at one extreme by those works of art history and art theory that are issued under my own name or in collaboration with others, and at the other by the artistic output of Michael and Mel. In fact, however, both kinds of work impinge on and are impinged on by writings issued in the name of Art & Language, and authored by Michael and Mel, or by the three of us working together. Some of these are published in our journal *Art-Language,* which is it- self a representative product of the practice. Texts in all these modes will be found included in this book in the form of excerpts and quota- tions. The apparent "extremes" are connected by this production and by the habits it encourages. To the limits of their interest and tolerance, I subject my art-historical writing to Michael's and Mel's regard, while I aim whenever possible to join the critical conversation of the studio in front of artistic production completed or in progress, and to do my share of work on its public installation and discussion.

These are both the opportunities and the obligations of long associ- ation. But they are also, and not coincidentally, the conditions of per- sistence with that project that we understand the Conceptual Art movement to have initiated. This is to say that they follow from a com- mitment to open the professional closures of art, art criticism, and art history, and to keep them open. For better or worse, this book is de- voted to that end.

Charles Harrison
November 2000

I
CONCEPTUAL ART

1

The Trouble with Writing

A proportion of this book is taken up with discussion of what might be called paintings, or with paintinglike things. But it is not primarily a book about painting. It would in any case now be difficult or otiose to treat painting as an entirely distinguishable medium in the continuing practice of art. It might be safer to say that the book is concerned with some relations between pictures and texts, and with some of the details and complexities in these relations as they bear on the practice and interpretation of art.

Much of the work of Art & Language is written. Some of this writing has been hung on walls or stuck to walls, some painted on paintings, or printed on paintings, or stuck to paintings. Some of it has been published in books and catalogs and journals. But none of it wears the costume of literature. It is *artists' writing*.

What kind of category of writing is artists' writing, and how and why does it come to be accorded a significant status? The manner in which either of these questions is answered will tend to decide how the other is approached. This essay proposes three subcategories of writing: writing conceived as documentary accompaniment to artistic practice, writing conceived as literature, and writing conceived as art. It is the last of these that I am principally concerned with. Is there a kind of text that functions neither as complementary documentation nor as a kind of literature, but that may be art – even if it is in fact insouciant as to whether it is "art" or not? My initial aim is not to impose rigid distinctions where they don't apply, but simply to identify some ordinary cases of artists' writing so as to create a space for those less easily categorized.

Consider the following.

> I must tell you that your letter surprised me at Estaque on
> the sea shore. I am no longer at Aix, I left a month ago. I

have started two little motifs with the sea, for Monsieur Chocquet, who had spoken to me about them. – It's like a playing-card. Red roofs over the blue sea. If the weather becomes favourable I may perhaps carry them through to the end. Up to now I have done nothing. – But there are motifs which would need three or four months' work, which would be possible, as the vegetation doesn't change here. The olive and pine trees always keep their leaves. The sun here is so tremendous that it seems to me as if the objects were silhouetted not only in black and white, but in blue, red, brown and violet. I may be mistaken, but this seems to me to be the opposite of modelling.

The trees of Monster Field were another story altogether. If they had been no more than trees in their perpendicular life it was as much as you could believe. Horizontally they had assumed, or acquired, the personality of monsters.

To begin with, like many objects who suffer change, they were now, as it were, in reverse. In the old life as trees, they were accustomed to stand more or less solidly attached to earth, growing outward and upward, waving their crowns against the sky. In the new life their roots and trunks formed throat and head. The uplifted arms had become great legs and hoofs outstretched in wild, mad career. What were they like? What did they resemble most in life?

In life? Let me be clear on that point. We are not studying two fallen trees that look like animals, but two monster objects outside the plan of natural phenomena. What reference they have to life should not be considered in relation to their past – therein they are dead – they now excite our interest on another plane, they have "passed on" as people say. These now inanimate natural objects are alive in quite another way; but, instead of being invisible like so many of that huge community, or only made visible by the complicated machinery of spiritualism, they are so much with us that I was able to photograph them in full sunlight. Not that I made this record in any spirit of scientific research. Both as a painter and a collector of objects, it was impossible for me to ignore the occupants of Monster Field.

Views of immensity are no less docile than scenes of quiet property. They hang around domestically in the hope of a kind word.

We shall execute a landscape incapable of receiving or of conferring a syllable of homely comfort.

It will not, however, abstain from the terror of homely things.

It will be callow and eager to please – a frump but no freak.

It will reassure all but those who see irony and are reassured by that. It will go to a degeneration in the ironists' speech.

The first of these is taken from a letter written by Paul Cézanne to Camille Pissarro in 1876,[1] the second from an essay published by Paul Nash in 1939.[2] The third is the entire text of *Hostage (Views of Immensity)*, a work of 1989 by Art & Language. The visible aspect of the work is simply this text printed in silkscreen on paper.

Categorical distinctions between these texts are by no means conclusive on the page. They follow from the ways in which they are used and read. Cézanne's letter is without literary pretensions. It is likely to be of interest only to someone interested in the artist's painted work, or in Cézanne as a maker of paintings. Nash's essay might well be consulted by someone interested in the paintings to which it relates, but it was clearly intended as a self-sufficient and engaging piece of writing. As such it can be connected to the neo-romantic interests of certain English littérateurs who resisted the effects of full-blooded European modernism in the later 1930s.[3] The Art & Language text refers to a landscape to be painted at some point in the future, and might thus be thought to stand as a complementary document to some more securely "visual" work. But in point of fact the text allows no such escape. The imaginary painting exists as the product of the text itself. Despite its declarative form, the text has no actual projective implication in the world of realized paintings.

Documentation and its absence

The great majority of artists' writing can be readily enough accommodated to the category of documentation. Manifestos and treatises acquire documentary status immediately, through the intentional actions of their artist-authors, while other materials such as journals and correspondence usually gain it post hoc through the interest of dealers, collectors, curators, art historians, and biographers (who may or may not be art historians). For all the stimulus they may provide to interpretation, documentary materials have a necessarily dependent status. We study the texts in question because we are interested in the artistic work they can be made to bear upon, because we want to know more about that work, and because we place a particular value on information from the horse's mouth. Artists' art criticism is something of a special case, but the more secure the author's identity as an artist, the more

likely it is that any critical writing will be read with a view to that artist's own work rather than to the work it explicitly addresses. If we read Don Judd's early writing in *Art News*, it will not usually be for the sake of his views on other artists – this despite the exemplary and free standing character of his criticism. It will be because they are Don Judd's views. Even where we read out of a primarily biographical interest it can be assumed that that interest was aroused in the first place by some value placed on the artist's work. After all, their engagement with their work apart, and notwithstanding public fascination with the idea of bohemian excess, artists generally don't have time to lead very exciting lives.

The occurrence of artists' writing as valuable documentation is nothing if not patchy, however. For much of the past ten years I have worked with Paul Wood and Jason Gaiger on a project of publication under the title *Art in Theory*. Our aim was to survey the intellectual materials out of which art has been made during the past 350 years, and to publish a comprehensive selection of these – as it transpired, in three large volumes.[4] Of course one turns first to the artists themselves. For any enterprise of documentation such as this, theoretically relevant and substantial writings by the actual producers will always be sine qua non. Poussin's letters to Chantelou, Hogarth's "Analysis of Beauty," Friedrich's "Observations," the "Discourses" of Reynolds and of Constable, Delacroix's Journals, Van Gogh's letters to Theo, Matisse's "Notes of a Painter," the manifestos of the Dadaists, the tracts of Kandinsky, Malevich, and Mondrian, Rothko's "The Romantics were prompted . . . ," Robert Morris's "Notes on Sculpture" – these are among the materials that anyone seriously interested in the art of the wider modern period will want to have to hand, even if they will not read through them all with the kind of expectation or enjoyment aroused by more evidently literary works. Delacroix was an entertaining and accomplished diarist, while Matisse and Rothko wrote with an economy and intelligence rare in professional writers on art. But many other artist writers make heavier demands on the reader. The texts of Kandinsky, Malevich and Mondrian are engaging so long as we can maintain their connection to the strange experimental practices and peculiar speculative theories they once accompanied, but it's hard to imagine them being read for pleasure or for any other reason by anyone not already interested in the early development of abstract art.

The early-twentieth-century avant gardes were in general much given to publication, and the emergence of abstract art certainly saw a proliferation of theory written by artists. But such wealth of documentation is exceptional. Collections restricted to the *obiter dicta* of artists tend to be disappointing to all but the uncritically enchanted. Had we confined the selection of *Art in Theory* to texts by artists, our published volumes would have been very much thinner than they are (and thin they are not). They would also have been very unevenly connected to the standard narratives of art history. For example, within those narratives a high priority is normally accorded to Impressionism and to Cubism. Yet were we to rely entirely upon the written testimony

of the artists involved, Impressionism would appear as a movement concerned almost exclusively with quotidian financial problems and chronic minor illnesses, while the account of Cubism would allow no significant role to Braque before 1917 or to Picasso before 1923. In contrast, Symbolism would dwarf all other early modernist movements in the sheer quantity of relevant texts by the artists involved. The anthologist seeking to represent a body of generative theory relevant to Impressionism or to Cubism must thus redress the balance with other stuff – not the post hoc ratifications of sympathetic writers, but text that is representative of the intellectual and conversational world in which the artists' work emerged.

When we go back into earlier periods, the problems of documentary representation are greater still. The third and most recently published volume of *Art in Theory* is concerned with the years from 1648 to 1815. My coeditors and I were presented with an enticing wealth of letters and discourses and treatises with which to complement the study of French art in the later seventeenth century, following the foundation of the Académie Royale. But when we turned to the Low Countries at the same period – to the rich artistic culture of Rembrandt, Vermeer, Jan Steen, Ostade, Pieter de Hooch – the archives were bare of theoretically pertinent text. There was virtually nothing, not even the quasi-ekphrastic and radically uninformative self-justifications that are all too often found in anthologies of artists' writings. Only once the so-called golden age was effectively over in the Low Countries did a familiar chorus swell among the ranks of the conservative, calling for a return to just those classical values that Rembrandt and others had managed critically to circumvent or to transform. Of course this quantitative difference in the available documentation tends simply to confirm what we already know about differences in the market status and class character of art in France and the Low Countries respectively. But there may also be a more interesting conclusion to be drawn, and it is one that bears directly on the matter of artists' writing. It seems possible that one reason so little writing accompanied the art of Rembrandt or of Monet or of Picasso and Braque as Cubists is that some significant essaylike impetus was already driving the work itself – and driving it beyond the reach of any writing that was still caught in the toils of exegesis.

Art as essay

The notion of an essaylike impetus in works of visual art is one that has often featured in the conversation of Art & Language. In the writing of a speculative essay, the author tailors thought to the habits of speaking and writing. Language is chosen not simply in response to the intellectual requirements of imagination and argument, but as though it were addressed "to . . ." and not simply written "about. . . ." The resulting text is both a deliberation on its overt subject and – insofar as it has an imagined addressee – a *self-conscious* account of the dialectical

relationship between language and thought. It is the one *insofar* as it is the other. The competent reader of such an essay – in Roland Barthes's terms, the "writerly" reader – engages with the artifice of its linguistic expression as a condition of engaging with its argument.

By the same token, as the essayistic work of art develops in practice, its surface elaborates a reflexive account of its own life as representation, and of the complex dialectical relationship between imagined reality and material genre. The competent spectator of such a work sees whatever the surface shows, but is at the same time alert to its status as representation – to the relationship between how it appears as decoration and how it has come to be as it is. This relationship is rarely a straightforward matter. For it can often happen that an understanding of how a painted surface has come to be as it is effectively controverts its appearance as decoration, thus putting into question whatever response that appearance may have provoked. The spectator may then be induced into a form of self-critical reflection – a reflection, for instance, on the disparity between those predicates of appreciation that the culture makes available and the practical and ethical circumstances under which the work of representation actually gets done. It seems that the essaylike impetus involves some speculative address to an opposite or contrasting world of discourse. This is to say that it implies a dialectical structure of some sort. One of the characteristics of essayistic art is that it "contains" the materials that bring it to an end. It seeks out its own contingency – seeks a serviceability that is not hiding the desire to appear *sub specie aeternitatis*.

Rather than attempt any further identification of the essay, I offer a couple of examples of what I understand by an essaylike impetus at work in art. The first is the late self-portrait by Rembrandt that hangs in Kenwood House in London. To the spectator who keeps her moral distance from the image, this is an arresting picture of an aging man, divested of his customary role-making attributes, composed in a harmony of warm colors, with concentrated highlights and patches of impasto on the figure contrasting with the soft and neutral tones of its ground. To devote oneself more assiduously to the work is to be drawn into the account of its composition that the picture narrates. In imagination we then occupy the practical and intellectual circumstance of one who looks and sees himself, and who works to constitute an equivalent not only for what is seen, but for the vexed psychological activity of looking – and of reflecting both on that looking and seeing and on the facticity of its practical equivalent. To concentrate in this manner on what the picture shows is to be caught in a world of contradictory perceptions: on the one hand the vividness of the achieved if figuratively incomplete image, imbued with an inescapable sense of imagined presence; on the other the sheer artificiality of its constituted surface, on which the artist has at times scribbled with the pointed handle of his brush; and stalking both these modes of perception, the character of one's own inflected self-consciousness. Dealing with this experience is like making sense out of a vocabulary of widely diverging predicates:

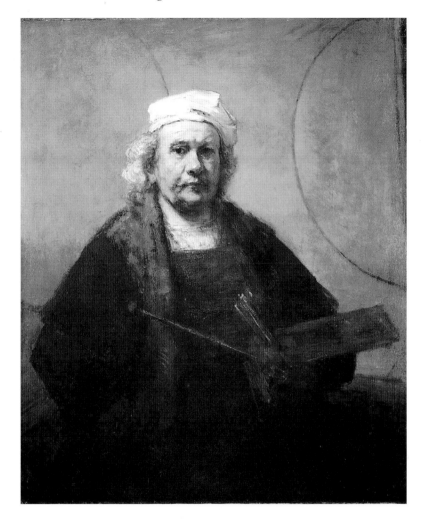

Plate 1 Rembrandt van Rijn, *Self Portrait*, 1665. Oil on canvas, 114.3 × 94 cm. Kenwood House, London, the Iveagh Bequest.

one set going to articulate intuitions of another human physical and psychological presence, a second to describe the physical particulars of a marked surface, a third to locate the viewer's self-awareness, with no one set quite capable of silencing the other. Richard Wollheim has given the name "two-foldness" to the dual aspect of surface and what it contains, and has suggested that it is characteristic of all painting when it is practiced as an art.[5] But the convergence of aspects in cases such as this is sufficient to mark out a virtual difference in kind, testing our own powers of representation to a relevant limit. If we have once come this close to the self-deflating bravura of its inscription, how purblind a valuation it must be to speak of the work as a beautiful picture, and how hostile to the spirit of its maker it must seem to employ such valuations as one's normal currency.

My second example is drawn from the work of Art & Language. The painting *Attacked by an Unknown Man in a City Park: A Dying Woman; Drawn and Painted by Mouth* was made in 1981, as one of a

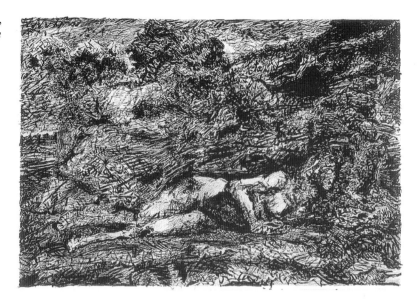

series of three pictures of women.[6] It shows the prone figure of a nude woman – almost life-sized – isolated and expiring in a dark and empty landscape. The expressive distortion of the figure and the agitated treatment of the ground encourage a presumption that the woman is a tragic victim – perhaps of violence. The resourceful iconographer might note an echo of David's unfinished study of Barra (Musée Calvet, Avignon), the Horst Wessel of the French Revolution, itself in part derived from Poussin's *Narcissus* (Louvre, Paris). So far the painting invites connection to a tradition of elevated subject pictures, to the moderate modernization of the classical nude, and to that moment in the mid-nineteenth century when the lingering aesthetic credibility of heroic Romanticism was finally extinguished in the French Salon. Given the time of its composition the painting also relates or refers to the revival of a kind of romantic and expressionistic machismo in the work of the "Neue Wilden," the "Young Italians," and other constituents of the so-called Trans-avantgarde of the late 1970s. But this painting comes accompanied by a text as title. It might in fact be more appropriate to say that the title defines a conjectural work that the picture then both enacts and illustrates. It transpires, in other words, that the expressive distortion and agitated brushwork were generated as it were automatically as consequences of a thoroughly bathetic technical procedure.

> PBM$_1$ [the attached claim "Painted by Mouth"] can be strangely vivid. But it isn't just because of the brushwork. (Or rather it goes directly to the brushwork in ways that are readily exhausted – trivial.) The pictures of women are expressionistic (and expressive). They also appear to belong to certain high (modern) genres. And they evoke a sense of the masculine aggression of the mechanisms of

their production – but this is castrated by PBM_1. The canons of competence and so forth are cast culturally adrift. PBM_1 itself impairs a "natural" way of looking for the technical consequences of its truth (or falsity?). (Note also that these pictures are supposed to *depict* the consequences of pathological masculine aggression. They refer to the topicalisation of representation as invitation to rape, etc. This is a further inflection that should [or might] enable the hiatus-generating function of PBM_1 to be reconstructed.) (Art & Language 1982)[7]

To envisage the artists with brushes in their mouths, heads nodding away, is effectively to rule out any vestigial propriety in the classical or romantic connotations of the image, and a fortiori to uncouple its expressionistic appearance from any authentic expressive disposition – which is to say a disposition that is both male and aggressive. Once again the apparently inflated appearance of the image as decoration is countered by the self-deflating evidence of its production. In this case that evidence is given in writing, but it is writing from which the picture cannot dissociate itself – not, at least, without the risk of being seen for that which it is not. It would make as little sense to treat the picture as art and the title-as-text as documentation as it would to treat the text as literature and the picture as illustration. It is in the mutual operation of picture and written claim that the essayistic character is produced. Its effect is to render exegesis potentially absurd. (I do not mean to project the work of Art & Language into the elevated company of Rembrandt in any other sense than this: that in my own experience, the attempt to represent each work to myself was vexed by a similar hiatus-generating capacity.)

To the extent that the title-as-text of Art & Language's work generates a picture that exemplifies it, it might be thought that the relationship between picture and title is like the relationship between the Duchampian ready-made and its name: the urinal and the name *Fountain*, for example. But there is a crucial difference. The ready-made and its numberless descendants are enterprises devoid of real essayistic power, insofar as such power is a function of relative internal complexity. In its oscillation between the identities "commodity" and "artwork" the ready-made marks the power of the artist – or of some other cultural agency – to render the one into the other. But the spectator is unlikely to become self-critically engaged in the *relationship* between its status as decoration and the narrative of its production, since its status as decoration is necessarily low. As Thierry de Duve has demonstrated, in Duchamp's hands the ready-made could be an instrument for generating considerable complexity in the world of our aesthetic protocols and expectations.[8] It is not in our reading of the object itself, however, that the essaylike impetus is continuously felt, for there is no syntactical mediation between what the ready-made is like and what it is as art. Its artificiality is not at any point what is put in question. Even

in the event that the object nominated as a ready-made is possessed of some internal complexity or intrinsic interest, that interest is always liable to exceed the critical force of the art-gesture – as it might do, for instance, were some overexcited follower of Duchamp to claim *The Bride Stripped Bare* as a ready-made in her own name.

Regarding the status of artists' writing as documentation, there are two observations to be borne in mind. The first is that while some writings by artists may be of unquestioned documentary significance to those interested in their work, there will be many substantial cases where artists' writing is uninformative or simply nonexistent. Clearly, if we insist on some form of literary accompaniment to a given body of artistic work we will often have to turn to other writers than the artists themselves. The second observation is this: while the inclination or ability of artists to put pen to paper may be revealing of their contingent aims and preoccupations, the very absence of writing as documentation may also direct us to some critically reflexive properties of artistic work – properties that may be significantly languagelike even when they do not actually involve writing.

Literature and theater

So to the second of our categories: artists' writing as literature. Here it is the very emptiness of the category that is of interest. To put the matter bluntly, there is no single artist whose writing has made a substantial contribution to modern literature. The world would not be much worse off for the loss of Kurt Schwitters's poetry or Wyndham Lewis's novels or Picasso's drama. And as to the fictionalized autobiographical writings of exhibitionists like Gauguin and Dalí, we are generally more comfortable according them an unquestioned standing as documentation than in addressing them primarily as literary texts. It is of some additional interest that writers in the modern period have generally made indifferent artists. There have been a few critics who could paint plausible pictures and there have been one or two literary figures whose exotic graphic output is of undoubted interest – Victor Hugo and Antonin Artaud come to mind – but there have been no writers whose artistic work could be said to have been significant in the development of a modern artistic tradition. There are the Gestalter von Gesamtkunstkunswerken, of course, but among those who deserve serious consideration there is never any doubt as to which form of art their technical elaborations are actually required to serve. Would anyone but a really desperate Ph.D. student bother to read Wagner's librettos or to study his architectural designs were it not for the claim his music makes on the attention? In modern Western culture, at least, it appears that some principle of mutual exclusion operates to distinguish the production of one art from the production of another – or, perhaps, to prevent anyone from being seriously noticed in more than one profession. It is an open question whether the problem is one of sheer capacity – some relevant limit on what one life can sustain – or whether the re-

spective competences are simply irreconcilable at some level, but it does seem that no one nowadays gets to be very good at *both* art and literature as conventionally conceived.

There is a potential confusion here that needs to be faced and avoided. To say that the designations artist and writer tend to be clearly distinct at the professional levels is not necessarily to assent to all and any grounds on which the distinction might be explained or theorized. For instance, the finding that no one gets to be very good at more than one art form is apparently commensurable with the familiar account of modernism in art that was developed by Clement Greenberg and extended by Michael Fried.[9] According to this account the condition of modernism imposes a demand of specialization; the virtue of each art form is secure to the extent that it is entrenched within its own area of competence, the aesthetic effects of art are compromised by any similarity to literature, notions of aesthetic merit have meaning only within the individual arts, what lies between the arts is theater, and all arts degenerate as they approach the condition of theater. This account both supports and is demonstrated by a canon of authentic Modernist art that tends to exclude those Dadaists, Futurists, Contructivists, and Surrealists whose work slips out of the categories of painting and sculpture into the fields of the ready-made, of performance, of poetry or of agit-prop. It is a purified canon.

But of course this is by no means the only account of modernism available. Indeed, its final refinement in Fried's 1967 essay "Art and Objecthood" has been widely represented as a last attempt to conceal an actual loss of critical potential in painting and sculpture and to stem that tide of "three-dimensional work" and "generic art"[10] by which its authority was finally to be undermined. Nowadays, the account associated with Greenberg and Fried is so lacking in support that one might assume its theoretical basis had been wholly overthrown. The narratives now more favored by the art-historical academy are those that tend to associate the dynamic of modernism specifically with the early twentieth-century avant gardes,[11] with a sustained assault on the autonomy of artistic genres and technical hierarchies, and with a continual skirmishing in the no-man's-land between image and text. Far from seeking to prise the literary and the artistic apart for purposes of evaluation, the typical tendency of the critic is now to emphasize the mutual implication of the verbal and the visual. According to W. J. T. Mitchell, recent laureate of the American College Art Association, "The dialectic of word and image seems to be constant in the fabric of signs that a culture weaves around itself. What varies is the precise nature of the weave, the relation of warp and woof."[12] In other words, just where the conceptual boundaries are drawn between the verbal and the visual is seen as a historical and an ideological matter, and thus as open to inquiry.

As might be expected, the boundaries established by Greenberg between "literature" and "aesthetic effect" and by Fried between "theatricality" and "presentness" have attracted their fair share of such inquiries.[13] The "Modernism" these critics were concerned to defend

is now typically conceived as an area of cultural dead ground across which the postmodern artist reconnects with the unjustly marginalized aspects of previous avant-garde episodes. The artist Martha Rosler may be taken as representative of those for whom critical virtue lay precisely in transgressing the boundaries in question, and in breaching the larger cultural decorum these boundaries are assumed to protect.

> I read Michael Fried's essay . . . which was a sort of terribly starchy defence of high Modernism, and he spoke of the problem of art that did not follow these modernist precepts as being "theater." And I said, "bingo, that's it, that's right." The art that's important now is a form of theater, and one thing *that* means is that it has to be in the same space as the viewer. . . . (Rosler 1991)[14]

It may be, however, that responses such as these fail to address Fried's more substantial point. A large painting by Pollock or a sculpture by Caro is in a literal sense "in the same space" as the viewer who regards it. What Fried seems to have meant by "theater" was not per se those artistic enterprises that were not-painting or not-sculpture, but rather *any* form of art – no doubt including some painting and some sculpture – that was too obvious in its designs on its audience. In his later work *Courbet's Realism* he cites Diderot, who maintained, in criticism of the painting of the *ancien régime*, "that it was necessary for the painting to actively 'forget' the beholder, to neutralise his presence, to establish positively in so far as that could be done that he had not been taken into account."[15] The point of this admonition is not so much to protect the sanctity of the medium as to preserve the ethical autonomy of the work of art and of its technical concerns. In this sense, the urge to theatricalization may be contrasted with the drive to resolve technical problems in relative independence from any actual or presupposed audience. It is not medium-specificity as such that is the core issue, nor was Fried's admonition adopted simply as a stick with which to beat the avant garde of his time. It has an honorable pedigree in a distinguished critical tradition. As with the "theatrical" art of Diderot's time, the problem with some kinds of not-painting and not-sculpture is not so much that they are inherently bad, as that the absence of a substantial material tradition and of its attendant technical demands means that audience response is more likely to be sought as a measure of success – at the expense of art's autonomy.

It seems we need to distinguish two separate issues that are easily conflated. On the one hand we may observe certain categorical distinctions between art and literature or art and writing, and we may inquire into the reasons for these distinctions. On the other hand we may argue over the constitution of a Modernist canon, and in the process may draw upon or may implicate arguments about the autonomy of art vis-à-vis literary forms of narrative or theatrical forms of relationship between work and viewer. The two issues are clearly connected, but

they are not connected symmetrically. For example, it might be conjectured that the competences respectively involved in painting and in writing are connected to different biological structures, or that they are differently connected to the ways in which we are wired for language and grammar. If there is indeed some such biological structure or tendency affecting our various means of expression – as it now seems clear that there is[16] – then we can be sure that it will in the end bear upon the conditions of success or failure in any given art form or perhaps even in any genre, irrespective of our contingent aims and interests. In this event we might expect Fried's admonitions to be of some continuing critical pertinence.

On the other hand, in allowing Fried to have something interesting to say about the need for a material tradition, we would not necessarily be committing ourselves to his views about the continuing vitality of modernist abstraction or about the security of modern aristic genres. (This, after all, is someone who preferred Jules Olitski's three-dimensional work to Donald Judd's.)[17] To speak of biological determination and of cognitive domains is not to say that practices of art or of writing are conducted outside ideology, nor, of course, is it to suggest that we can be free of conventional wisdom either in the ways we distinguish the artistic from the literary or theatrical or in the criteria we employ to decide success or failure in one form or another. It may well be the case that transgression of cognitive or categorical domains is a likely condition of critical redundancy and thus of some kind of aesthetic failure, and that the theoretical limits Fried sought to define go to some real material conditions. But it may also *and coincidentally* be true that transgression of habitually adopted demarcations between "verbal" and "visual" forms of expression is a condition of critical vitality and thus of aesthetic success, and that some refusal of "Modernist precepts" and genres is therefore justified.

The point needs to be made, however, that insofar as the results of any such refusal achieve the status of representations, they cannot be "in the same space as the viewer" in Rosler's sense, since it is precisely in the distance between viewer and viewed – between "reality" and "genre" – that the very possibility of representation is established, in whatever medium it may be explored. It is in the articulation of this distance that substantial critical problems are encountered, not in the merging of genres per se. To wonder about, or at, the expressive powers of the Gesamtkunstwerk – the union in breaking down the differences between the arts – is to risk degeneration into self-inflating experiment. This is the world of "Out of Action" and its cognates.[18] The more interesting question is whether there is or can be a form of artist's writing that is neither documentation nor literature, that is challenging to beliefs about the ways in which the visual and the verbal are to be demarcated, but that connects to and extends a tradition of artistic *rather than literary* representation. However that question is answered, any evidence adduced is likely to be controversial. We are in the territory of potential scandal and aporesis – a territory marked out in

some accounts by Duchamp around 1915 to 1917, in others by the Conceptual Art movement of the later 1960s and early 1970s, in still others by some conflation of the two. Whichever account we favor, it will not be easy to decide how far we can speak of the extension of a tradition, and how far of its transformation or ruination – any more than it is easy to decide whether what the term Modernism should refer to is a describable theory of art, a delimitable period in artistic culture, a coherent but now exhausted tendency in artistic practice, or a continuing and still inescapable condition variously determining on the formation of theory, on the problems of practice, or on both. It is to the possibility of artists' writing as art, therefore, and to the third and last of our categories, that I now turn.

Writing as art

What might it mean to conceive of artists' writing as art? We can start with two extreme cases, and with examples drawn from either end of a long historical continuum. The first is a picture: the remarkable Tapestry of the Creation, made in the eleventh century and now housed in the treasury of the Cathedral of Girona in Catalonia. To whoever commissioned and manufactured the tapestry it was important that it should be understood, that it should be clear what was to be imagined by those who would use it as a picture. So in the section that shows the Creation of Eve, we are told in writing just what it is that is happening – why it is that this strange half-figure appears stuck to Adam's side. The Latin text informs us that the woman is being fashioned from the man's rib. The Tree of the Knowledge of Good and Evil is also labeled for good measure. It is probably safe to assume that at the time the tapestry was made

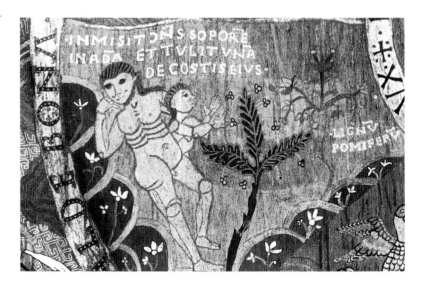

Plate 3 *The Creation of Eve*, detail from the *Tapestry of the Creation*, c. 1100. Wool and linen embroidery on wool. Diocesan Museum, Girona.

there was no current concept of art by which the combination of image and text might be disparaged. Such disparagement would in any case be wholly inappropriate given the ease with which both text and icon are accommodated to the decorative flatness of the tapestry. Of course this is not a text that the artisans themselves would have composed. Its presence was no doubt authorized by those to whom they were subject. This in itself tells us something about the social and cultural world within which pictures and writing were so readily conjoined.

The character of this first example may be clarified by contrast if we leap forward half a millennium, when we find the same episode still being picked out within pictured accounts of the Creation, but in circumstances where it is clear that the accompanying words no longer have a proper place. A later version of the Creation of Eve was included in the ceiling decorations for the Sistine Chapel in Rome. Within the figurative world of Michelangelo's picture the descriptive text has no appropriate function to fulfil. There is no nonvirtual surface for it to inhabit – or none that would be congenial to the expressive character of the picture; which is effectively to say that the kind and degree of mimesis achieved by the picture is sufficient to render the written text superfluous. We might conclude that the picture is now a world within which the artist is allowed a certain authority and autonomy – a certain freedom from the power of others to attach texts to images.

There are many ways in which we might explain this development from one type of the biblical image to the other. Some of these might be used to support or to prefigure a quasi-Modernist account of the necessity for specialization among the different humanistic disciplines. Already in Michelangelo's day, Florentine theorists of art were associating technical progress with challenge to the primacy of literature as a communicative and expressive resource. Using the language of

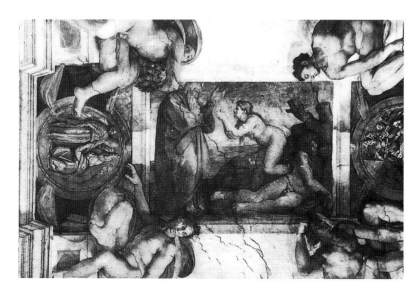

Plate 4 Michelangelo, *The Creation of Eve*, from the ceiling of the Sistine Chapel, Rome, 1508–1510, fresco.

hindsight we might say that to have inserted words into a picture such as his would have been to compromise its modernity. Or to put the point another way, the apparent necessity driving word and image into different cultural worlds is actually an early function in a long historical narrative – one that receives its final formulation in Greenberg's "Modernist Painting" of 1960.[19]

The second exemplary case is taken from the first issue of the journal *Art-Language*, published in 1969. Notoriously, the editorial introduction to that issue invited its readers to consider the following hypothesis.

> . . . that this editorial, in itself an attempt to evince some outlines as to what "conceptual art" is, is held out as a "conceptual art" work. At first glance this seems to be a parallel case to many past situations within the determined limits of visual art, for example the first Cubist painting might be said to have attempted to evince some outlines as to what visual art is, whilst obviously being held out as a work of visual art. But the difference here is one of what shall be called "the form of the work." Initially what conceptual art seems to be doing is questioning the condition that seems to rigidly govern the form of visual art – that visual art remains visual.[20]

Note that this hypothesis functioned as such primarily within the speculative framework of the essay itself, which was addressed to recent developments in art and art theory and in the relationship between the two. In other words, the significance of the editorial lay not in the avant-gardism of its potential status as an art work, but rather in its critical pertinence as inquiry. What was most substantially at issue was not whether essays or other texts could actually count as "primary" works of art, but rather how the nature and direction of artistic work was to be understood *once that question had become unavoidable.*

> Suppose an artist exhibits an essay in an art exhibition. . . . The pages are simply laid out flat in reading order behind glass within a frame. The spectator is intended to read the essay "straight," like a notice might be read, but because the essay is mounted in an art ambience it is implied that the object (paper with print upon it) carries conventional visual art content. The spectator being puzzled at not really being able to grasp any direct visual read-out meaning starts to read (as a notice might be read). It goes as follows:
> "On why this is an essay. . . ."[21]

It may have been *necessary* that the essay fail in its conjectural claim to artistic status precisely in order that it might succeed in raising the more substantial issue at stake in the Conceptual Art movement: not

whether words could be used to make works of art, but how to reinvest the work of art with an essaylike character, *whatever it was made of.* Michael Baldwin has said of the Art & Language work of the late 1960s that it was subject to a reciprocating form of "emergency conditional": it was "art" just in case it was (taken for) "philosophy," and it was "philosophy" just in case it was (taken for) "art"[22] – in other words it was intentionally volatile in the face of any attempt to represent it as one or the other. It was not simply resistant to the presumed authority of those accustomed to attaching texts to works of art. In living in – or closing – the gap between work of art and text, it preempted that authority entirely. Those who first encountered the work of Art & Language in the role of critic may testify to the strangeness of the experience. Any attempt at exegesis was doomed to self-parody. (I write from the memory of my own humiliation.) One either ignored the enterprise or joined it.

Conceptual Art

In case the point needs making, it is not here proposed, absurdly, that the Tapestry of the Creation is a work of proto–Conceptual Art. Nor is it suggested that the possibility of healing some merely art-historical breach between image and text was what motivated the Conceptual Art movement. That movement has often been represented as engaged in a radical critique of the "visual" and as seeking to reclaim art's lost intellectual potential by writing, as though this was a means to fulfil Duchamp's program to "put painting back into the service of the mind." But as the *Art-Language* editorial argued, painting and sculpture had never been out of the service of the mind. They have simply been subject to certain practical limits. As to the exiling of words from the pictured surface, this may never have been more than a contingent necessity in the practical development of specific kinds of pictorial mimesis – those that culminated in the achieved naturalism of Western figurative art. And long as that development lasted, it reached its point of furthest practical interest as early as the 1830s, at which point photography became available as a means to automate the previously manual processes involved.

The ensuing development of modernist painting may well be regarded as a long working-through of art's self-separation from literature and language, and of the consequences of that separation. This process may have been inescapable as one set of technical issues generated another. But it was never a straightforward pursuit of visual means of expression. Baudelaire's verdict on Manet – "You are only the first in the decrepitude of your art"[23] – could with hindsight be interpreted as warning of the prospect of loss, and of the necessity of technical shift and subterfuge if the possibility of intellectual content was somehow to be preserved in painting. Viewed from such a perspective, the American abstract painting of the late 1940s and 1950s might be seen as the furthest point of a historically remarkable development – the maximum

expressive capacity attainable with the minimum translatable content. As such it would furnish an extreme test of Nelson Goodman's dictum that "in aesthetic experience the *emotions function cognitively.*"[24] But by the end of the 1950s, with the consequences of specialization dogmatized into a theory about the necessity of art's opticality (of which Greenberg was only the most intelligent and lucid exponent), it seemed that the expressive capacity of painting could be maintained only *at the expense* of its unarticulated intellectual content.[25]

The Conceptual Art movement might be regarded both as a product and as a mode of recognition of the ensuing crisis. It was one significant finding of that movement that very little art is unproblematically visual; that seeing and the rest of the purely optical categories do not of themselves make art possible; that while the "visual" is necessarily open to complication, to single out an "optical" aspect of art is to be left holding on to very little. As Thomas Crow has observed,

> Conceptualism, which long anticipated recent theory on the level of practice, can be encompassed only within an unapologetic history of art. Its arrival in the later twentieth century recovered key tenets of the early academies, which, for better or worse, established fine art as a learned, self-conscious activity in Western culture. One of those tenets was a mistrust of optical experience as providing an adequate basis for art: the more a painting relied on purely visual sensation, the lower its cognitive value was assumed to be. The meaning of a work of art was mapped along a number of cognitive axes, its affinities and differences with other images being just one of these – and not necessarily the strongest. Art was a public, philosophical school; manipulative imagery serving superstitious belief and private gratification could be had from a thousand other sources.
>
> It was only in the later nineteenth century that the avant-garde successfully challenged a decayed academicism by turning that hierarchy on its head: the sensual immediacy of color and textured surfaces, freed from subordination to an imposed intellectual program, was henceforth to elicit the greater acuity of attention and complexity of experience in the viewer. The development of Conceptual Art a century later was intended to mark the limited historical life of that strategy. . . . (Crow 1996)[26]

There were two possible implications to be drawn from this finding. According to the first and weaker of the two, the culture of "visual art" had been shown to be mere Modernist humbug. The proper course for the alert avant-gardist was therefore to abstain from any activity that might be assimilated to Modernism's privileged categories: painting,

sculpture, and so on. Conceptualism thus freed art from the forms of an outmoded specialization, dissolved the traditional boundaries between media, and ushered in an age of generic art. This was the position of the Conceptual Art purist. The weakness of this position resides in its historical short-sightedness, its self-serving underestimation of the case for "optical" art's actual capacities and implications, and its validation of a great deal of work that is actually cognitively thinner than much of the painting and sculpture it claimed to supplant. Purist Conceptualism has also tended to accommodate itself to the distributive and promotional structures more or less as it found them. This accommodation notwithstanding, it has tended to encourage vulgarization of Conceptual Art as a liberation from the material restraints of traditional practices.

The second – and I think stronger – response to the "crisis of modernism" started as a kind of *social* discomfort with the available models of individual artistic practice. If the *idea* of the "purely visual" had been shown to be a mere function of late-modernist anti-intellectualism,[27] the need was somehow to hold on to art's traditional complexity and depth. In other words, it could be thought that Conceptual Art's project was not to make an entirely new art of "ideas," but rather to recover the subversive character of modern art's decorativeness, and thereby to readmit its traditional skepticism, its class politics, and other aspects of its long and purified history. Once the relevant closures had been relaxed, the critical purport of such things as paintings, sculptures, installations, texts and so on would remain matter for open inquiry. (By open inquiry, I mean inquiry that recognizes that there will always be some closure and that this will [probably] be nonarbitrary and will [probably] not be cognitive, but that tries to achieve a good match between the conditions of closure and the question asked. An answer to a question about how light switches work is likely simply to exhaust the patience of the inquirer if it has to include material about energy generation, carboniferous deposits, and labor relations within the power industry. Open inquiry stresses that while Verstehen is a condition of any inquiry at all, it is set in a world criss-crossed by different paths; these represent material transformations – practices and interests – within that world. These have to be brought into focus if Verstehen is to be anything more than a condition of absolute relativism.) At the start, however, Conceptual Art's contingent objective was to resist the dogmatization of Modernism and the entrenchment of those models of competence and professionalism that ensued. What followed was not straightforwardly an injection of language into art, but a militant assertion of art's implication in its own distributive and promotional structures, and of its adjacency to and implication in text – starting with those texts by which art's own expressive capacity and value were increasingly established.

No matter how many upwardly mobile bits of philosophical cant are adduced concerning the sudden and

stunning discovery of "the linguistic basis of art" . . . it is
far more informative to say that Conceptual Art grew in
a perhaps unexpected way out of the entrenched compe-
tences of Modernism. This was not so much out of Mod-
ernism itself, but out of the increasing aggregate of junk
by which Modernism was supported: galleries, maga-
zines and the whole carry-on of emotivistic commerce.
The celebratory provocations of Neo-Dada, Fluxus,
Duchamp, etc., often got a sneaky sideways glance, but it
would be a mistake to overestimate their hold on the at-
tention. Minimalism was the big, White, fast art of the
time. Minimalism had proceeded to reduce, or to remove
altogether, the necessity of internal detail within objects,
in favour of the "external" relations between the object
and its circumstances of display. Robert Morris wrote,
"Every internal relationship reduces the public external
quality of the object." Without a ritualistic support linked
with business, Minimal Art just wasn't there at all. . . .
Late professional modernist Minimalism caused atten-
tion to be focussed on the constitutive role of the art lan-
guage, of the gallery, the museum, the magazine and the
accompanying criticism . . . If art objects now depended
upon a framework of supporting institutions, what was
required was not so much "works" as work on the circum-
stances of work. Some redescription might thereby be ap-
plied to the so-called "art context" and not simply to the
autonomous works within it. The conditions whereby work
gets legitimated and ratified became the proper subject
for art work. *Alternative* grammatical or legislative con-
ditions might be prescribed; that was how art might in
one sense be remaindered by language. Virtuality *would*
be reintroduced. It would simply be removed from the
studio, but now located in language . . . or . . . in "the-
ory." (Art & Language, 1998)[28]

In practice what this required was that art's intellectual and theoret-
ical grounding in language be reasserted, and that a measure of realism
to human mental processes be recovered. It was not assumed that this
entailed either the denial of figuration or the possibility of its revival,
or that any given medium could be held more secure than any other.
There was no knowing at the time what "art" might follow, or indeed
whether what followed would be "art" at all. What was positively re-
covered, however, was the prospect of a socially distributed practice.

Conceptual Art does not correspond *tout court* to some
sort of linguistic turn in artistic practice. It does represent
an appropriation of certain dialogic and discursive mech-
anisms by artists who sought thereby critically to em-

power themselves and others, and to that limited extent it represents a linguistic turn. But Conceptual Art did not reduce (or attempt to reduce) the pictorial to the linguistic (or textual). The point is, rather, that the gaps and connections, the lemmas and absurdities between the pictorial and the textual, are space in which much cultural aggravation was and is possible. The eruption of the text into the cultural and historical space of the picture or the painting is an exemplary moment. A dialogic – and consequently more or less linguistic – sense of work and action provides a considerable critical purchase upon the prevailing stereotypes of artistic personality and practice, and even upon what is to count as artistic practice in a social context. (Art & Language, 1998)[29]

In fact, of course, the exile of words from art had never been absolute. It was suggested above that some painting that is far from literature may nevertheless possess a significant dialectical and dialogical aspect. It might be said that pictures hazard a form of existence as texts in history, and that texts put themselves at risk to the extent that they constitute possible kinds of pictures in history and in culture. Sometimes the risks involved may be conceived as reciprocal and may be invested in one "compact" work. Such occasions are rare, however, and may be connected to relatively exotic cultural and historical circumstances – such as those that gave rise to Conceptual Art. It is nevertheless clear that in the long development of modern pictorial forms, texts of one kind or another have made frequent anomalous but significant appearances, sometimes within the picture's figurative world, sometimes on its literal surface, as though testing the political climate with a view to some imagined return in the future. Consider, for instance, Poussin's *Arcadian Shepherds* (Louvre, Paris),[30] Ribera's *Magdalena Ventura with Her Husband* (Palacio Lerma, Toledo), Moreelse's *Scholar Holding a Botanical Thesis* (Toledo Museum, Ohio), David's *Marat* (Musée des Beaux-Arts, Brussels), the *trompe l'oeil* paintings of Edwart Collier, William Harnett, John Peto, and others, and, of course, the various collages and montages of Cubism, Dada, Futurism, Constructivism, and Surrealism. In a retrospective survey of "artists' writing," such works might be installed in some interesting niches.

In light of these considerations we might amend the Greenbergian account according to which modernism entails progressive specialization within individual media. If the inception of modernism follows on the culmination of pictorial mimesis around 1830, its extension over the next hundred and forty years appears less as a gradual and logical development constrained within the limits of individual media than as a restless and wide-ranging search for other principles and practical procedures by which the currency of artistic representation might be secured. Among the expedients to which artists resorted some were a great deal closer to writing than others. Within this scenario, we might

say that Cubist collage, Constructivist montage, and abstract art each in their different ways involved cognizance of art's necessary implication in language.

Ironically enough, none did more to effect the final collapse of writing into art than those who argued longest and most eloquently for their practical separation. From the point of view of Art & Language, the more theoretically sophisticated the supporting structure of criticism by which abstract painting and sculpture was upheld in the 1960s, the more the art in question was reduced to the status of mere demonstration, leaving the writing looking more and more like the effective representational medium. In 1965 Fried claimed that "Criticism that shares the basic premises of modernist painting finds itself compelled to play a role in its development closely akin to, and potentially only somewhat less important than, that of new paintings themselves."[31] This claim may have won Fried few allies at the time, but in the light of hindsight it looks positively modest. With hindsight of this order the emergence of Conceptual Art appears highly overdetermined. To paraphrase Mel Ramsden, "The time had come, finally, to put the writing on the wall." Around 1967 the entranced Modernist spectator was finally dislodged from his century-long rule as primordial arbiter of art, to be replaced by an engaged and inquisitive reader of writings – discursive writings that both occupied and reanimated the space of painting and that might or might not themselves be art.

Certain competences are involved in reading text qua text; that is to say as paragraphs and pages and so on, as distinct from rebuses, Constructivist adventures with letter forms, and such like. Other competences are involved in seeing decorative detail, texture, pattern, and so on. Under what circumstances could one conceive of these competences as possibly brought together? Works such as the Tapestry of the Creation offer a kind of juxtaposition that is merely spatial, the straightforward convergence of icon and text justifying our sense of the apparent simultaneity of viewing and reading. In comparison, we might say of certain early works of Conceptual Art – Joseph Kosuth's *One and three chairs*, Mel Ramsden's *Guaranteed Paintings* and *Secret Paintings* – that text and image were made to bear critically on one another, in such a manner that they seemed to compete for the *same* space in the spectator/reader's attention, rivaling each other in their powers of definition. Some other works of Conceptual Art – such as Lawrence Weiner's *Statements* – achieved a degree of parity between the relevant competences as a consequence of ambiguity in their ontological status: "One standard dye marker thrown into the sea," "One aerosol can of enamel sprayed to conclusion directly upon the floor," "A 2″ wide 1″ deep trench cut across a standard one car driveway."[32] In such cases it was not clear whether a given work was to be realized by making or by imagining an object on the basis of the written text, or whether the writing was itself the object under critical regard. If the ambiguity was resolved, this was less a matter of one kind of competence being favored over another than of recourse being made to some specific cul-

PAINTING CONTAINS A 6'x6" BLACK SQUARE

Plate 5 Mel Ramsden, *Guaranteed Painting*, 1967–1968. Liquitex on canvas and photostat, two parts each 30.5 × 45 cm. Courtesy Mulier Mulier, Belgium.

tural or critical theory or preference, according to which one or another form qualified for attention. Michael Baldwin has written of this period, "There was still some ambiguity – an ambiguity which persisted for some years – as to whether one was nominating as art what was referred to by the text, or offering the text itself as some sort of art in itself. . . . This ambiguity . . . remains either a central dilemma in what might be called the aesthetic ontology of Conceptual Art, or an aporetic complexity vital to its cultural functioning."[33] In some cases the ambiguity was self-conscious and strategic. According to Weiner's formulation, written prescription and actual fabrication "being equal and consistent with the intent of the artist the decision as to condition rests with the receiver on the occasion of receivership."[34] You paid your money and took your choice.

It seemed that the critical move was from painting-with-words to a kind of practice in which the meaning-bearing functions of the writing – and, perhaps, of the painting – were far less easily contained.

> The development of Conceptual Art was not even . . . and insofar as its beginnings were critical it (i.e. I, we etc.) went through quite rapid changes. I don't think there's very much doubt that at the beginning it was a subspecies of painting-with-words. The difference (for me/us) was that the words weren't treated like (or not precisely like) found objects. They were there "to be read," not just recognised as texts etc. The idea of a critical practice grew out of this and various other ur-ish discourses and ur-ish practices. It would be wrong to have the later state of things fully imagined early on. It was a *concrete* development, not a realisation of our heart's desire. The move was from "order" into a kind of chaos. That's the narrative. I don't think that the status of a text even then was at all stable. The point about the mess was that if we were to keep going (rather than simply revert to an intellectualised-up version of the *status quo ante* – i.e. bureaucratic Modernism), then there had to be instability in the very metaphysics of the text – in what a text was . . . and in how and where it was used. (Michael Baldwin, 1997)[35]

Plate 6 Art & Language,
*Index 01 ("Documenta
Index")*, 1972. 8 file cab-
inets, text and photostats,
dimensions variable.
Collection Alesco AG,
Zürich. Installation at
"Documenta 5," Kassel,
1972.

The significant point here is that the necessary instability could not
simply be a matter of what the text in question actually said. It was de-
pendent on some critical complication in the relations between reading
and seeing. If the moment of public emergence of Conceptual Art can
be dated around 1967, the culmination of that moment coincided with
"Documenta 5" in 1972, when Art & Language exhibited the work
known as *Index 01* or the *Documenta Index*. At least ten individuals
can claim direct experience of this work, though at widely varying lev-
els of involvement in its design, working-out, and installation.[36] As one
might expect, there are considerable differences in the accounts that
have already been offered of its production, and perhaps more signifi-
cant differences in the implications drawn from it. But the *Index* was
actually built on a more or less common conversational terrain. Per-
haps the best way to indicate the nature of that terrain is as follows. The
eight filing cabinets of the Index contained some eighty-seven separate
items of text by those who contributed in one way or another to the
work of Art & Language. What was displayed around the four walls of
the room was an enlarged typescript specifying certain kinds of rela-
tions between those texts. Yet this was a work that could not have been
made by *writers* – not, at least, unless they were writing as artists. In
fact few if any of those who worked most assiduously on the design
and production of the Index were either confident of its potential sta-
tus as art, or much concerned at the time that that status be attained.
Yet in the end the writing was in a sense displaced, and displaced by
something that was almost a picture – the conversation of texts made
into the quasi-decorative representation of a conversational world. The
spectator of the Index was provided with conditional means of entry
into this world. The condition was that she become a reader, and thus
a potential writer in her turn. But the writing that would *qualify* the
spectator of the work was neither art criticism nor documentation. It

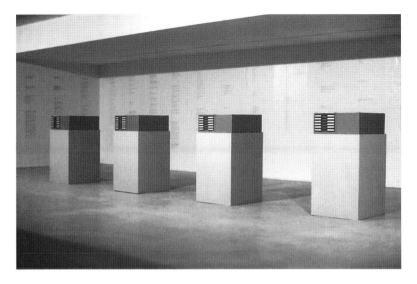

Plate 7 Art & Language, *Index 01*. Installation at "L'Art conceptuel; une perspective," ARC, Paris, 1989–1990.

was writing of a kind that might be inserted into and might extend the Index itself: writing that could thus be art.

The idea of a "post-Conceptual" art

Mel Ramsden has described Conceptual Art as "like Modernism's nervous breakdown." By the same analogy, if we are now to recover and to go on with a clear mind, we may need to revise our understanding of the past that has made us what we are. Whatever might be in prospect, there can of course be no return to the easy coexistence of text and picture that distinguishes the tapestry from Girona. We have as much hope of recovering the lost innocence of past modes of representation as we do of solving the problems of modern capital through a revival of peasant agriculture. It may be more to the point to return to a suggestion made earlier: that some art that appears entirely free of text, either as documentary accompaniment or as complication of its actual surface, may yet be seen as driven by an essaylike impetus. If we seek an antecedent tradition to which a post-Conceptual art might establish some critical connection, it may not be in the writing of artists that its traces are to be found, but rather in those works that invest ordinary artistic genres with some significant discursive aspect. This is certainly not to say that a plausible twenty-first century art could be envisaged as a simple series of portraits, still-lifes, landscapes, and history paintings. What is required is a strong hermeneutics, not a weak principle of conservation. (See my parenthesis on "open inquiry" above.) Nevertheless, if artists' writing as documentation can be sorted into a range of available categories, and if artists' writing as literature tends to reduce to minor literature, the possibility of artists' writing as art may depend on its being significantly rooted in artistic traditions *as*

distinct from established documentary genres or literary traditions or traditions of theatrical experiment.

If the writing is still in some manner to go up on the wall, then, what may be required of that writing is that it be somehow distinct on the one hand from theory conceived as secondary, and on the other from literature and theater; that it have, in a sense, no other place to go. The sense of "place" I mean to evoke here is not quite captured by the "art context," as exhaustively discussed in sociological and institutional theories of art. It is not a location in which some appropriated allographic composition might be more or less opportunistically installed in the hope of its being validated as "art" – and, as such, as autographic.[37] The destination I have in mind is one significantly decided by the character of those technical and theoretical issues that are generated by artistic traditions and by the problems intrinsic to their continuation. (In an artistic practice with any pretensions to realism, these issues will, of course, include many of those considerations of context that are differently treated in sociological and institutional theories.)

> Artists can, for example, make pictures of writing and they can use other people's writing as Readymades.[38] This touches on the matter of the *use* of writing by artists as opposed to the actual writing of speculative or theoretical texts. There is an ambiguity here. A philosopher may perhaps not be capable of exploiting writing or language in the same way as an artist. Artists have shows and spaces to fill. These go to activities which are usually distinct from writing. Here are the beginnings of strangeness. . . . Artists write in the presence, as it were, of galleries, collectors and museums. These are hungry institutions. . . . Some writing is made to be traded and collected. Some writing is placed on the walls of galleries and museums and some is placed *in* or *on* paintings. So writing and language – that is to say texts by artists – can be approached both as reading *and* looking material and also as reading *or* looking material. And this reading and/or looking material involves not just the production of text – some form of typing – but also various forms of graphic or architectural design, and many other possible modalities which may be quite unadjacent to the world of theorising or writing in an epistemologically or culturally "normal" sense. . . . Sometimes the graphic appearance of a text, or its context or situation, will militate against or categorically undermine any first-order textual content. For example, if a text is treated pictorially the recovered pictorial detail will go to a cultural terrain which the text itself may not be able to touch. What is important, however, is that "reading" the text insofar as it is the recovery of pictorial or quasi-pictorial detail is categori-

cally distinct from reading the text simpliciter. We might call the former case "looking *at* writing," the latter "reading". . . . We might simply say that artists more than anyone else have produced unstable inscriptions. . . . There is also a form of work which is in *practice* talkative and conversational. . . . (Art & Language, 1999)[39]

If it makes sense to conceive of an image/text boundary that may occur in one place quasi-naturally – genetically – as a function of neural programming or some other innate capacity for grammar, but which might be drawn in another by habit or convention, by disciplinary boundaries or religious protocols, then perhaps "writing as art" might be thought of as writing that, in hazarding though not necessarily voiding its semantic content, tends to generate quasi-theoretical or quasi-poetic structures and gestalts rather than arguments or narratives, and that in doing so bears critically on ordinary assumptions about the means by which such structures and gestalts are brought to mind. The practical circumstance here envisaged is one where, for all the semantic content with which writing as art might be endowed, it is as something like improbable *decoration* that its critical power is in the end discharged. It should be clear that the concept of "improbable decoration" is *not* here meant to refer to that graphic elaboration and enlargement which has enabled some quondam Conceptual Art to transform itself into museum-friendly décor. What is at issue is not the visual style in which artistic texts may be publicly presented, but rather the possibility that the intension of a given text might somehow be realized in its quasi-pictorial remainder.

The untidy edges of the decorative remain more or less thinly populated. These are the places which might produce an uncomfortable silence in the minds of those who arbitrate the artistic self-image of the age. What we mean is that the decorative promises a collapse from the significant to the meaningless. This is the scandal (the reason to continue) which attends all possibilities of conversation.

We're saying that the conversational and the decorative are connected. There is in the resistant (semiotically resistant) decorative always a possibility (due to excess of compunction) of collapse into meaninglessness. This is often a meaninglessness which is associated with alienness or criminality. A mark of the conversational is that it is liable to collapse into a pragmatic or concatenatory excess or emptiness – a practical resistance to theory – and that is resistance to a hegemony of academic observance, protocol and closure. It could be that conversation is the criminality of theory just as decoration might be the forensic degeneration of sense. . . .

> The decorative in our sense absconds from the mean-
> ingful – at least from the meaningful in the actual world.
> Indeed it is decorative only in the sense that it does ab-
> scond. There is nothing of course that is incapable of
> being meaningful in some sense, and of course one per-
> son's or perspective's decoration is another's votive object.
> So there are no absolutely decorative items. (Art &
> Language, 1999)[40]

In 1997, twenty-five years after the first *Index* was shown in Kassel,
Art & Language returned as exhibitors in "Documenta X." On this
occasion there were two large rooms to be filled. The work was based
on units of identical size and type, identified under the generic title
Sighs Trapped by Liars. In each of 436 small canvases, the image of an
open book was set within an apparently shallow illusionistic space.
Each canvas was given a single color, its tone varying only in accor-
dance with the shadowed center of the book and its surroundings. Each
showed a different spread of printed text. The majority of the
texts were writings by Art & Language. Some were based on available
pornographic narratives transformed by Michael and Mel through the
device of malapropism; that is to say by "translation" of the original
words and phrases into their homophonic near-neighbors.[41] Thus the
generic title was derived from an original sadomasochistic image of
"thighs wrapped by wires."

> Could we say that the malaprop is in one sense paradig-
> matic of artists' writing? It lives somewhere in the mar-
> gins of the literal. We might say that a malaprop "theory"
> would simply be the theory "translated" into malaprop.
> Though we don't talk malaprop normally we could per-
> haps try to translate it in order to recover the "theoreti-
> cal" text that lies behind it. Is this a dialogical diagram –
> a diagram of dialogue and of possible radical alterity – or
> is the malaprop just a reified text – a *thing* that possibly
> belongs on the wall? (Art & Language, 1999)[42]

The texts used in Art & Language's canvases varied in legibility ac-
cording to the depth of tone, the degree of contrast with the type, and
the extent of loss in the shadowed gully of the open book. In one room
at "Documenta" some 244 of these panels were arranged into the
forms of domestic furniture: a table with dining chairs, a sofa and two
armchairs. While some of the texts could be easily read under the cir-
cumstances, others required some degree of physical exertion from the
spectator if they were not to be reduced to the *mere* status of decora-
tive panels. In the second room 192 panels were set horizontally into
twelve vitrines composing a large square. A spectator standing at one
edge of the square could easily read the text on the nearest row of pan-
els, contrast permitting. The next row was harder to read, the third row

very difficult, and so on. As the individual texts shaded into illegibility, so the spectator was invited to surrender to the decorative properties of the whole. At the spectator's furthest horizon the panels formed a brightly colored chequered border.

In teaching students new to the humanities it is often necessary to dwell on the relationship between adequacy and completeness in the reading of both texts and pictures. A complete reading of a novel would entail the reading of every word of the printed text. Of course no one required to provide a critique of the novel could be expected to recall every word, or even to guarantee that all had been read. Yet *understanding* what a complete reading should entail would still be a necessary condition for an adequate critique. No one could read every word of Art & Language's *Documenta Vitrine*, however assiduous they might be. It is an inescapable condition of spectatorship of the work that it shades into decorative illegibility. Yet it matters that its text be understood as continuous throughout its 192 panels, and it matters that it be experienced as legible – that at least some of it be read. However enchanted viewers may be by the work's decorative properties, if they fail to read any of the texts they have failed to understand the relationship between detail and overall form. On the other hand, viewers who read the printed text attentively to the limit of their powers of focus have also failed unless they have looked up to the work's horizon,

Plate 8 Art & Language, *Sighs Trapped by Liars 651*, 1977. Alogram on canvas over plywood, 29.5 × 42.5 cm. Art & Language.

Plate 9 Art & Language, *Sighs Trapped by Liars 373–391, 413–508*, 1997. Alogram on canvas over plywood and mixed media, dimensions variable. Courtesy Grita Insam, Vienna. Installation at "Documenta X," Kassel, 1997.

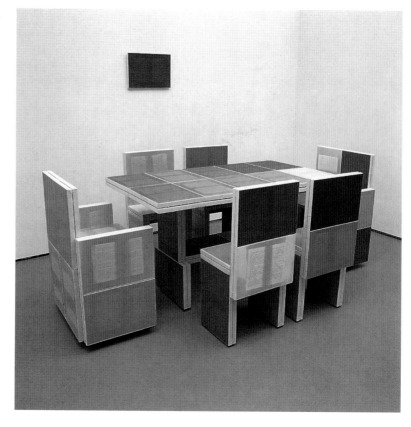

Plate 10 Detail of *Sighs Trapped by Liars*.

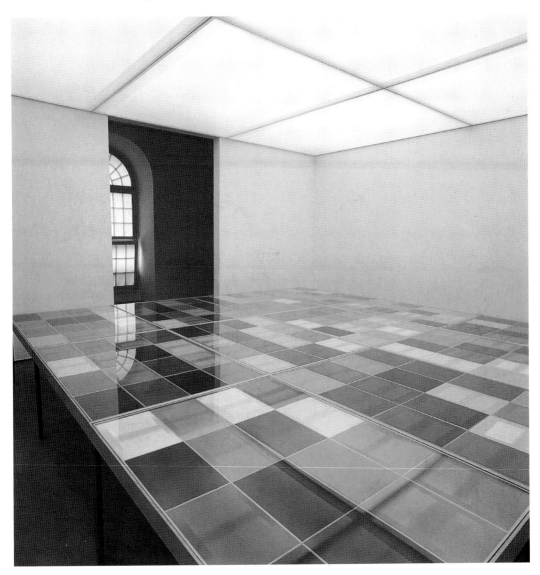

have acknowledged the illegibility of the intervening material, and have allowed that very illegibility to be a condition of the work's decorative extent.

> Recovering the detail of a picture is not the same as reading a text. The detail of the pictorial image slips into text (something read) and then back again – and vice-versa. The spectator's position is threatened by the slippage as he or she recovers spatial relationships which collapse into reading and so on. This work is an index of surface and interface, of what is "in" a painting conflating with what is done "to" a painting or done "with" a painting. (Art & Language, 1999)[43]

Plate 11 Art & Language, *Sighs Trapped by Liars 1–192 ("Documenta Vitrine")*, 1996–1997. Alogram on canvas over plywood, 192 elements each 29.5 × 42.5 cm in 12 vitrines. Installation at "Documenta X," 1997. Collection Fond nationale d'art contemporain, Paris.

Of course we still know when we are reading and when we are not. And what has been argued here puts us in no greater danger than we ever were of confusing texts with pictures – or of assuming that the respective competences could somehow be united in the conjuring of mental images. The point is that what change are the specific cultural and aesthetic circumstances under which we practice the relevant distinctions and assign value to the respective activities. Artists' writing as documentation is rarely of much interest in the study of these changes. Nor is there much to be hoped for from the enforced coexistence of artistic materials with texts. It is when art strives for the reflexive character of writing and when writing – *rather than* literature – strives for the nonallographic, decorative character of art that we are most likely to be exercised to some larger critical effect, not simply as readers or viewers, but as persons whose ability to make sense of culture and the world is at stake.

There were some works of early Conceptual Art – such as Ramsden's *Guaranteed Paintings* – where the actual or potential iconic content was so low or so incidental as to invoke a more or less undifferentiated visual field – one where it was hard to connect "seeing" to the registering of any significant detail. At another extreme, there were pictorial forms of high modernist art – such as Olitski's spray paintings of c.1966–1968 – that so explicitly distanced themselves from writing that the very necessity of writing *as other* became their raison d'être. If what we are concerned with is some possible convergence of the competences of reading and viewing, then examples of these latter types might be thought of as highly diffuse. To say this is not necessarily to disparage these works. They are cited merely to draw attention by contrast to the intentional *compactness* of the Art & Language work in the series *Sighs Trapped by Liars*. What distinguishes these works is that picture and text appear on and in the same image. While the recovery of detail in a picture may be categorically distinct from the reading of a text, in the confrontation with these works the two practices merge, not because the exercise of one competence is in the last instance rendered sufficiently incidental to let in the other, but because a maximal decorative vividness and a maximal textual content are both invested in the same surface. Around this point of convergence it seems that "artists' writing" may offer some interesting challenge to the competences of criticism.

2

Conceptual Art and Its Criticism

The establishment of Conceptual Art

In any standard account of the art of the second half of the twentieth century, the moment of Conceptual Art now figures as a point of significant change – the hinge between artistic modernism and the postmodern, perhaps, or more prosaically – and increasingly plausibly – between significantly different phases of modernism itself. A possible scale of comparison is given by replacement of the pair Modern Art/Abstract Art by the pair Modern Art/Conceptual Art as a framework of journalistic reference for the artistically odd and alien. The long currency of the first pair – lasting from the 1920s to the 1960s – was testimony of a sort both to the strength of art's previous marriage to pictorial representation, and to the depth of those changes that followed from its dissolution. The implication is that Conceptual Art may have effected or been driven by changes at least as fundamental as these. For Benjamin Buchloh, writing in 1989, "Conceptual Art truly became the most significant paradigmatic change of post–World War II artistic production. . . ."[1]

Since the late 1980s there have been three major surveys of the international Conceptual Art movement. It would perhaps be more accurate to say that there have been three major exhibitions of art to which the label "Conceptual" has been attached as the means to single out a specific tendency emerging in the mid- to late-1960s and continuing for at least ten years thereafter. The qualification is required given the tendency already cited, in which the designation "Conceptual Art" may be applied to more or less any current art that is neither painting nor sculpture – or which, if it is painting or sculpture of a sort, owes nothing to and acknowledges nothing of a relevant material tradition or memory.

The first of the three exhibitions, under the title "L'Art conceptuel, une perspective," was held in the winter of 1989–1990 at ARC, the Musée d'Art Moderne de la Ville de Paris. Thirty-eight artists were represented (if Art & Language is counted as a single "artist"). The inclusion of works by Marcel Duchamp, Piero Manzoni, and Yves Klein revealed a concern to establish some European antecedents of the Conceptual Art movement. Over half the artists included were American by nationality or adoption, however, with Robert Rauschenberg, Jasper Johns, and Robert Morris included as forebears. Editorial contributions to the catalog came from a variety of American and European sources.

The second exhibition was staged at the Museum of Contemporary Art, Los Angeles in the winter of 1995–1996, under the title "Reconsidering the Object of Art: 1965–1975." This was also an international exhibition, though its agenda was predictably different from that of the ARC show. There was no attempt to represent antecedents, and of the fifty-five artists or collaborations included well over half were from North America. Of the five editorial contributions to the catalog four were by Americans and the fifth by the Canadian artist Jeff Wall.

Finally, between April 1999 and November 2000, "Global Conceptualism: Points of Origin 1950s–1980s" was shown respectively at the Queens Museum, New York, the Walker Art Centre, Minneapolis, and the Miami Art Museum. Some 140 artists or collectives were listed in the catalog, while a dozen curatorial essays served, with varying degrees of credibility, to represent "Conceptual" tendencies and movements in Japan, Europe, Eastern Europe, Latin America, North America, Australia and New Zealand, the Soviet Union, Africa, South Korea, Mainland China with Taiwan and Hong Kong, and South and Southeast Asia.[2]

Quite apart from the material issued in connection with these exhibitions, an increasing flow of publications and of publishers' commissions testifies to the rapid development of interest in the Conceptual Art movement. Meanwhile the past ten years has seen the growth of a competitive market in "established" works of the "classical" period – a moment located between 1965 and 1975, or, for the less gullible, between 1967 and 1972. It should occasion no surprise that the curatorial and commercial ratification of individual works and careers coincides with art-historical reification of the movement as a whole. It does not follow, however, that retrospective views are now readily organized into a consensus. Some awkward questions remain to be addressed: when Conceptual Art is on the conversational or institutional agenda, who is it that gets mentioned? Which works are included in survey exhibitions, which are discussed and illustrated in books on the movement, which are acquired for the permanent collections of major museums, and so on; how, in the first place, are "works" and "texts" distinguished so that examples of the former might be included in an exhibition like "Reconsidering the Object of Art," while examples of the latter might end up in a "critical anthology" (such as the one ed-

ited by Alberro and Stimson and published by MIT Press in 1999)?[3]
How is art-historical precedence decided; and how, in particular, are
the grounds of precedence connected to answers to the previous ques-
tion about "works" and "texts," or to other questions, for instance,
those that would consider the conjecturally dated occurrence of
"ideas" with regard to their practical and confirmable implementation
in or as "art"?[4]

An answer to any of these questions naturally provokes another
question: on what grounds? Unless we are simply to submit to the dic-
tates of fashion or of chauvinistic prejudice, to the self-curating pow-
ers of artists, or to the noncognitive interests of the market and of its
representative institutions, we will need some purchase on more sub-
stantial issues: those concerning the relationship between historical
understanding and critical discrimination.

Clement Greenberg was wont to say that he measured the compe-
tence of other critics by their ability to tell a good Pollock painting
from a bad one. Of course we may assume that agreement with Green-
berg's own verdicts was all that was required to pass the test. Yet it
could still be argued that a writer unable to make significant and rele-
vant discriminations between Pollock's paintings would be incompe-
tent to represent his work as a whole, and probably incompetent as a
critic of Abstract Expressionism in general. We have seen at least one
substantial publication on Conceptual Art that is clearly vitiated by its
author's inability to make appropriate and relevant discriminations.[5]
Such verdicts come easily enough. It may be harder, though, to estab-
lish secure grounds on which critical assessments may be made.

The end of "quality"?

The avant garde of the late 1960s and early 1970s has rightly been as-
sociated with a certain subversiveness as regards the conventions of
artistic quality. To the extent that the question of qualitative discrim-
ination has genuinely been shown to be otiose or irrelevant to the
enterprise of Conceptual Art, no good purpose can be served by
reintroducing it. Yet works of art are appraised in the market, whether
or not certain art historians and curators consider it proper or relevant
to discriminate. (Among those with avowed scruples against discrim-
ination there is a tendency to conflate the making of distinctions –
including distinctions between "good" and "bad" art – with elitism.
There is of course no necessary connection.) If the critical character of
Conceptual Art is inseparable from those wider forms of critique that
came to a head in 1968, it may also be observed first that Conceptual
Art failed during the 1970s and 1980s to achieve any plausible public
presence outside the art-world, and second that the economic substrate
of the art-world was among those repositories of power and influence
that survived the 1960s virtually untransformed. In face of this unfal-
tering power on the part of the market (the very power that it was once

thought by some that Conceptual Art would challenge or subvert), it would seem a matter of mere piety to accord works of Conceptual Art any general immunity from critical assessment, as it might be on the grounds of their supposed radicalism as forms of distribution. In introduction to the exhibition "557,087" in 1969, Lucy Lippard wrote:

> Idea or conceptual art, like that of Darboven, Atkinson, Baldwin, Borofsky, Kawara or Kosuth, and physically extant but imperceptible art like Barry's, share basic conditions with all previous art. What is radically new is its context, the exhibition and dissemination possibilities (cf. Seth Siegelaub's March and Summer shows, 1969, which took place all over the world – simultaneously or however the artists chose to govern their time).[6]

This is informative about the ways in which some Conceptual Art differed from previous art, but it does not actually serve to connect that perception to the question of whether some or all Conceptual Art is any good, except insofar as curatorship in itself implies advocacy.

In fact it seems inconceivable that so ample a survey as "Global Conceptualism" could have been put together unless axiological considerations had been *deliberately* suppressed. There are of course advantages to highly inclusive and relatively undiscriminating exhibitions. A survey of "Global Cubism" might be highly informative about the spread of a style or paradigm of art, about the differences between regional variants, even about the character of provincial transformations, appropriations, or misunderstandings. In the organization of such an exhibition, however, it would still be necessary for some limit of furthest attenuation to be applied – and applied with some understanding of what might qualify as a "core" example – so as to prevent virtually all post-1908 art from coming up for the count. Is Conceptual Art like Cubism in this respect? Or does the term mark out so categorical (or "global") a disruption in the historical development of art that we can – or should – no longer conceive of a "core" in relation to which the periphery might be decided? In her introduction to the exhibition "557,087" in 1969, Lucy Lippard echoed the utopian fantasy that Mondrian had articulated some forty years before,[7] and that Joseph Beuys subsequently adapted to serve as the supposedly ethical basis of his activities: "The time may come when art is everyone's daily occupation, though there is no reason to think this activity will be called art."[8]

Perhaps the time *has* come. Perhaps not. How would we know? Opinions will be widely divided as to the meaningfulness of such statements or to the feasibility – or desirability – of the outcome they seem to evoke. The divisions in question will entrain substantial theoretical controversies in the realms of aesthetics, anthropology, and ethnography. We can at the least say that there are strong grounds for scepticism wherever avowedly antidiscriminatory or antielitist programs are allied

to the concept of a global culture. Insofar as they are in thrall to an increasingly confident global capitalism, the managerial imperatives of curatorship are antielitist only in the absurd sense that the universal provision of Coca Cola is antielitist. They are, in effect, powerfully distributive and necessarily imperialistic. Traditionally, "aesthetic" grounds and mechanisms of selection offered notable mismatches with such imperatives. At the time of the Conceptual Art movement, the claim to Kantian disinterest associated with aesthetic criteria was itself subject to some strong kinds of redescription. It does not follow, however, that the imperatives of "globalization" now present the traditional criteria of selection with any radical or transforming critique. Rather, what they establish are the conditions of a prudential silence.

I do not mean to bemoan the passing of any certainties. Unless we can countenance aesthetic value as an essential and immanent value (as in "the beautiful"), we must accept change in the criteria of its ascription. These criteria will vary in response to changes in art or, more realistically, in response to those changes by which art itself is changed. Workable – nonadministrative, nonarbitrary – critical resources are not discovered as abstractions, nor do they emerge as well-formed sets. They are elaborated in practice, in the process of assiduous reading, and they are recognized in forms of difference from those principles of assessment that, for one reason or another, have become dogmatic or bureaucratic or simply ineffective. The first aspiration of this essay is to suggest some grounds on which the adequacy of any critical account might be decided. The second is to suggest how such an account might proceed, and what kinds of distinction it might enable.

The authority of Modernism

It is surely self-evident that to claim historical or cultural significance for Conceptual Art as a movement is implicitly to assert some strong critical distinction between the representative works of that movement and whatever is taken as establishing the normal ground of the practice of art at the time in question. And this is to say that a relationship of mutual implication will hold between on the one hand one's view on the art-historical priorities and interests of the modern period in general and the early 1960s in particular, and on the other the grounds on which one singles out certain works as representative of the critical character of Conceptual Art. The present text is written on the assumption that no account of Conceptual Art can be adequate if it does not involve some effort to understand Modernism. (I should make clear that by Modernism here I do not mean the entire artistic culture of the modern period – whenever this is taken as commencing. Nor do I mean either the sinister cultural arm of American capitalism or those vagrant forms of commentary that announce what it is that artists can get away with this year. I mean Modernism as substantial history and theory that has been close to practice and informative to practice; not

just the standard conflation and caricature of Greenberg and Fried, but the elaborated discussion of modern art and culture that variously engaged Baudelaire, Zola, Bell, Fry, Mondrian, Schapiro, Benjamin, Adorno, Breton, Merleau-Ponty, and many others.) This is not to say that Conceptual Art was in any sense the necessary outcome of Modernism. Rather, it is to assert that the representative critical character of Conceptual Art was established by reference to the epistemological conditions and implications of Modernist theory (what it claimed to know or to need to know), to the ontological character of Modernist production, and to the moral and ideological character of Modernist culture, and that the historical significance to be accorded to Conceptual Art is therefore relative to an estimation of the status and character of Modernism in the 1960s.

It is the further contention of this essay that by the mid-1960s the Modernism that was theorized in dominant forms of criticism and represented in dominant institutions was (a) morally oppressive and cognitively exhausted, and (b) materially entrenched; and, in consequence, that there could be no critically adequate form of continuation of the practice of art that did not avail or imply both an account of the practical exhaustion of Modernist protocols for the production of a nonoppressive and nonsubmissive art, and an account of the mechanisms by which the effective power of those protocols was nevertheless sustained.

> It might be best to try not to engage with the narrative of the often odious curatorial category of conceptual art and talk about a project which occurred in one form or another to some in the 1960s following the deflating challenge which was faced by late high Modernism. Many who had been students in the late- to mid-1960s had concluded that recent European developments from Pop art to various forms of kinetic art and sculpture were without critical virtue and certainly without vividness. What was vivid was a set of puzzles, questions Jasper Johns had reworked via Duchamp, which Frank Stella's black paintings had posed for abstraction (emptying it of its high Modernist aesthetic while seeming to preserve the letter of the Modernist law), which Judd and Morris had posed for painting in general. The avant-garde didn't come from Europe, its critical potential came from the possibility of the break up of the finally attenuated Abstract Expressionist Empire. The territory to be contested was the manipulative and constituting power of Modernist criticism and the surfaces (including the uncrusty "optical" surfaces) to which that criticism assigned virtue. (Art & Language, 1997)[9]

According to this view of the conditions of the time, the task was twofold – albeit the respective requirements were not necessarily distinct in practice. The first requirement was to establish a critique of the

aesthetics of Modernism. This entailed the development of appropriate art-theoretical and art-historical tools. The second requirement was to establish a critique of the politics of Modernism. This entailed the development and application of socioeconomic forms of analysis.

Art & Language as instance

This somewhat bloodless series of assertions is unlikely to find favor either with all those who count themselves as contributors to the Conceptual Art movement or with many of its critics and curators and historians. I acknowledge some contingent factors that bear on its composition. The first is that the issues about which I am attempting to theorize were generally encountered by the individuals concerned in relatively inchoate circumstances, in the form of fissures and discontinuities and dissatisfactions in practice. The second is that the practices in question included teaching and art-theoretical writing as well as such activities as might or might not have resulted in the production of artworks. The third is that my own learning in this respect was done largely in the company of Art & Language in its earliest formations during the 1970s, and subsequently as the learning of one who associated with that name in practice. That learning was also done in light of work completed before the early 1970s by others who used the name.[10] That I write largely from within an intellectual framework associated with Art & Language may be taken as damaging to the credibility of my observations on the Conceptual Art movement as a whole. I assume that that damage is limited, however, to the extent that the framework in question furnishes a case-study relevant to the issues under discussion.

It is certainly true that the project of Art & Language developed, awkwardly, unsystematically, and unevenly, and occasionally elegantly and systematically, as a kind of critical resistance to the dogmatization of the aesthetic and to those political and theoretical prescriptions by which the agents and clients of Modernism sought to protect its failing conceptual apparatus. This project involved skeptical and elliptical reexamination of two now familiar assumptions that were central to the theoretical and ideological character of Modernism. The first assumption was that the authentic experience of art – the experience by which the very function of art is defined – is a disinterested response to the work of art in its phenomenological and morphological aspects, which is to say that the experience is cast in the self-image of the sensitive, empiricistic, and responsible (bourgeois) beholder. The second assumption was that modern art – or the modern art that matters to those to whom "Art speaks for itself"[11] – develops along a trajectory marked by the gradual and self-critical reduction of its means.[12] Unsurprisingly, apparent exceptions to this tendency were normally disqualified in Modernist theory on the grounds that the sensitive and responsible beholder is unable to see them as art that matters. The character of Modernism as an ideology of art was thus established by the relationship

of mutual dependence between a linear model of the development of art and an account of aesthetic experience as involuntary and disinterested. The historical matrix, that is to say, was the "empirical" validation not of some objective canon but rather of an arbitrary manipulative power – the power perceived within Art & Language as exercised in the image and agency of the beholder.

This manipulative agency could not be resisted in artistic acts that were mere orthogonal projections of the historical matrix, and which thus aligned themselves, however covertly, with the mechanisms of validation. As suggested in the previous essay, the view of Art & Language in the later 1960s was that Abstractionist Modernism had become a system that made the objects of its own attention. It followed that the requirement for a critically interesting artistic practice was not simply that it should evade the more evident protocols of Modernist aesthetic judgment, but that it should be opaque – other – vis-à-vis that account of the history of art that represented the progressive reduction of means as a logic of development. Among American artists particularly there was a tendency to advance ideas and statements as "art" on the principle that they constituted radically reduced – "post-Minimal" – forms of object. (Robert Barry's 1969 work, "Something very near in place and time but not yet known to me," is a representative example.)[13] Within Art & Language such procedures of reduction or "dematerialization" were regarded not as the manifestations of a transformed aesthetic, but as symptomatic of the very system they were designed to supplant.

> And consider what to do with other "material" from this period: columns of air, chemical constituents, ice, fog banks, water, etc. Are these (pre?) conceptual, ultra minimal *devices*, or are they *in* the black box of conceptualism? These invisible or theoretically specified "objects" must be identified somehow. How? They must be spoken about, written about, even photographed. This can be discursive or social activity. The identification of the "invisible" entity might involve the circumstance through which it is identified. Here, doubt is thrown on the divisions between "artist" and "critic," "participant" and "spectator." The implication is that a lot of artworld protocols were rendered provisional at least and endangered at most. In the middle was *confusion*. This seems to be the paradoxical consequence of the urge to drive the literalism of minimalism literally into absence and then into a paradoxical virtuality – a virtuality of "theory" – if it was "virtual" or if it was even "theory." (Art & Language 1997)[14]

Many "texts-as-painting" and "dematerialized objects" appeared to be resting on an assumption of the theoretical and social continuity of

art (and of the practical continuity of a public already enchanted with avant-garde art). On the other hand there were other initiatives in which the reductivist principle of Modernism appeared in the form of a *reductio ad absurdum*. It was not always easy to distinguish those works that were effective prolongations of the critical system from those that proposed some sort of new beginning insofar as they reduced it to absurdity. The difficulty of distinguishing these in turn from the significantly transforming was made clear enough by such manifestations as Seth Siegelaub's now canonized "January" exhibition in 1969, which brought Robert Barry, Douglas Huebler, Joseph Kosuth, and Lawrence Weiner together in public. By 1969 it was already clear that the artist's-appropriation-of-bits-of-the-world-by-nomination was a dead duck, and a corrupting dead duck at that. It required that relations between language and the world be treated as secure and unquestionable – or securely and unquestionably "artistic" – just when it seemed clear that the relevant logical grammar was in urgent need of wholesale reexamination and renewal.

> The possibility here is that the author or the artist is no longer alone; that a socialised base of art just might be developed not from a sentimental notion of commonality but as a necessary internal development of "the work" itself, a queer consequence of speculation or conversations about "invisible" or de-materialised objects. Such talk made for itself the requirement that it be not *just* overexcitedly neological but turn sometimes towards some kind of epistemic adequacy or at least be conversationally sustainable. It demanded of itself that its character should not be art-wordly and knowing but somehow ordinary and dialogically substantial even if that ordinariness compassed a high degree of wildness and absurdity. Grammatical and legislative conditions might be described and prescribed. The conversational and collaborative "language" base of (some) conceptual art starts here and the stabilised identities of "artist," "critic," "theory," "practice" start pulling apart. (Art & Language 1999)[15]

It was a position representative of Art & Language in the later 1960s that given (a) the artistically inclined beholder's status as personification of the Modernist moral and aesthetic disposition and (b) the exhaustion of Modernism as a discursive system, the possibility of critical transformation in the practice of art implied not the exploitation but the ruination of those mechanisms of validation that this beholder's authority represented. To imagine a transformed art was thus to imagine the experience of art as a possibly different *kind* of experience, and to imagine the public as a constituency of which different dispositions and competences could be expected or hoped for or predicated. (This

understanding reflects the kinds of class-analysis that informed avant-garde art in England at the time.) It followed both that different competences would have to be brought to bear in the production of art, and that they would have to be exercised on some different range of discursive and possibly aesthetic materials. The works of Conceptual Art that ensued were typically opaque – disappointing – to the intuitive responses of the typical Modernist connoisseur, *even in his post-Minimalist guise*. Viewed under their phenomenological and morphological aspects they remained – and remain – insignificant, inconstant, or absurd. Into the resulting aesthetic void they instilled the demand for a reading – that is to say, a demand that Modernist beholders could not easily satisfy without abandoning the secure grounds of their own authority.[16]

Other heirlines?

The search for materials and precedents outside the accustomed range of Modernist connoisseurship was one that variously occupied the larger avant garde of the later 1960s. Among those adopted were some from earlier avant-garde episodes that had been marginalized in the process of establishment of the Modernist historical canon – forms of enterprise that had been derogated as "impure" on the grounds of their adjacency to the theatrical, the narrative, or the political, or because they had floated loose from the security of established genres and media. Thus the broad period of development of Conceptual Art coincided with a recuperation of the critical and informal aspects of such earlier avant-garde movements as Dada, Constructivism, and Surrealism. Consequent shifts in the conceptual relations of mainstream and margins are observable in standard art-historical perspectives on the twentieth century. In some European accounts, the moment of Conceptual Art is seen as marking the end of that long American diversion that Modernism is taken to have been, as effecting the reidentification of the history of modern art with an authentic avant-garde tradition, and even as reestablishing the status of such disregarded antecedents as the Fluxus group and the Nouveaux Réalistes.[17] There have even been attempts to represent Conceptual Art as a form of Situationist "terror."[18]

Such rewritings are understandable as corrective responses to the chauvinism of the normal American art- and art-critical-world – a chauvinism that in the 1970s and 1980s fed and grew gross on the products of that Modernist apostasy that Minimalism had initiated. But however decisive American writers and curators may have been in establishing critical and art-historical protocols, Modernism does not refer to a uniquely American moment or agency, nor does it mean American art rather than French art. Modernism is a system of representation, complexly connected to a system of distribution, within which European and American art alike are accorded a certain character and value. Modernism is ideological, and as ideology American

Modernism has been powerful and hegemonic. It does not follow, however, that all that has been hidden in its margins is possessed of an unquestionable critical virtue. Nor does it follow that all claims on behalf of the work, say, of Jackson Pollock or Donald Judd are hegemonic mystifications; nor does it follow that the work of Piero Manzoni or César has been underestimated. Such accounts as would equate the critique of Modernism solely with resistance to American cultural hegemony tend to be notably uninstructive as regards those conditions that Modernist theory itself has explicitly and often successfully sought to address – conditions of continuity and depth in modern art over the course of more than a century.

The authority of Modernist history is not overthrown by narratives of "alternative" practices; the Modernist concern for continuity and depth is not effectively countered by claims made on behalf of artists such as Hanne Darboven or Daniel Buren or On Kawara, which assume that stylistic monomania is interesting in itself; nor is the Kantian claim to disinterestedness that lies uneasily at the heart of Modernist aesthetic preferences undermined by claiming a supervening nonaesthetic virtue for varieties of art that have given up the *critical* (immanent) struggle in favor of journalism or some other kind of tendentiousness. To say that a critique of the notion of disinterested value was something that preoccupied the Conceptual Art movement is not to allow that all or some not-painting/not-sculpture can be automatically co-opted to a given set of interests, however apparently virtuous. Nor is it to associate the critical struggle with any overtly sociopolitical program. (Whatever it is that decides the art-critical interest of Hans Haacke's *Shapolsky et al. Manhatten Real Estate Holdings . . .* of 1971, or Martha Rosler's *The Bowery in Two Inadequate Descriptive Systems* of 1974, it is not their potential standing as evidence of social and economic injustice.) Political solidarity is not established in artistic enterprises, nor have political themes ever been simply *available* to counter the dogmatization of the aesthetic. Transparency of effect tends to entail some sacrifice of depth and complexity and it does not necessarily equate with discursiveness. No art is possessed of an automatic "truth-telling warrant."[19]

The point is not that the pursuit of significant formal or intentional identity necessarily involves submission to the idea of an essential aesthetic value, nor is it that art has to be seen to absolutize or to dehistoricize the contingent (or the political). The point is rather that unless the given contingent material is such as to be transformable by or in the complexly self-describing system that is art, then it is probably better to treat it through practical politics or journalism; and if the system in question is such as to impose no limits on the admission of the contingent or the political, it is probably not worth considering as art. Conceptual Art is nothing if there is no power to its claim to be occupying the space of art, and that claim will have no power unless it entails a transformation in what art is, such that Conceptual Art is art. What I mean by this is that Conceptual Art is not art at all unless its objects

are intentional objects under some description; and it is not art of any critical interest unless it effects a transformation among that range of descriptions under which something might be seen as intentional.

> One might imagine, for example, that out of a real expansion [in the category "art"] and a substantial increase in complexity, a possibility of study or inquiry would emerge beyond the [antecedent] categorical margins which would nevertheless possess some critical resonance within them. (Art & Language, 1999)[20]

Other readings

At this point someone might want to object that the radicalism of Conceptual Art lay not in its occupation but rather in its *displacement* of the space of art – a displacement effected precisely by breaking down the barriers between the aesthetic and the political and between the overspecialized high arts and the more notionally popular (though in fact simply more readily distributable) arts of publicity. From this point of view the concern for critical depth and extensiveness might be seen as an "elitist" abnegation of the requirement of effectiveness. This argument is all very well, but the works on which it tends to hinge are liable either to establish themselves in a thoroughly conventional world of art or to be absorbed without remainder into the larger world they purport to invade. (Among the artists who might be cited in support of such arguments are Hans Haacke, Jenny Holzer, and Barbara Kruger.) In the first case the works thus represented are subject to whatever institutional or fashionable criteria may happen to prevail. In the second case they do indeed put themselves beyond the concerns of evaluative criticism of art, but only by failing to be of interest as intentional objects under some critically significant description. In neither case do they offer any novel address or alternative to the requirement of cognitive depth in art.

What is at issue here is the kinds of limit that traditions and artistic categories impose or provide, and the ways in which these limits bear on the business of critical differentiation. Imagine three models of what may or may not count as works of art.

> W1 is intentionally connected to a tradition, in the sense that it is informed by certain conventions, and that it explicitly or implicitly addresses them. It can therefore position itself so as to effect a critical transformation of the conventions in question.

> W2 recognizes no limiting tradition or convention as bearing on it. It stands outside these limits. It therefore leaves the conventions intact, and procures its identity from a parasitical presumption that that is how they will remain. If the conventions

do not remain intact, W2 has no artistic identity. It is undifferentiated from the set of "meanings" that are the rest of the world.

W3 aspires to enter the world from the start devoid of any sense of limit or necessity imposed anywhere by any material tradition. It is therefore engaged in a dialogue with anything it resembles or resonates with in the world. It has, as it were, to compete with the entire spectacle of semiotic stuff. It is likely to lose out badly in this competition. In fact W3's aspiration must be fraudulent. If it is in any sense an intentional object, it requires some continuity in a tradition or set of conventional limits from which to distinguish itself. W3 is simply a manipulative and mendacious form of W2.

It seems that if a case is to be made for the art-historical significance of Conceptual Art, it will not be enough either to reproduce the protocols of late-Modernist aesthetics under a new post-Minimalist disguise, or to replace the critical question as to whether or not something is any good as art with questions designed to measure noncognitive effectiveness. The case will have to be one that, although it may resist the *conventions* of aesthetic value associated with Modernism, nevertheless admits the possibility – and difficulty – of critically assessing works of Conceptual Art as intentional objects under a range of relevant descriptions.

The important point is that this will entail some assessment of the different *readings* – and not simply of the category mistakes – that works of Conceptual Art avail. I suggest that the demand for readings that seek to make the work intelligible is still instinct in those examples of Conceptual Art that have remained interesting. That demand should not now be replaced or forgotten in the name of an assumed authenticity, whether conferred as a consequence of some inadequately theorized sense of art-historical precedence, or of agreement with some "truths" supposedly told. The suppressed beholders have to exert themselves.

This is not a plea for the restoration of connoisseurship on some already-discredited basis (such as the self-serving fiction that art speaks for itself to the innately acultured and sensitive). Rather it is to affirm that need for interpretative reading (*Verstehen*) that was implicitly asserted in the early work of Art & Language, and that is still felt within our practice whenever some congeries of physical and discursive materials takes the form of a "work." What is meant here by reading is not the willful digression of the self-enchanted, but rather the critical elaboration of the object of thought, where that object is recognized as the other, both as regards the self-image of the observer and as regards any given historical narrative or tableau.

We may well want to hold on to a sense and a tradition of modernism (as distinct from Modernism) that evokes an extensive and internally

diversified current of artistic practice and theory, extending approximately from the 1840s to the end of the 1950s. And we might well acknowledge that the mark of this modernism is a reflective and reflexive concern with art as a mode of address that invites reading of the order outlined above. But no grounds for complacency would be furnished by this acknowledgment. The need for strong interpretative reading is now all the more urgent in the face of two prevailing tendencies: the first – characteristic of the emergent ruling class of the 1980s and 1990s – is to identify rational judgment and preference with the "findings" of the market; the second – characteristic of a now established academic clerisy – is to fetishize causal inquiry (*Erklärung*) as the means to uncover authentically subversive meanings. However mutually distinct they may believe their ends to be, the respective adherents of these two tendencies have the same ideal object in view: the unimpeachable work of art that confirms their picture of history and authenticates their image of themselves.

It is an important function of interpretative reading that it serves to distinguish the cognitively critical from the factitiously avant-garde. As regards the art of the past thirty-five years, this is a result of specific moment to the matter of distinguishing between various candidates for attention. The suppression of the beholder was not simply a matter of making things that were radically unartistic or radically political – and in that sense unamenable to being beheld. Nor did it *simply* mean envisaging a different constituency. It meant establishing the grounds for a different kind of transaction. From the perspective of Art & Language, the distinguishing critical feature of Conceptual Art lay in the requirement of collaboration or silence it made of its imagined public, and in the transformed image that it thus offered spectators of themselves as historical beings: the image of people of whom something is demanded by the material presented to view: people challenged to act on that material and its place in a history that might or might not be their own, to take thought on the conditions of thought – or to keep quiet.

3

On a Picture Painted
by Actors

Preamble

This essay takes as its point of departure three performances of "Art & Language Paints a Picture installed in the Style of the Jackson Pollock Bar" that were given during the year from April 1999 to April 2000. Art & Language and the Jackson Pollock Bar were first brought together in January 1995 at the Symposium "Art & Language and Luhmann," organized by the Institut für soziale Gegenwartsfragen (Institute for Contemporary Social Issues) of Freiburg at the Kunstraum in Vienna. This was a somewhat mystifying occasion for us. We had only the vaguest idea of the character and composition of the Institute and at the time we were unacquainted with Niklas Luhmann's work, which was not then easily available in English. It was not very clear why we were there at all. The eminent social philosopher may in his turn have been baffled by the talks we gave and by the accompanying exhibition of Art & Language work, though if so he gave little noticeable sign of it. Among others who took their turn at the microphone were Catherine David, then at work on the organization of "Documenta X," and Peter Weibel, artist, curator and now supremo of the Institut für Kunst und Medientechnologie (Institute for Art and Media Technology) in Karlsruhe. The simultaneous translators did their best, and the contributors hoped for the best, but no one could have called the occasion a meeting of minds.[1]

The three-day event was rendered memorable, however, by a "Playback Production" by the Jackson Pollock Bar. This is both the name of a real drinking bar in Freiburg and the point of generation of "theory installations."[2] The production consisted of a replay – in German – of the so-called Philadelphia Panel, a discussion on "The Concept of the New" held at the Philadelphia School of Art in the spring of 1960. Five German actors played the parts of Jack Tworkow, Philip Guston,

Plate 12 Jackson Pollock Bar, *The Concept of the New*. Theory installation at "Art & Language and Luhmann," Kunstraum, Vienna, 1995.

Harold Rosenberg, Robert Motherwell, and Ad Reinhardt. Besides the evident flirtation with canonically modern art history, what gave this reconstruction its frisson was the fact that all five speakers were lip-synching their lines to a pre-recorded tape. Proposals for collaboration between Art & Language and the Jackson Pollock Bar followed from this occasion.

"Theory installation" as representation

In its original form, "Art & Language Paints a Picture" is a text first published by *Gewad Informatief* in 1983 to accompany an exhibition of paintings in the series *Index: The Studio at 3 Wesley Place*.[3] This came to the attention of Christian Matthiessen, director of the playback productions and partner in the real Jackson Pollock Bar, following the appearance of its German translation in 1998. It was Matthiessen's idea that the text should be made the basis for a work to be staged in connection with the Art & Language exhibition then proposed for the Fondació Antoni Tàpies in Barcelona. The protagonists would be actors of the Jackson Pollock Bar under his direction.

"Art & Language Paints a Picture" was accordingly first performed in Barcelona in April 1999. I refer to the event as a performance in full awareness that this is too weak a term to catch the principal critical issues that may be at stake. Drama, play, happening – none of the available genres seems quite to fit. The Jackson Pollock Bar use the name "theory installations," appropriately enough, for the strange collaborations that they have made their specialty. I mean in due course to consider what kind of theory might appropriately be installed by an organization named after a bar that is named after the most celebrated and least theoretically articulate of the American Abstract Expressionists.

a b

This was the second time that the Jackson Pollock Bar had supplemented an exhibition of the work of Art & Language. The first was at "Documenta X" in Kassel in 1997. On that occasion the actors performed "We Aim to be Amateurs," another text written by Michael and Mel as a fictional dialogue between themselves, with a walk-on part for myself.[4] This text was translated into German, and was then recorded and learned by the actors. The resulting theory installation took place in one of the galleries at "Documenta," transformed for each performance into a mock-up of the Art & Language studio, complete with paint-spattered tables, paint tins, overflowing ashtrays, and so on. The room was also equipped with a screen on which my representative projected illustrative slides of Art & Language work, much as I might now be doing were this text spoken from the lectern and not printed in a book.

Two actors, Martin Horn and Peter Cieslinski, appeared to speak the lines variously attributed to Michael and to Mel. But at some point – perhaps differing from one spectator to the next – it became clear that they were not in fact speaking but were miming to a pre-recorded tape, as they had done in Vienna two years previously. As before, the immediate effect was to add a further representational layer, at once to heighten the sense of alienation and to invest the proceedings with a powerful sense of the uncanny, the *unheimlich* – as though a man without a reflection had been caught staring at a reflection without a man. In Sigmund Freud's account, the uncanny is associated with the return of the once familiar in a form made strange by repression.[5] Julia Kristeva adds the gloss that "uncanniness occurs when the boundaries between imagination and reality are erased."[6] At the Jackson Pollock Bar's first performance in Kassel I knew better than most of the audience just what to expect. Yet despite my inability to follow the dialogue in German, it still seemed both as though the rhetorical style of an Art & Language discourse had been caught and preserved, and as though some other form of representational life had emerged as its dramatic shadow.

In the theory installation at "Documenta," though the two principal actors were obliged to behave like artists conversing in the studio – to gesticulate, smoke, walk about a bit – they were not required actually

Plate 13 a, b Jackson Pollock Bar, *We Aim to be Amateurs installed in the Style of the Jackson Pollock Bar.* Theory installation at "Documenta X," Kassel, 1997.

to make anything. It might be thought that they had quite enough to do to achieve that remarkable synchronization on which the uncanny effect largely depended. Yet in choosing their text for the performance at the Tapies Foundation, the Jackson Pollock Bar greatly increased the demand on the actors, for "Art & Language Paints a Picture" is just what it promises. The genre it both revisits and reworks as a kind of fiction was originally developed by the American magazine *Art News* in the 1950s and early 1960s, when a number of semi-abstract painters bathed in the success of Abstract Expressionism. The series "X paints a Picture" provided the reader with an apparent entree to the working studios of Jackson Pollock, Hans Hofmann, Naum Gabo, and others less noteworthy. In the manner of these now forgotten accounts, Art & Language's text appears to offer a representation not simply of the conversation of the studio but of the practical work that that conversation accompanies and in turn represents. In fact the fictional activity is temporally displaced from the outset, while the artists assume a variety of conjectural masks and dispositions. There are moments of self-mockery, of self-displacement in bombast and pretension, and other forms of play, interlocked with more or less accurate reflections of studio talk and activity. These are artists acting as artists, but not necessarily in the present – perhaps in allegory.

In this case, then, what was demanded of the actors of the Jackson Pollock Bar was not only that they mime a complex text but that they also perform the activities to which that text makes reference, both explicitly in the form of stage directions and implicitly through the artists' statements of intent, through their descriptions of what they are doing, and through their responses to what they have done. They were required, in effect, to paint a picture based on an Art & Language sketch – a picture of some considerable size – and to do so within the time span allowed by the text: a period just short of an hour.

There is worse. "Art & Language Paints a Picture" was the product of a particular moment in the early 1980s and it relates to a specific body of work from that period: a series of very large paintings titled *Index: The Studio at 3 Wesley Place*, this name being variously qualified "Painted by Mouth," "In the Dark," and "Illuminated by an Explosion nearby." (These are discussed in *Essays* chapter 6, "'Seeing' and 'Describing': the Artists' Studio.") Some of these paintings *were* drawn and painted by mouth – that is to say their designs were made and in some cases transferred and enlarged with pencils held in the mouth – and some of them were painted with brushes that Michael and Mel held between their teeth while they crawled over the studio floor, at times navigating by dead-reckoning across the pictorial surface with which that floor was covered. It is perhaps fortunate that the actual painting to which the text refers is the third of this series, by which time the occasionally freakish and spectacular compositional distortions first produced by mouth were being painted and reworked by hand. This was "The Studio in the Dark."

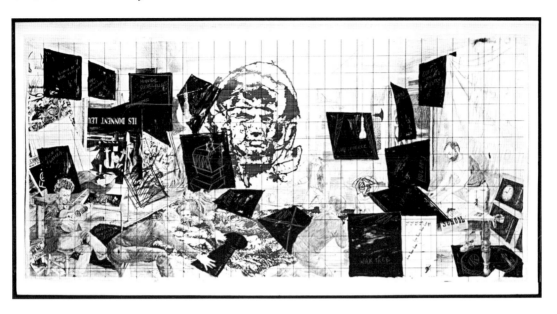

Although "Art & Language Paints a Picture" was originally written as a kind of drama, there was no intention or expectation that the text *would* be performed. In fact, though Michael and Mel intended the work for the page, the dramatic potential was soon noticed. Soon after its original publication in 1983 they recorded a version to the accompaniment of music by Mayo Thompson, and later that year it was performed by a group of Austrian artists at Galerie Grita Insam in Vienna, as part of a workshop conducted by Michael and Mel with Fred Orton. These were performances of the text. While the text contains stage directions, it did not seem all that likely in 1983 that anyone would ever carry them out, let alone do so while miming the words in Catalan, a language then foreign not only to the original text but also to the principal actors themselves. Yet this is the project that the Jackson Pollock Bar undertook: to mime the text in Catalan while fulfilling the practical instructions that the text contains, that is, to be painting actors, to act painting, not under any immediately familiar guise but under conditions of bathos and desperation, and to do so while miming to a language that, since it could not be learned as sense, must be learned as a series of merely phonetic sequences. The demands are comparable to those made of international opera singers in what is traditionally considered the highest of all artistic genres. When opera singers are learning their librettos, though, they normally do so with the considerable mnemonic advantage that melody provides.

It is in part this stringency in the demands made on those involved that renders the category of "performance" so inadequate to the work of the Jackson Pollock Bar. For all the energy that has been invested in its development and promotion, "performance art" remains at best a subcategory, whether of theater or of art. The typical instance of

Plate 14 Art & Language, *Index: The Studio at 3 Wesley Place showing the Position of "Embarrassments" in (III); Drawing (v)*, 1982. Ink and crayon on photograph, 79 × 168 cm. Tate Gallery, London.

Plate 15 a, b, c, d, e, f
Jackson Pollock Bar, *Art & Language Paints a Picture installed in the Style of the Jackson Pollock Bar*, 1999. Theory installation at Fondació Antoni Tàpies, Barcelona, 1999.

a

b

c

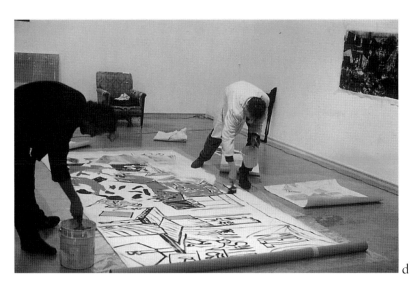

d

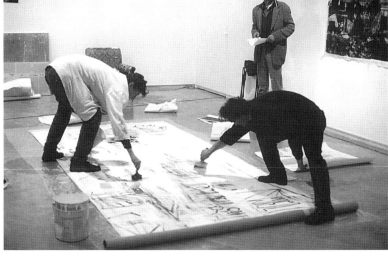

e

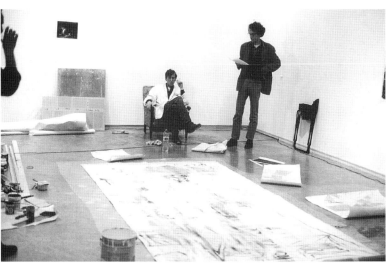

f

performance art is a moment of tedious and trivial exhibitionism, devoid of all intentional irony. The "theory installation," on the other hand, aspires to the conditions of high genre – albeit the aspiration is, as it were, scare-quoted. In the form in which it was demonstrated in Barcelona, at least, it might be thought of as a kind of nonmusical equivalent for opera: a contorted hermeneutic relation, perhaps, to Richard Strauss's *Capriccio;* an artistic discourse on the character of artistic discourse. Like Wagnerian opera, the theory installation proposes itself as a kind of Gesamtkunstwerk, but one in which the integrating function normally accorded to music is instead accorded to the practice of art. But if this is conceivably a high-genre enterprise it is one that is also deliberately and crucially rendered insecure – potentially incompetent in the eyes of its onlookers – through the bizarre effects of the playback technique. At times in the performance a minute gap is detectable between the movements of the actors' mouths and the speech sounds to which they correspond. The sense of hiatus is reinforced when such actions as striking a match or pouring a glass of water are similarly disconnected. The excess associated with the Gesamtkunstwerk descends into bathos. Appropriately enough, the effect is not unlike that generated in Art & Language's work by the technique or claim of "painting by mouth."

> To index the name of a picture P with the phrase "Painted by Mouth" . . . is to generate some sort of hiatus. The degree of confusion generated by the indexation will be a function of several considerations. Among these are the character of the painting referred to, the descriptive character of the name and the presuppositions of the onlooker. . . . PBM cuts down the syntagmatic and paradigmatic material by which reference to a given picture is made. It also displaces the paradigmatic locality of the picture itself. And this displacement conduces to an absence of canons, canons which condition judgements of competence, of vulgarity, of accidentality, etc. (Art & Language, 1982)[7]

The ordering of the genres

I should explain briefly what I mean by high genre. (Those in the know can skip this paragraph.) The academic theory of the genres proposed a hierarchy of technical types, according the dignity of de jure classification to those functional categories into which artistic products had tended to divide de facto in response to the requirements of their prospective users. As far as painting is concerned still life and landscape were traditionally at the bottom, portraiture was in the middle, and history painting was at the top. To some extent this ordering both followed the precedents of literature and served the ends of competi-

tion with literary culture, which tended everywhere to be better established than the visual arts. Classically the genres of highest status were epic poetry and tragic drama. It was in these forms above all that the writer treated of elevated lives and elevated themes – of victory and defeat, murder and love, in the lives of kings and heroes, of the workings of fate in the past and of the morals that might be drawn for the present. In the eighteenth and nineteenth centuries the range of potential high-genre forms in the West was expanded by the development of the novel and of opera. History painting was the one form in which the visual artist could lay claim to a similar range and gravitas – a similar potential for *edification;* hence its superior status and its claim on the support of the state. In the modern period, however, the grounds of comparison between the genres shifted. The cultural and technical consequences of modernism bore down in different ways on the different arts, in some cases leaving their respective genres more or less intact, in others rendering traditional distinctions irrelevant or subject to critical transformation. The visual arts suffered the most evident disturbance. Even now, at the commencement of the twenty-first century, credibility still attaches to the idea of modern tragedy, of the modern novel, even of modern operas. History painting has had its modern moments, but it had been reduced to a philosophical and technical absurdity – had become *unmodern* – before the twentieth century was more than halfway through.

A substantial question remains to be decided, however. Does it follow that we should no longer seek to make those kinds of hierarchical discriminations between artistic products and practices that the theory of the genres served to encourage? Is it possible that distinctions of intentional range and depth are simply irrelevant to current practice? Or alternatively should we seek to establish some kind of hermeneutic equivalent for the previous orders, weighing the various categories of contemporary artistic production for those to which the aspirations of high genre might appropriately be transferred? If so, what we should look for is some category of practice distinguished by the long resonance of its dialectical themes, and by its immanent critical bearing on the dominant discourses of the age.[8]

It should be clear enough that my argument commits me to the second of these alternatives, as does my implication in the Art & Language project as a whole. It is around the glassy shards of the higher genres that the interests of Art & Language and the Jackson Pollock Bar have tended to converge. In fact a preoccupation with the allegorical possibility of modern high genre was flagged from the start by Art & Language's engagement with the subject of the Artist's Studio, which commenced a mere few years after the practice of Art & Language came to include painting. This, after all, is the theme to which Courbet devoted his largest canvas, to which Picasso and Matisse returned again and again, and which the later Braque made the subject of an ambitious series. Between 1850 and 1950, it was in the Artist's Studio that painting most frequently approached that quasi-symphonic

complexity and breadth that history painting seemed no longer able to possess. And if the self-aggrandizing potential of the Studio genre appeared finally to have been exhausted, then this was all the more reason that a highly mannered reanimation might be of interest to Art & Language. The idea was the more attractive for the fact that the Studio genre had been invoked unwittingly once before, some twenty years previously. What was Art & Language's *Documenta Index* of 1972 if not the artistic representation of a place of work?

> It was certainly the pivot between early and later Art & Language work. Before the *Index* no seriously ultra-hip Minimalist-cum-Conceptual artist would be seen dead in a studio. The *Index* wasn't a studio exactly; or if it was, it was a conceptualist's studio, a kind of office, often an office floor. It may have been the final office of Conceptualism. The question is, whose office was it? Was it the office of a new and sinister management . . . ? Was it a centre of distribution? No. It was an imploded place of massive internal detail. It was a place of work. (Art & Language, 1997)[9]

Perhaps the materials of current practice might again be used to conjure a conversational world into the studio. In 1980 no less than in 1850, though, any explicit representation of historical themes condemned one to technical anachronism. This difficulty was overcome in the painted *Studios* by crippling the spectacle involved. The apparent ambition associated with high-genre work was continually and intentionally betrayed, first by the bathetic procedure of painting by mouth, subsequently by the expedients of picturing the studio in the dark, by visiting it with representations of Art & Language's failures, and by illuminating its surface with the imagined flash from a nearby explosion. As implied above, there are connections that might be made here with the alienating devices that characterize the performances of the Jackson Pollock Bar. It is an intuition apparently common to Art & Language and the Jackson Pollock Bar that the higher genres are now accessible *only insofar as they can be rendered "unheimlich."* Just why this might be the case is a question that will need to be considered in due course.

I have suggested some grounds of comparison between theory installation and opera. It is significant in this connection that Art & Language's explicit engagement with the genre of the Artist's Studio coincided with work on the libretto for an opera. A collaboration in the late 1970s and early 1980s had already produced a couple of longplaying records and some single songs with words and some performances by Art & Language set to music by Mayo Thompson and his band The Red Crayola. As a result, there was interest from a German TV station in the idea of an opera. The original plan was for this to be

performed and filmed at "Documenta 7" in 1982, when Art & Language was to show the first two Studio paintings. In the event, little progress was made with the organization of the event and the proposal was aborted. But by then the libretto had gained a momentum of its own. It was completed in 1983, and finally published in the following year as a monograph edition of the journal *Art-Language*, with the title *Victorine*.[10] Ten years later a French translation was printed in the catalog of an Art & Language exhibition at the Jeu de Paume in Paris. At the time of writing Mayo Thompson is still at work on the music, though interest has been expressed from some other quarters, including the Jackson Pollock Bar. We live in hope. But unless and until there is a score to match the libretto's exploitation of the absurdities of high genre, the text of *Victorine* must stand alone as the literary half of an ambitious and uncompleted project.

Pictures and readings of pictures are crucial to the organization of the drama – not only to the unfolding of its narrative, but to the interweaving of its representational layers.

Plate 16 Cover for *Art-Language*, Vol. 5, No. 2, March 1984 (*"Victorine"*).

> The story is set in Paris in the 1860s. It is a kind of detective story, and a dream. Its most prominent character is a detective, Inspector [Maurice] Denis, who misreads pictures. He misreads them not in the sense that he fails to recover appropriate meaning from them or that he does not see pictures as the pictures they are: he fails to see pictures as pictures.
>
> Women have been dying in suspicious circumstances. Denis, as the investigating detective, appears to be unable to distinguish bodies from paintings of bodies. Among the suspects are Courbet and Manet, whose painted works have been subject to his delusions. . . .
>
> His apparently subversive achievement is after all *only* incompetence. All he has is the power to deny with transparency and inverted solipsism the real and endless dissatisfactions of modernity. It is only in being made unaesthetic that the political effectivity of art may be directed and controlled. At risk, however, is Victorine Meurend herself. . . . (Art & Language, June 1993)[11]

In Art & Language's practice the Studio project and the opera were interwoven. One of the stage props for the opera is Courbet's *Atelier du peintre*, rolled up in the corner of his studio when Inspector Denis comes to call. Courbet's picture set the dimensions for Art & Language's Studio paintings, and it also appears, in reproduction as it were, as a represented detail within the composition on which they are based. The title of the opera refers to Victorine Meurend, the model for Manet's painting *Olympia*, on which the artist is seen at work in the final act. A reproduction of this painting also appears, like Courbet's, as

a detail within Art & Language's Studios, while Victorine Meurend herself is included, paintbrush in mouth, as one of four people engaged in painting Art & Language's *Attacked by an Unknown Man in a City Park; a Dying Woman; Drawn and Painted by Mouth,* which is shown as laid out on the floor of the studio. (For relevant illustrations see *Essays,* chap. 6.)

The various pictures represented in the Studio paintings and those referred to in the opera are works that are necessarily already achieved. Even the *Dying Woman* was actually complete before work on the Studios began. Within the opera, Manet's *Olympia* may be imagined as a work still in process – a cryptic clue to Victorine's fate, with its symbolic resolution still in doubt – but only because the painting now hanging in the Musée d'Orsay is available to attest to the fiction. By contrast, the text of "Art & Language Paints a Picture" defines a work that is necessarily in process – indeed at the outset uncommenced – and that is thus incapable of being measured against some model already installed in the nonfictional world. Though it may bear some resemblance to Art & Language's Studio compositions, the only form in which it can actually be realized is as an escape from the text: that is to say, as the residue of a performance that was the performance of a painting.

If the Jackson Pollock Bar was prepared to undertake such a performance in the context of an exhibition of the work of Art & Language, then the least that we could do was ensure that the resulting canvas would be displayed as part of the exhibition at the Tapies Foundation. After the performance it was acordingly stretched and hung in one of the galleries on the lower level. This, then, is the picture to which my title refers: *Art & Language's Studio at 3 Wesley Place; Painted by Actors.*

The picture as avant-garde object

At this point in the essay I face a kind of crisis: a choice between directions the argument might take – a parting of the ways. The issue is an important one, I feel, and not simply for the progress of the essay itself. There are some large critical principles at stake. While I may know which path I wish to take, if I am to justify my decision I will have to offer a view some way down the other.

So, the first course open to me is to argue the claim that the actors' painting should be considered on its own as a work of art. In its first version, this essay was sketched out in advance of the Jackson Pollock Bar's performance and before the picture was painted, and at that point I had no expectation of dwelling for long on its appearance, or of making any serious claims for such aesthetic properties as it might be thought to display. I assumed that the interesting issues would be those that surrounded the production of the painting, not those that might attach to its merits as a finished work. But I was given pause by the out-

Plate 17 "A Picture Painted by Actors" from *Art & Language Paints a Picture installed in the Style of the Jackson Pollock Bar,* 1999. Pencil and acrylic on canvas, 178 × 352 cm. Art & Language and the Jackson Pollock Bar.

come of the performance. Hence the dilemma. It is not because the painting turned out better than I had envisaged – by which I mean that it surprised me with some strange virtue in itself. It is rather, I suppose, that I was made aware how much *less* substantial a relic of performance might be and still be treated as deserving of serious if not reverential attention when displayed in an art gallery. The Museum of the History of Science in Oxford preserves a couple of blackboards on which Einstein wrote to explain the General Theory of Relativity. These could be considered to have some secure relationship to a cognitively significant moment. At the time of writing, Tate Modern in London displays three blackboards on which Joseph Beuys made some notes and drawings in chalk during a public lecture in 1978.[12] Their relationship to the prospect of edification is at the least less automatically established. The extensive "Out of Action" show staged in Los Angeles, Vienna, and Barcelona in 1998–1999 was largely composed of objects that had evidential status in relation to past events conceived as primary. I have seen few shows I enjoyed less. There was little work on display that, left alone, I would have saved from a fire. But I am not alone, and I would have to be far more confident than I am in the grounds of my critical judgment not to be shaken by the attention others have paid to the various physical remainders of ephemeral installations, actions, and performances conducted over the past half century. In recent years the gap between artwork and memento – and between art-celebrity memento and historically vivid artefact – seems clearly to have closed in the minds of curators. But it has also to be acknowledged that a deliberate merging or confusion of the two categories has been an intentional strategy in some prominent artistic careers, that of Joseph Beuys among them.

Such cases resonate in a now familiar world: the world of "theater," as conceptualized over thirty years ago by Michael Fried. In his essay

"Art and Objecthood" Fried used the term "theater" to designate an area of critical dead ground between the traditional artistic media, where installations and actions and performances abound.[13] Fried aimed to stem what he saw as a rising tide of decadence. If his intervention had any practical consequence, however, it was to precisely the opposite effect. As suggested in the previous essay, those soi-disant anti-Modernists who considered him a conservative took heart from the strength of his condemnation, working all the harder to theatricalize the relationship between artwork and viewer. Certainly, it is within the very area of operations Fried described that cultural expertise has most evidently flourished and grown fat. In the now densely populated spaces between the traditional media, the manager, the therapist, and the academic gather to polish their various curatorial manners, in the certain expectation of exploitable confusion.[14]

Perhaps I should try to confront the issue head-on. In the present critical climate, and given the relative unpopularity of Art & Language's work among the opinion-formers of the age, it seems well within the bounds of possibility that some informed visitors to the exhibition in Barcelona could seriously have preferred the picture painted by actors to anything that hung in the main galleries on the upper floor of the Tapies Foundation. Someone might claim, for example, that the picture is possessed of a relative indexical vividness, that it testifies to a degree of spontaneity and insouciance generally absent from the work of Art & Language; that it is more approachable, because less technically or intellectually forbidding, and so on. More substantially, they might claim that it is not through membership in the categories of painting or sculpture that any artistic object can now lay claim to serious critical attention; it is only by virtue of its power to address questions to our understanding of what art is generically, or of what is or might be "art." According to arguments such as these, it is not as a composition critically if improbably connected to the Studio genre that the actor's picture may rightfully claim our attention, nor even as a member of the quasi-genre "semi-abstract painting." The only category that matters is the generic one, "art." As Joseph Kosuth claimed, notoriously, in 1969:

> Being an artist now means to question the nature of art. If one is questioning the nature of painting, one cannot be questioning the nature of art. If an artist accepts painting (or sculpture) he is accepting the tradition that goes with it. That's because the word art is general and the word painting is specific. . . . All art (after Duchamp) is conceptual (in nature) because art only exists conceptually. . . .[15]

Of course the straw man I am setting up here will not bear a great deal of beating before he falls to bits. I am at risk of conflating a range of different theoretical positions, some of which are actually irreconcilable with each other. Thierry de Duve accords a similar authority to

Duchamp's example, but as he has argued at length, his understanding of Duchamp's admonition to "do whatever"(*fais n'importe quoi*) produces a very much less programmatic and more open sense of the generic than does Kosuth's.[16] And yet, the artistic culture we now face in practice is one in which an effective conflation *is* typically made between: (a) a belief that the tradition of painting was effectively terminated around 1960 by the advent of the blank canvas on the one hand and of "three-dimensional work" on the other; (b) a belief that the significance of the ready-made lies in its *permitting* (rather than, in de Duve's sense, requiring) that one "do whatever"; and (c) a belief that the generic "whatever" is necessarily invested with a critical potential beyond the now exhausted reach of painting or sculpture. According to this perspective, the interest of art resides in its power of exemplifying or calling attention to certain of the meanings with which the world is saturated. It does this not by working those meanings up into the novel formal complexes associated with the traditional understanding of artistic genre, but by placing ordinary – or even extraordinary – meaning-bearing things in the special circumstance of the "art context": the gallery, the museum, and so on. It is here – and not in the space within the frame – that representation now takes place.

Proceeding down the route this culture marks out, then, I might seek to connect the picture painted by actors to a tradition of avant-garde gambits, all variously challenging to those traditional criteria according to which the artistic has been singled out and dignified: Duchamp's unassisted ready-mades, Picabia's iconoclastic ink-blot, Moholy-Nagy's painting ordered by telephone, Magritte's *peinture-bête*, Klein's Certificates, Manzoni's canned shit, Rauschenberg's *Portrait of Iris Clert*, Morris's *Statement of Esthetic Withdrawal*, Buren's ubiquitous stripes, Baldessari's *Commissioned Paintings*, and so on. Whatever our interest may be in the physical presentation of these enterprises, so the argument goes, their true critical power resides in the "questions" they raise. (That it is the business of the artist to "raise questions" rather than "provide answers" was the stock-in-trade of the artistic scoundrel as portrayed, for instance, by the British comedian Tony Hancock as early as the 1950s.) Traditionally, the analysis of artistic form has been so conducted as to reinforce specific kinds of value placed on authorship and professional competence. The claim for the avant-garde work is that it renders these values radically insecure, so that artistic form has to be assessed according to different priorities – perhaps even discovered at some moment in the productive process prior to the extrusion of any physical object. To quote Kosuth once more, "If Pollock is important it is because he painted on loose canvas horizontally to the floor. What *isn't* important is that he later put those drippings over stretchers and hung them parallel to the wall."[17]

In celebration of its avant-gardism thus conceived, I might represent the picture painted by actors as positively unstable in respect of its authorship, and as incompetent only according to just those fixed and professionalistic standards that it actually serves to undermine. I might

ask rhetorically whether the picture is to be seen as a self-reflective work by Art & Language, or as a critical travesty of Art & Language work on the part of the Jackson Pollock Bar. I might argue that its appearance of relative incompetence is in fact a thoroughly competent *representation* of incompetence on the part of highly skilled actors, and that it is actually the form of their performance that the painting serves critically to enshrine. I might go on to question the larger division of the cultural world into artists and performers, or presentational and theatrical modes, reentering now from a different position the controversy that gathered around Fried's "Art and Objecthood." And I might conclude that the best – because most radical – claim the actor's picture may have to make on our attention in the art gallery is precisely that it is *not* the work of artists.

So much for treating the picture painted by actors as a work of art in its own right – the first of my two directions. I mean to go no further down that route, at least for the time being. But there is one point I should make before I turn back. If we do indeed treat art as a generic concept, and if we evaluate individual works principally in terms of their power to problematize that concept, then we must necessarily be consigning an interest in artistic genres to the realm of the conservative. It is worth remembering, however, that the separation into genres has always been driven by practical considerations and mechanisms. For all the post hoc codifications by which art's various Academies have sought to regulate their professional terrain during the past four centuries, the categories in question are in the end decided by certain market relations, and by the contexts and types of use that these reflect, which is to say that they are relative to the material and cognitive practices of given societies. It is through the history and transformation of the genres that the modalities of artistic practices can be seen to submit to social conditions of realism. Might it be that indifference to these modalities is in part what leads to fascination with the ready-made and its generic legacy (which, it should be allowed, may not be its only significant legacy); or at least that that indifference is a consequence if not a cause of interest in the generic? So much the worse for that interest if so, since whatever virtues there might be in a theory of art indifferent to the theory of the genres, realism could hardly count among them. And where would all the ordinary and extraordinary objects be *without* that principle of autonomy that the "art context" now so readily and *uncritically* confers? Lost in a competition with the rest of the semiotic stuff and with the material conditions of existence – global or local, it would not matter.

The risks of high genre

The requirement of my second route, then, is that the actor's picture be considered as inseparable from the theory installation by which it was generated – a form I've described as aspiring to high-genre status. From this second perspective, the picture is not an artwork in its own right,

but a merely contingent outcome of the text in which its production is described, and a generic product of the pictures that text refers to. It was painted because the script required that it should be painted and it was rehearsed insofar as the performance required rehearsal. As far as concerns its presence in the exhibition, it served in the end to accompany a video of the performance. It is at best a stage prop with a life of its own, and no sensible controversy attends on the issue of its authorship. What I now wish to consider is the convergence of Art & Language and the Jackson Pollock Bar on the possibility of modern high-genre work. There are two questions in particular that need to be addressed: How might the condition of high genre now be achieved? And if it is true that modern high-genre work needs, if it is to be plausible, to be possessed of some self-deflationary aspect, how is that necessity to be explained?

Plate 18 Video of Jackson Pollock Bar, *Art & Language Paints a Picture installed in the Style of the Jackson Bar*, 1999.

I have quoted the argument that the critical value of Pollock's work lay in the radicalism of his painting on the floor. As already implied, this is not an argument deserving of much support – and would certainly have received none from the artist himself, who sensibly described his technique simply as "a means of arriving at a statement."[18] But Pollock's example may be turned to a quite different end. His career offers vivid testimony not just to the struggle for a modernized high genre, but, more tellingly, to the risk of involuntary and disastrous collapse that struggle apparently came to involve.

Pollock's standing as example is highly overdetermined in the present context. Item: it is with a work by the self-consciously named Jackson Pollock Bar that we are primarily concerned. Item: represented at the center of Art & Language's Studio compositions is a *Portrait of V. I. Lenin in Disguise in the Style of Jackson Pollock*, the last of a series of such works produced by Art & Language in the year before work on the Studios commenced. Two other paintings from the same series were shown on the large wall in the exhibition at Barcelona. Item: Pollock makes a thinly disguised appearance in Art & Language's opera as Jean Fils Merlin, police-informer, agent, and flâneur. Item: it was Pollock who was set at the commencement of the "Out of Action" exhibition, the implication being that it was his "action" of 1947–1950 that subsequent avant-garde developments were "out of." Pollock's work thus stands at one and the same time as a possible model for high-genre abstract art and as cultural prototype for an imagined transcendence of the traditional genres. According to Allan Kaprow, writing in 1958, "He created some magnificent paintings. But he also *destroyed painting*."[19] And finally, it was Pollock, to the virtual exclusion of all other candidates, who inherited from Pablo Picasso the mantle of stereotypical modern artist in the popular imagination – a mantle to which no undisputable successor has yet laid successful claim, though Pollock has been dead now for over 40 years. To represent an artist on film as a person who smokes and drinks and paints on the floor – as the artists of Art & Language are represented in the video of the theory installation – is now inescapably to summon up the ghost of Jackson Pollock, forever trapped in Hans Namuth's avant-garde movie, the making of which re-

Plate 19 Art & Language, *Portrait of V. I. Lenin in the Style of Jackson Pollock V*, 1980. Oil and enamel on canvas, 239 × 210 cm. Art & Language.

putedly projected him back into his alcoholism, leaving him damaged beyond recovery by a sense of his own revealed inauthenticity.

> *Jackson Pollock was the artist of the Marshall Plan;*
> *He broke ice for artists when the Cold War began;*
> *He was the leading artist of the New York School;*
> *He was the action painter who rebelled against the*
> *rules.*

*Jackson Pollock threw his canvas down and laid it on
 the floor,
And then he threw his brush away:
He didn't need it any more. . . .*
– – – – – –
*They say it's art killed Pollock –
As if that could be.
In fact he missed a bend
And drove his Ford into a tree.* (Art & Language, 1981)[20]

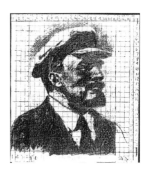

Plate 20 Art & Language, *Map for Portrait of V. I. Lenin in the Style of Jackson Pollock*, 1979. Pencil on paper, 20 × 20 cm. Collection Jan Debbaut, Temse.

No paradox is involved in saying that the reason all this is of more than incidental interest to our discussion is that we can imagine many still assenting to the verdict on Pollock that was offered some thirty years ago by Philip Leider: "It is as if his work was the last achievement of whose status every serious artist is convinced."[21] One reason this statement still seems valid is that that "last" was invested with a more than merely temporal sense in the world of the putatively Postmodern. If Pollock's status remains terminal, perhaps it is because art itself terminated around the mid-twentieth century – if what we understand by "art" is merely some repository of value by which the development of taste may be measured and on which judgments might in the end be expected to converge. Après lui, le déluge. It is relevant that some of the journalistic models for "Art & Language Paints a Picture" were taken from the New York art world of the late 1950s and early '60s, when one minor artist after another acted out the aftermath of Abstract Expressionism.

But this is apocalyptic play. Let me recover the substantial point I mean to make in citing Pollock's example. It is clear from all the evidence that he would not be satisfied by the production of what Clement Greenberg called easel pictures. He came to New York to contribute to the development of a public mural art – in other words to the highest of painterly genres at the very moment of its political and aesthetic exhaustion in the hands of the Mexicans. He learned fast that the technical and psychological conditions of modern painting rendered that ambition unattainable in the form in which he had envisaged it. But I don't think that he ever lost the ambition itself. In the sometimes-disparaged black-enamel works of 1951–1952 he came close to realizing that ambition: to establishing the technical conditions under which a transformed public art – a *modern* public art – might actually be feasible. I am sure it is no coincidence that it was to these works specifically that Michael and Mel gravitated thirty years later at a time when their aim was to force the public discourses of modernism and realism, capitalism and communism into stylistic coexistence upon the surfaces of Art & Language's paintings. (See *Essays*, chap. 5, "On 'A Portrait of V. I. Lenin in the Style of Jackson Pollock.'")

In any event Pollock's large works of 1948–1953, say from *No. 1 1948* to *Portrait and a Dream*, seem to me to mark the cusp between two sets of technical and moral circumstances. For all the fugitiveness

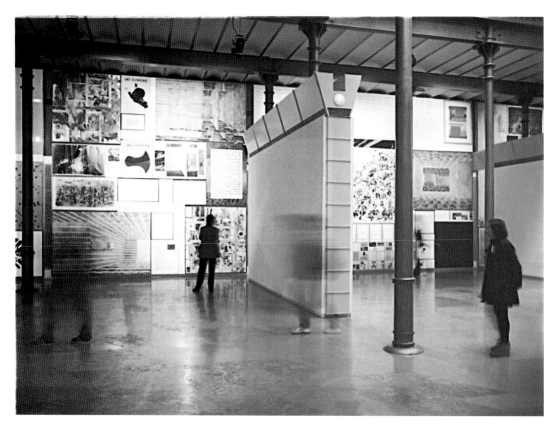

Plate 21 "Art & Language in Practice," Fondació Antoni Tàpies, Barcelona, 1999. Wall display, bays 2 and 3 of 4.

of their figuration they demand comparison with the high-genre painting of the past, as no previous abstract painting had entirely managed to do, though Mark Rothko and possibly Clyfford Still were to match Pollock's achievement in this respect. And yet it is true that Pollock's paintings are terminal in this sense at least: they seem to deny the possibility of remaining within the technical boundaries of painting and of doing as much again. Or rather – and this is a crucial point if a difficult one – what they seem to rule out is the possibility of sustaining the same intensity of intention *without at the same time incorporating the means of its deflation.* Standing in front of these paintings you immediately register the artist's fear of his own possible fraudulence and vulgarity; the fear that what he was making was mere decoration; that his drawing would not prove significantly caused; that the psychological content with which he invested his work would not be recoverable from its surface; that his paintings would prove lacking in cultural staying power, empty, absurd – as some of the last of them must unquestionably seem should the protection of his name be removed from them.

I do not mean to make this fear a function of Pollock's individual psychology. On the contrary, I would rather say that his susceptibility was a measure of his qualification to "express this age" as he put it. I see the fear itself as historically specific and historically produced. I do not know how or why. This much can perhaps be conjectured: first,

that the possibility of self-importance and gravitas in the consumption of high art had traditionally been sustained by considerable social and rhetorical privilege; second that that privilege was gradually but greatly eroded in Western countries during the second third of the twentieth century, even as other inequities replaced it. There are few mistakes more damaging to artists who want their work taken seriously than to court the attentions of those once but no longer privileged. Some substance is added to these conjectures by subsequent events. It is not that Pollock's fears were unjustified; rather that since his death art's power to exemplify the decorative tastes of the marginal has become a positive theme in criticism. And what could deflate a Pollock more effectively than to find itself in the company of the small-scale, the decorative, and the homely advanced to the status of the avant-garde?

Rothko, like Pollock, clearly suffered an almost paralyzing terror at the prospect of his own inauthenticity, though in his case the crisis came a few years later, at the end of the 1950s. He was clearly not well placed to get over it – as we all must from time to time. The so-called Houston Chapel is certainly a dreadful demonstration of what lies in wait for the self-inflating artist on the other side of the cusp, where to ignore the demand for deflationary action is to escape from history into nightmare: a nightmare in which "painting those terrible things men's passions" with red and green – or purple and brown – is not even *possibly* comic. It is the fate of such places as the Houston Chapel that they are irresistibly attractive to people enchanted by the importance of their own feelings. As for Clyfford Still, if his painterly and literary rhetoric was not a self-conscious flirtation with the jargon of authenticity and with what it concealed, then he was truly mad – or perhaps it was and he was mad anyway.

For the Abstract Expressionist generation the problem, as Clement Greenberg put it years later, was that "You could no longer dissolve your aspirations in larger ones."[22] Since then it has become ever harder to find the grounds of a "larger aspiration," as the long project of agnosticism has extended inexorably outwards from the religious sphere, on the one hand into the realm of the political, on the other into the psychological. As skepticism finally extended to the idea of high art itself, artists of my generation were left stranded in a profession with no memories it could trust and no given measures of ambition except those it had already derogated in conversation and in thought. How then were we to keep ourselves interested and alive? Should we take Hegel with an unwarranted literalism and become incompetent philosophers, as though the spirit contemplating itself might mask the fact that philosophy has never had much of really serviceable interest to say about art? Or should we try to think up new genres in which to keep ourselves practically occupied? Of course a new genre could *only* be an idea unless it both connected to a tradition and was grounded in some analysis of the world as it now represents itself, and thus as it is. But without some equivalent to a hierarchy of genres, how was one to enlarge one's art? How to increase its complexity and depth? For those

since the mid-twentieth century who have wished to make a substantial vocation of the practice of art, there has been no more urgent question, though of course to feel the urgency of a question is by no means to know how it might be answered. "Embarrassing art is good because it means you might be doing something interesting. It is also true that you might be doing something embarrassing and not interesting" (Bank, 2000).[23]

Painting past the frame

At this point I should come clean. I see all complacent conviction regarding the generic concept of art as dull and dissuasive – a generally naive mode of philosophizing only too suitably matched by the attentions of philosophers ignorant of art's rhetorical and substantial history, both pretending that the differences don't matter any more. And I see the accompanying abandonment of the possibility of genre as masking a self-induced and self-serving blindness – blindness to art's history and memory, leading to a kind of callowness in present production. There are other symptoms of evasion of course: literal enlargements in the fabrication and installation of artistic objects, which yet entail no increment in intellectual or emotional scope; endless duplications of inconsiderable artistic tokens; cunning complications in the physical relationship between work and viewer that are unjustified by any real complexity of thought or intuition; ingenious extensions over time and space that reduce to mere conjurings of the already aestheticized; and more. These are all ways of appearing to solve the problem of enlargement and depth – or of staying awake – while actually failing to address its substance.

Such enterprises are realistic, though, at least in the sense that they betray the conditions they passively reflect. That is to say, they offer valid testimony to the real insecurity of artistic production in the period since the later twentieth century: to the impossibility of any longer containing the sense of genre within such traditional limits as the framing edges of a painting or the physical perimeter of a sculpture. The point is not that work in either painting or sculpture is necessarily inconsiderable, but merely that the critical expectations carried through the higher artistic genres are not now to be met by any variety of figurative content or by any pitch of formal integrity, or by any combination of the two. The point is that there is no longer a credible language in which those expectations might be expressed. It might be – indeed has been – argued that these are favorable conditions for a democratic transformation in artistic culture, and in the kinds of ambition traditionally associated with its production. There are lessons to be learned from the history of the past century, however, when the *idea* of a democratic artistic culture tended sooner or later either to be conscripted to totalitarian ends or to be deployed as a kind of cover for the exploitations of mass culture, or both. If "no longer" can be allowed

to imply "not yet," we might try to think another outcome, one in which the generation of an adequate and adequately skeptical critical language is among the motivating ambitions of artistic practice.

However we conceive the present alternatives, one thing is clear. At a certain moment it ceased to be desirable – or perhaps in the end even possible – that the work of art should be insulated against the discourse that represented it. The very adoption of "Art & Language" as a name might be seen as an acknowledgment of this circumstance. More generally, as argued in the preceding essays, the Conceptual Art movement of the later 1960s and early '70s can be regarded as a realistic response to the terminal aspect of high Modernist abstraction between 1950 and 1965. It came in that sense as a decisive critical counter to the Modernist apostasies of Pop Art and Minimalism and their various progenies. An appropriate image can be found in the representation of Art & Language's Conceptual Art on the large wall in Barcelona (discussed in the last essay of the present volume), where it was used as "filler" between pictures of one kind and another: in the space opened up by shrinkage of the traditional genres, Conceptual Art insinuated a body of text; in doing so it served to realize the intuition that what hovered at the fraying edges of art's traditional media was the very discourse by which art's meaning was constituted. As one of the artists declares in "Art & Language Paints a Picture," "We are artists acting 'artists.'"

It was this intuition, I think that neither Pollock nor Rothko could admit explicitly into the psychology of their practices. Their paintings had in a very real sense to appear as their progeny, which no representation of them must be allowed to alienate. Pollock talked of "getting acquainted" with his painting and of its having a "life of its own."[24] Rothko claimed that "a picture lives by companionship" and was liable to be "injured by the eyes of the insensitive."[25] As artists, their paintings were all they could be seen to have. And if those paintings could not somehow be given completeness, autonomy, and being within the world of their framing edges, then as artists they had made nothing. No doubt there were moments in the privacy of the studio when the fear of inauthenticity was replaced by the cynical self-knowledge of the actor-manager. But as a public performance, a Pollock or a Rothko painted by an actor could only be a travesty hostile to the artist and to the rhetorical spirit of his work – and threatening to the sensibilities of the enchanted spectator.

Of course conditions change. It has been a feature of the development of modernism that what appears as an absolute requirement to one generation is rarely binding on the next. By 1967 the idea that one might make nothing – or nothing in which one's self was at hazard – had already become a virtual commonplace of the avant-garde artist's vocation. The now inescapable demand was that one maintain a critical self-consciousness with regard to any form of production. "The work must be open to investigation. Reconstructable, adequately retro-dictable. And this goes to a morality of moral strenuousness." So says the artist acting an artist (in "Art & Language Paints a Picture"). This

Plate 22 "Art & Language in Practice." Detail of wall display, bay 3.

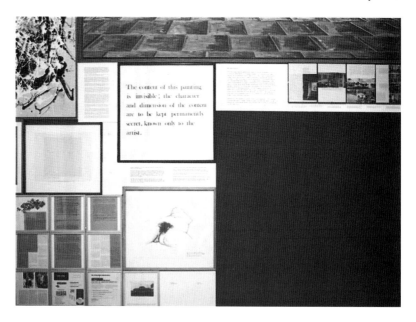

was not simply a matter of artists taking responsibility for the interpretation of their work. What was required was that the form of the work should somehow acknowledge its implication in any discourse by which it might plausibly be represented – including such discourses as might represent it as inauthentic, or its maker as a fraud. A painting might still have a framing edge, but there was no longer any pretending that that frame was sufficient to define or to delimit the form of the work for the purposes of an adequate criticism.

This critical circumstance was made palpable by Art & Language's large wall in the Barcelona exhibition. At least for the duration of that exhibition the divisions between separate works could be experienced in all their contingency, sometimes perhaps even redefined in thought. Around those kinds of work we call "paintings" flowed others we tend to think of as "texts," but it was not always clear where one ended and the other began, nor where a painting had been made of text or a text become pictorial. Nor was it clear whether the wall should be conceived of as a kind of complex mural – an emulation of the highest and most inflated of pictorial genres – or whether it existed simply as the monstrous sum of its various disparate and often low-genre parts. It was not even possible to establish any definite priority between the wall and its accompanying printed handbook. Either could be conceived as a kind of index to the contents of the other.

At the close of the exhibition the wall was disassembled and its various components reassigned according to established protocols of reification and patterns of ownership. I suggested earlier that the separation of art into genres has always been driven by material considerations: by market relations and by the contexts and types of use that these reflect. There is nothing to regret in this. In fact, the in-

evitability of this dispersal was welcome confirmation that Art & Language's aesthetic pretension is always subject to some realistic limit.

It is time to reach for a conclusion. It may seem that I have been ignoring the work that furnished the title for this essay: the "Picture Painted by Actors." Or rather that I have failed to do what I said I would: to consider it within the context of the theory installation as a whole. It is true that I have had little to say about the particulars of the actors' performance. But this was not a play. It was a theory installation – a genre of a different kind. And what this genre involves, if I understand it aright, is a form of provocation to thought: the materialization of the contents of a specific discourse and of its critical bearing on some more common order of sense. What I have tried to do is respond to this provocation, and trace in thought those intuitions about the making of painting that the theory installation may be made to reveal. This process encourages certain conclusions about the theory thus installed. At one level it is a theory about the historical practice of painting, and about the prohibitions and potentials by which that practice may currently be defined. It is also by implication a kind of revision of the theory of the genres, offering material for thought about the possibility of some continuation of high-genre work by different means under present conditions. And at a perhaps deeper level it is a theory about the demands that may now bear on any critical discourse in the sphere of culture. If there is one theoretical conviction on which Art & Language and the Jackson Pollock Bar are united it is this: any modern artistic practice aspiring either to cultural eminence or to critical power or both will tend inexorably to generate technical and critical garbage unless that aspiration entails some self-deflating consciousness.

Under the specific conditions of the exhibition at the Tapies Foundation, the theory installation of the Jackson Pollock Bar helped to hold open the framing edges of Art & Language's practice. It took the allegorical – that is to say artificial – form of a discourse, and either inverted or doubled it. It would be hard to decide which. We might say that "Art & Language Paints a Picture" was already uncanny in Freud's or some other sense, and that the Jackson Pollock Bar made it function as though it were straight "documentary," but rendered uncanny by the techniques of the theory installation. This would be a form of inversion or strategic misrepresentation or dissembling of the original (dissembling) text. Alternatively we could say that the text was treated as somewhat uncanny and that its uncanniness was *represented* by the actors, so that its original aspect was reinforced by the playback technique.

Finally, in the form of the Picture painted by Actors, the theory installation furnished a fitting memorial to those occasions of bathos, failure, and cancellation by which the ambition of the studio is necessarily brought low – and which the text itself represents. The realization of "Art & Language Paints a Picture" thus satisfied one important

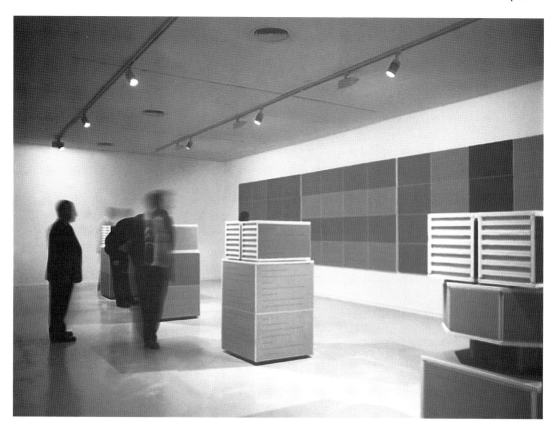

Plate 23 Art & Language, *Wrongs Healed in Official Hope*, 1999. 8 cabinets on 4 plinths with 64 wall panels, alogram on canvas over plywood, dimensions variable. Installation at Fondació Antoni Tàpies, 1999.

condition for any high-genre work within the culture we now share: that such work should somehow incorporate the very terms of its own repression. "What is required of us," the painting actor says, or seems to say, "is that our desire to reproduce . . . the form of life which gives us our materials . . . be matched by our desire to hang our heads in shame."

In the gallery downstairs at the Tapies Foundation a large new work by Art & Language encouraged some reflection on this "form of life that gives us our materials." Among the resources employed in the making of *Wrongs Healed in Official Hope*, and both represented and misrepresented on its surface, was a sadomasochistic text of absurd but chilling brutality. The finished work is also very decorative, in a manner evoking the highest pretensions of abstract art in the decade after Pollock's death. It might be seen as both exalting and shaming. It is exalting as high-genre art has been supposed to be – for all that the blandness of its surfaces renders that exaltation insecure. It is shaming because it implicates the spectator as a reader of degenerate text – though the reader's imaginative engagement is in turn rendered absurd. These apparently contrary aspects remain inseparable in the experience of the work. It is not clear whether the decoration offers salvation from the shame, or whether the shame is the price to be paid for the deco-

ration – and the decoration a price to be paid for Conceptual Art. (*Wrongs Healed in Official Hope* is discussed at more length in essay 9 of this volume.)

In "Art & Language Paints a Picture" my actor-representative joined the two actor-painters in speaking a conclusion. It seems appropriate that this essay should conclude with the same words:

> Those who long for a nondecadent aesthetics, a non-decadent art, do their longing in images of their arbitrary power. The longings are themselves decadent. This gives us something to do. But we are bound to use these resources as their products and to make *nothing* of them. Those resources of which we do not, perhaps, make nothing are little better than nothing themselves. There is no angst in this remark. Only a sense of necessity and scarcity.

II
LANDSCAPES

4

On Painting a Landscape

From Incidents to Hostages

The aim of this essay is to discuss some landscapes of a kind.[1] These were paintings made by Michael Baldwin and Mel Ramsden in the years 1989–1991 as the outcome of a significant practical hiatus. I write in this case not only with the specific project of Art & Language in mind, but also from a more general interest in the kinds of untidy and improvised compound that are among the materials of the practice, since these are the kinds of material that tend to get lost from view beneath art history's hidden joins. I refer to them as landscapes, but the works in question are more properly referred to as *Hostages*. As such they are distinguished only by their numbering from other, preceding subseries with the same overall designation. The title provides a key to the raison d'être of the project as a whole. The following brief recapitulation is intended to explain its origins.

For a period of three years, between 1985 and 1988, the image of a modern museum featured in all Art & Language's painted work. In the long series known as *Incidents in a Museum* this image served not simply as a convenient compositional scenario. It served also to represent what modernity had become. Like the image of the studio before it, the museum was set up as a form of allegory-making device. The painted studios offered a kind of mystification as place or site of production. The museum is both a place of distribution and a place of production of interpretation and cultural value. In these pictures the modern museum appears as the headquarters of an administered culture: an oppressive here and now. As an immediately recognizable and recognizably self-important monument, the Whitney Museum of American Art was chosen as an illustrative token of the type. The museum appeared first as a kind of allegorical theater – what was once fashionably called a *mise en abîme* – within which various travesties and remainders of Art & Language's all-too un-American works could

Plate 24 Art & Language, *Study for Index: Incident in a Museum 26*, 1987. Acrylic and crayon on paper, 101 × 153 cm. Private collection, London.

be ironically situated and reviewed. (The series *Incidents in a Museum* is discussed in *Essays*, chap. 8.)

But allegorical worlds tend to develop according to their own inexorable logic. As they do, they may come critically to transform the very imaginative resources from which they were first developed.

> Whereas the symbol postulates the possibility of an identity or identification, allegory designates primarily a distance in relation to its own origin, and, renouncing the nostalgia and the desire to coincide, it establishes its language in the void of this temporal difference. In so doing, it prevents the self from an illusory identification with the non-self, which is now fully, though painfully, recognized as a non-self. (de Man 1983)[2]

Over the course of some twenty-five separate works, the figurative museum established itself as a conceptual and technical framework by which Art & Language's psychological activities were increasingly constrained. What this meant in practice was that Michael and Mel found themselves bound to a repertoire of compositional devices that became harder and harder to animate. As the series progressed, the effort to maintain a sense of difference and anomaly resulted in some remarkable inventions, among them the museum conceived as obscured behind a facade of plywood shuttering (*Index: Incident in a Museum [Madison Avenue] XIV*, 1986), and the museum seen as the repository for Art & Language's own undistributed publications (*Index: Incident in a Museum XXV*, 1987).[3] But the critical potential of an artistic project is always at risk when a device becomes established as its signature. One of the last of the *Incidents* – the twenty-sixth of the series – was produced in a mood of some desperation; and it shows. A plywood surface, roughly decorated with a vertiginous perspective of a museum

interior, is bored with holes that allow glimpses of another painted surface beneath – a surface that may also contain a kind of picture of a kind of museum.

It is at moments such as these – moments of inertia and of dissatisfaction – that the ethical implications of artistic invention can sometimes be uncomfortably revealed. I do not mean to recount the full sequence of moves by which Art & Language finally achieved its escape from the museum. To do so would inevitably be to tidy up an awkward and often alienating process of calculation and hazard – a process that lasted over the course of some three further years, embracing two complete phases of new work, but also leaving a number of loose ends. Rather I want to look back to a single initiative, which seemed at the time like a cul de sac.

Hostages to the future

Late in 1987, at the time when the last of the *Incidents in a Museum* were being painted, I came upon and was drawn into some conversation in the studio about the possibility of representing a museum in the future. The intention was not to paint a futuristic picture. The idea was rather that if no escape was possible from that psychological *place* that the Modern had come to be, then perhaps the idea of a shift to a different *time* might offer a counterintuitive and hence ironic alternative. But how, without absurdity, was a work of art to be projected into the future?

> Not only were the *Museum* paintings allegories of containment, they also touched the matter of cultural inclusion and exclusion. . . .
>
> The fetishism of "next," the motor of transformed and untransformed commercial modernism, effectively denies the artist (and in a sense the consumer) access to his work. His (or her) work of now is no work of now. It is temporarily excluded from his sight, dislocated not by what it follows, but by what might follow from it.
>
> How might we bring out this exclusion, how might we literally produce something which was not yet dislocated from our power to produce let alone to see . . . ? What figure could we make of this sense of loss?
>
> . . . Predictive images are like forgeries, always illustrative of the preoccupations of the time of their production . . . [T]hese are images of the *future* and although they are intact portraits of the present, including present fashions in predictive thinking, they and their captions are non-discomfirmable except in and by future events. As *pictures* alone, one might say that they are immune to disconfirmation at any time. . . . And this is no matter how ridiculous they may be.

One very tempting possibility (tempting because of the laughs) was an *Incident in a Museum* showing visitors in rocket-powered shoes and so on.

We even tried to find some sort of pictorial proposal . . . but they're killers these conventions of illustrative futurology.

We tried obscure mystery, shadows and allusion, we even asked our children for a few ideas . . . but whatever we tried it took on the appearance of late vernacular School of Paris. (Baldwin and Ramsden, 1997)[4]

Not for the first time – and no doubt not for the last – Michael and Mel embarked on a series of what were probably unpaintable images.

One or two studies survive, principally as records of paintings unachieved or destroyed. It was a single surviving failure that was in the end immured behind the plywood surface of the final *Incident in a Museum* – the very museum from which it was supposed to furnish a means of escape. Finally, in 1988, the image of the museum was fragmented, to reappear as a form of insertion in the literal surfaces of a new series of paintings, given the generic title *Unit Cure, Unit Ground* (see *Essays*, chap. 9). The pictures were of interiors that now looked

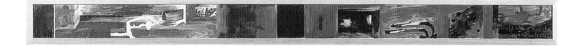

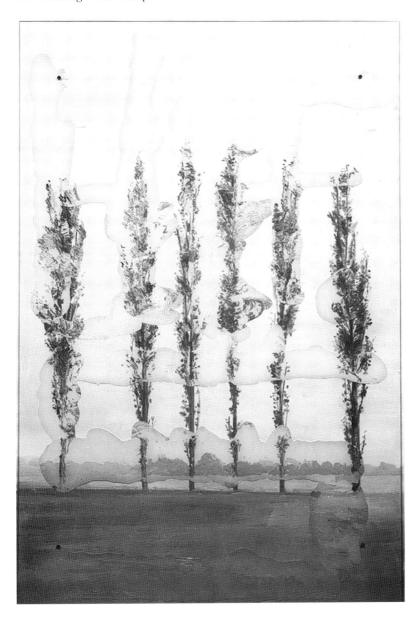

Plate 27 Art & Language, *Hostage XXIX*, 1989. Glass, oil on canvas on wood, 183.4 × 122 cm. Courtesy Marian Goodman Gallery, New York.

psychologically if not artistically vacant. The patterns of insertions appeared as visitations by which the decorative surfaces of these works were shown to be physically and psychologically compromised.[5]

The project for the museum in the future did indeed turn out to be a dead end. But there was one significant remainder. The idea of the work of art as "hostage to the future" furnished the title that was employed for Art & Language's ensuing three series of works: paintings based on representations of palettes that were shown at the Lisson Gallery in the summer of 1988 (see *Essays*, chap. 11); a group of flag-paintings shown at Max Hetzler's Gallery in Cologne in 1989 (see *Essays*, chap. 12); and finally the long series of landscapes that forms the principal

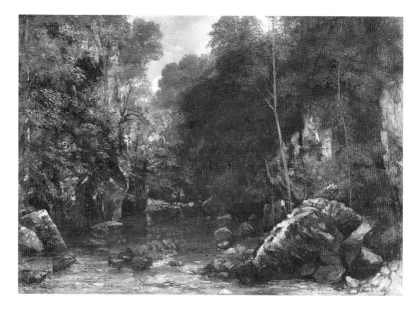

subject of this and the following essay, the earliest first shown at the
Marian Goodman Gallery, New York, in March 1990 and the latest at
Galerie de Paris, Paris, in May 1991.

The title *Hostage* thus carries connotations not only of captivity and
subjection – in this case subjection to the unsanctioned conditions of
the present – but also of some possible emancipation in the future; an
imaginary emancipation, to be bought at a price, accomplished with
violence or as farce (if the evidence of American military initiatives,
from the Bay of Pigs to the Iranian fiasco, was then to be believed). In
all, the various subseries of *Hostages* comprised over a hundred indi-
vidual works.

In the Palettes and the Flags the museum may no longer be deter-
mining the architecture of the picture space, but it is still there as an im-
age of control, insinuating itself in the form of details and fragments,
compromising the decorative integrity of the painted surface, giving
the lie to any pretense of spontaneity, insisting on the relativity of any
artistic autonomy. It is only with those *Hostages* that are paintings of
landscapes that the determining presence of the museum seems finally
to have been exorcised.

Unseeable pictures

In the late spring of 1991 I was asked to give a paper at the University
of Chicago, where I was then teaching as a visitor, removed for a while
from the immediate conversation of the studio. I decided that I would
concentrate on what was then the most recent of the landscape
Hostages, completed earlier that year. These had been shown for the
first time in a double exhibition at the Lisson Gallery and the Institute
of Contemporary Arts in London and were still hanging there when I

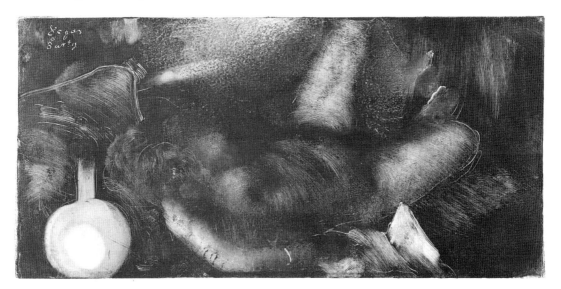

left for Chicago. The moment of alienation of the work from the Art & Language studio has always been important to the assessment of its effect, and I felt then that I had barely had time to see how the paintings looked on the walls. I was nevertheless sure that I knew enough about them to talk informally on the issues I thought they raised.

But two problems seemed to stand in the way of my doing so. The first was the thought that I should offer some broader context for the work of Art & Language than I could easily do through concentration on a couple of recent paintings. The second was that as soon as I had agreed to speak, I found myself so distracted that I began to doubt my ability to talk about the work with any relevance. In themselves these were unremarkable anxieties. But the distraction seemed to have something to do with some other pictures – or thoughts about them; pictures and thoughts put on the agenda for me following my arrival in the United States at the end of that March: specifically some pictures by Courbet that Michael Fried had written about, and a monotype by Degas that I found myself discussing with some students in the Art Institute of Chicago.

In his recently published study of Courbet, Fried had drawn attention to the significance of automatism – of the emergence of an imagery incapable of prior *formulation*, and in that sense unintentional – in the painter's work and practice.[6] What assures Fried of the realism of Courbet's art is not the artist's avowed Realist program, but rather the very involuntariness of those processes and procedures whereby pictorial form was originally invested with significance. Foremost among the defining preoccupations of Courbet's work, Fried diagnoses an urge – necessarily and significantly doomed to frustration – to transport himself bodily into the painting taking shape, and thus to close the gap between painting and beholder. By whatever psychoanalytical or other factors it may be thought to have been impelled, Courbet's attempt to eliminate the distinction between painting and painter-

Plate 29 Edgar Degas, *Woman Reclining on her Bed*, c. 1885. Monotype, black ink on paper, 22.1 × 41.8 cm. Art Institute of Chicago (Clarence Buckingham Collection).

beholder is seen by Fried as a means to defeat theatricalization, and thus to preserve the integrity of modern painting. What is art-historically distinctive about Courbet's work is that it is through the painting's *representation* of that engagement that an "absorptive thematics" is established in his work. It is not required of us that we believe Courbet to have been working consciously in accordance with the theory Fried outlines. On the contrary, what is required if Fried's account is to hold its ground is that we believe the painter to have acted involuntarily in response to those determining conditions that the theory purports retrospectively to describe.

The Degas monotype in the Art Institute shows a nude woman reclining on a couch, her body extended away from the picture plane, which virtually coincides with the assumed position of the head. Viewed in the context of Fried's thesis, this had appeared to me as a picture that virtually and significantly closed down the possibility of an external viewpoint. The idea that kept insinuating itself was that there were pictures that were in some significant sense *unseeable*. The idea was no clearer than that sentence suggests.

I seemed at the time to be afflicted with a species of migraine. Whatever I looked at was no longer there. Of course, it is one of the distressing features of migraines that the onset of symptoms is accompanied by uncertainty about one's mental condition; or, to put it another way, that a breakdown of confidence occurs in the conceptual economy by means of which we transact our business-as-usual between the psychological and the ontological worlds. I had to ask myself whether I was indeed seeing a void – noticing an area of significant absence – or whether there was something I was significantly failing to see. My one hope was that my distraction could somehow be connected to the landscapes I wanted to discuss. It seemed just possible that questions about what is or is not seeable, what is or is not seen, might be of some specific relevance to the very works I meant to address; that these works might even have had some hand in the generation of my uncertainty. In order to explore this possibility, I resorted to the formality of a written text for the talk I had agreed to give. There had been previous occasions on which the paintings of my friends had seemed to deprive me of sense – which is to say of language. When I join Michael and Mel in their studio, and am faced with new production, I take it as a normal obligation to struggle for some workable description. But I do so in their company and in circumstances where descriptions are negotiated in conversation. In this case I was on my own with the echoes. My aim, then, was to write my way out of trouble and to make sense of a kind. The origins of this chapter lie in that moment and that text.

Outside the museum

My first point of reference is a work painted in 1989 and given the title *Hostage XXIV*. This painting is one of a small group of transitional

Plate 30 Art & Language, *Hostage XXIV,* 1989. Silkscreened text on paper, glass, oil on canvas on wood, 183.4 × 122 cm. Art & Language.

> There might be a picture of a place where a certain confusion is systematically suppressed; a place where a minor pragmatic violence is sustained by a trivial mechanism of fear. It is a place where Humpty Dumpty has the power of small adjustments in his metier. It is a place of contrivance and factitiousness, an unimportant enemy of public safety. For some reason it is an important place of celebration and display. It is also a place where inundation is ruled out by protocol.

works made by Michael and Mel in 1989. There are two technical features of these works that need to be explained. The first is that each is covered with a sheet of toughened glass that ends just short of the edges of the canvas. The second is that the paint adheres in places to the underside of the glass. The effect in both cases is to ensure that the glass is included in the spectator's experience of the painting, that it is seen as part of what makes the painting the thing it is, and that it is not mistaken for a protective layer that is merely to be looked through – a distraction to be filtered out in the process of competent viewing. The

blotting of the wet paint against the glass also calls attention to the literal, factive character of the painted surface. In so doing it acts as a kind of Modernist counter to the illusory properties of the picture, keeping its theatrical effects in check.

A reproduction of this painting was used on the dustjacket and paper cover when my *Essays on Art & Language* was first published in 1991. Associated as it is with completion of the volume preceding the present one it bears a particular significance for me. More to the point, however, it marks a moment of transition from one series of *Hostages* to another, or rather it locates a hiatus that preceded the commencement of the landscape series. It represents the interior of a now vacant museum. A sheet of paper has been stuck to the center of the sheet of glass that is fixed over the surface of the canvas. The paper is large enough to obscure the majority of the image. Printed in bold letters on the paper is the following text, which is a kind of description of a "cultural space" that may be a museum. This is a place where words mean what persons in power want them to mean; where "water" always means fire.[7]

> There might be a picture of a place where a certain confusion is systematically suppressed; a place where a minor pragmatic violence is sustained by a trivial mechanism of fear. It is a place where Humpty Dumpty has the power of small adjustments in his metier. It is a place of contrivance and factitiousness, an unimportant enemy of public safety. For some reason it is an important place of celebration and display. It is also a place where inundation is ruled out by protocol.

It is clear that this is not a painting that has been protectively glazed, but a painting that is partly composed of glass. It follows that what is seen in or on the glass will have to be included in our sense of the intentional scheme of the work, and not relegated to the status of visual accident, as adhering notices or reflections tend to be in the case of paintings that have been glazed. To the extent that the total image can be read figuratively, then, its various levels evoke an interior space, a window or transparent wall dividing us from that space, and a kind of broadsheet fly-posted to the outside. In addition, as soon as you move to one side or the other, reflections of your own image and environment serve as it were to bring the picture home into a world of contingent effects. The "merging" involved is deceptively familiar from the world of still photography and film. Though the effect of reflection is not a specific effect of photography, it is one that the camera has served to emphasize, to imitate through the technique of double exposure, and to thematize into a metaphor for the state of dreaming.[8]

In Art & Language's *Hostage XXIV* the text offers a kind of description of the museum, or rather it refers to a conjectural picture of a conjectural museum; perhaps to this picture of this museum, an insti-

tution from that waking nightmare that is the disabused view of sponsored modern culture. It might be said that text and image compete in some categorical fashion, each striving to be the one doing the representing, like partners in a damaged relationship, each working to include the other within its own sphere of operations and competences. If so the competition is not one that can be resolved; rather the work embodies a conceptual state of affairs that appears irresolvable.

A second and related painting bears the designation *Hostage XIX*. Here the text pasted over the museum refers to a picture clearly other than the one to which it has been affixed.

> We aim to be amateurs, to act in the unsecular forbidden margins. We shall make a painting in 1995 and call it Hostage; A Roadsign Near the Overthorpe Turn. The work will be executed in oil on canvas. It will measure 60cm. x 40 cm. The white roadsign will occupy about half the picture. It tells us we are 7 miles from Brackley, 2 from Overthorpe and 2 from Warkworth. These names will be scarcely visible in a tangle of lines. The professional may cast a colonising eye, but the tangle will go to a corporeal convulsion beyond her power. The painting will be homely and priggish. We may hide behind our speech at this appalling moment.

The painting proposes a landscape, to be painted at some point in a future that is now in the past, a landscape that will be amateurish and manifestly local, homely and priggish, too awkwardly and unsuccessfully passionate even to be recuperated as naive. Viewed from the perspective that the image of the museum may be taken to represent, the prospective painting will be the most abysmal and embarrassing of failures. The text is clear enough, I think, about the inevitability of this failure. What lies in the forbidden margins is not the romantic integrity of the oppositional, not the dogged virtue of Modernism's excluded Others, but irredeemable failure born of cultural miscalculation.

This (the picture in the text in the picture) is no doubt a painting that cannot be painted, or at least it is a painting that cannot be painted and meant – a void in place of a meaning. So to what did Art & Language commit itself in the writing of the text, and in the figuratively aggressive act of fly-posting it on the figurative museum window? To intending *something*, I think – unless a collapse into mere avant-gardism is to be allowed as a kind of practice – but presumably not to producing a failure, unless "failure to signify" can be counted, *pace* T. J. Clark, as a form of success.[9] Proposals in art – and a fortiori proposals *on* art – are not to be taken literally. Some real prospect of jeopardy does seem to haunt the work, however – does seem to be a part of its expressive effect – and this jeopardy is associated with a possible marginality, with the prospect of exclusion from the world of the museum. This is a world not limited simply to the physical space of the museum itself – or

Plate 31 Art & Language, *Hostage XIX*, 1989. Silkscreened text on paper, glass, oil on canvas on wood, 183.4 × 122 cm. Galeria Juana de Aizpuru, Madrid.

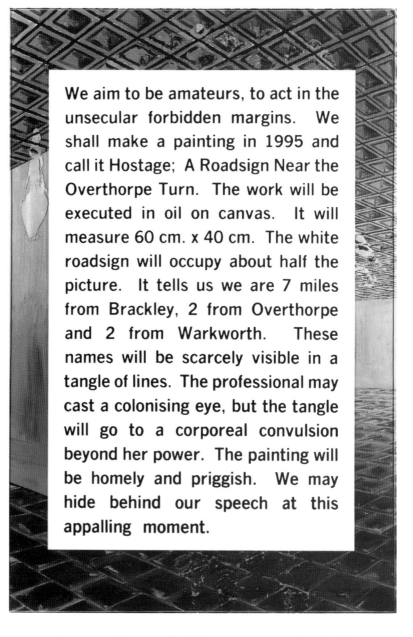

We aim to be amateurs, to act in the unsecular forbidden margins. We shall make a painting in 1995 and call it Hostage; A Roadsign Near the Overthorpe Turn. The work will be executed in oil on canvas. It will measure 60 cm. x 40 cm. The white roadsign will occupy about half the picture. It tells us we are 7 miles from Brackley, 2 from Overthorpe and 2 from Warkworth. These names will be scarcely visible in a tangle of lines. The professional may cast a colonising eye, but the tangle will go to a corporeal convulsion beyond her power. The painting will be homely and priggish. We may hide behind our speech at this appalling moment.

even to the space of any or all of those institutions for which the museum might be seen as representative. It is that historical and ideological place that is the world of *successful* culture. The risk entailed in the prospect of landscape, the text implies, is that where we situate ourselves will turn out not to be professional. And it is further implied that, however unappealing the professionally modern may be, to fail to be a modern professional is to commit cultural suicide.

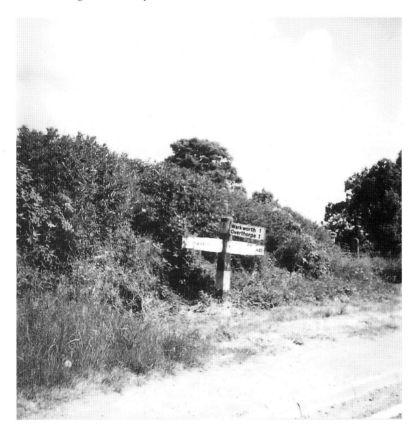

Plate 32 A roadsign near the Overthorpe turn, Middleton Cheney, England. Polaroid photograph.

Viewed as a moment in a chronology, it might seem that the text proposing the landscape did effect a kind of move away from the museum, and thus a figured or prefigured escape from the claustrophobic space of modernity itself – perhaps a late migration into the pastoral world of the postmodern.[10] What Michael and Mel next painted were indeed forms of landscape, albeit not landscapes that sought to satisfy the description of a possible picture – or range of pictures – that the text proposed. The development was not quite so orderly however. Things tend not to happen in practice in quite the rational succession that monographs and retrospective exhibitions normally reconstruct. The most significant moves are sometimes made in the light of ineluctable confusion. The disorderliness is important and, I think, informative.

A painting killed in action

After the long series of *Incidents in a Museum* and the museum-haunted *Hostages* that followed them, Art & Language did indeed attempt to leave the museum behind – to expunge it from the iconography, the conversation and the psychology of the practice. Early in 1989, after the exhibition of paintings in the series *Hostage and a*

Plate 33 Art & Language, "*What remains of the theme of nature . . . ,*" Summer 1989. Silkscreen, oil on canvas on plywood, approx 180 × 120 cm. Destroyed.

People's Flag, Michael and Mel returned to the abandoned project for a painting of the future. But this now involved the writing of texts proposing landscapes. These texts were not written to be stuck to the museums in the manner of the two paintings I have just described. At this point the use of glass had not in fact been considered. The texts were originally to be printed directly onto prepared canvases. They were written before *Hostage XIX* was completed.

These works would be paintings in the *genre* of landscape, and as such would be quite independent of the museum as cultural figure. As the texts described them, the projected works would concern themselves with some of the less dignified consequences of modernity. Their putative subjects would be found in the margins of the modern world – the only place where a possibly paintable piece of land might still be found (which is to say a landscape that has not already been so thoroughly aestheticized as to be beyond reclamation for the purposes of a critically significant art). The promised paintings would, however, be endowed with a kind of superficial complexity and glamour. They would be bathetic in their scale and in the amateurishness of their modernity. They would not be realizable as modern paintings suitable for a modern museum – or not, at least, unless modern culture were to be transformed in such a way that bathos and irony became its representative modes, so that the modern was revealed as a mere ruination of its own supposed attachments. One prototype was made. Its text read as follows.

> What remains of the theme of nature in landscape painting? Pictures of trees, rocks, growing things – paysages – are the vernacular of the amateur or the sentimentalist. The genre has been emptied of its terror; its classical forms are rendered harmless.
>
> We mean to restore the terror. A work which we shall execute in 1995 is specified as follows: *Hostage III; Fields near the Astrop Road,* oil and gold leaf on canvas, 120cm. x 180cm.
>
> The genetic character of this work will link it causally to the site identified in the title: a field of wheat in South Northamptonshire in the English Midlands. The viewer will be able to see an undramatic hillside, a standing crop of wheat, a tiring hedgerow patched up with desultory fencing and a few bits of junk. Unexceptional. These things are to be seen close up; made singular. (It is the extracted nature of some of Courbet's landscape fragments which articulates their real dependency. They are swatches made local and specific by decomposition.) The landscape will materialise as a kind of drawing, a mesh of black and green lines on the gold surface. The recovery of

signification or meaning from the topological complexities of this mesh will be borne upon by the possibility of its aetiological disfigurement – the possibility that this "drawing" is not attached to the formal, topographical and psychological properties of the landscape at all, but to something which rejects or denies them.

There are two features of this text that are of particular relevance to the discussion so far. The first is the challenge to the capacities of painting conveyed by its language – a challenge that is both threatening and self-mocking. The second feature is the use of the first person plural. It is not an "I" that speaks, but a "We." The intention that is declared is not the intention of an individual. These two features are connected. As always in the work of Art & Language, the power that language is given to wield in the context of art derives in large part from its status as guarantor that – for better or worse – the significant conditions of our experience are sharable or shared.

The original purpose of this text, as of the others that were envisaged – was that it should itself be presented as a kind of painting. Four texts were in the end printed directly onto stretched canvases, in the form of white lettering on a light gray ground. In this format they looked like Conceptual Art, well done, clean and professional. But this was Conceptual Art promising a cultural product that was declassé and amateurish – an outcome inconceivable to the cultural ethos generating the very appearance of the product itself. Therein lay their intended critical force. A form of Conceptual Art renders itself aporetic or absurd in bearing forth a content it could not have. The viewer conceived for these works was someone stranded between imagining an actual landscape described in the text – or a picture somehow satisfying that description – and confronting the cultural or stylistic implications of the vehicle that delivered it. As envisaged these works would be inversions of Art & Language's own discursive and ad hoc works made in the late 1960s, when the incursion of texts into the cultural space of painting was pursued to some critically aggressive end. (I have in mind those works of 1967, given the generic title *Title Equals Text*, that were printed texts presented *as though* they were paintings [see for instance *Essays,* pp. 54 and 57, plates 34 and 38]). In this case, though, an incursion was made into the space of Conceptual Art itself by a bathetic amateurishness, benevolent but bereft of avant-garde virtue.

That, at least, was the idea. In the event, however, it seemed to count for little that the actual text was of a very different character from those earlier insouciant interventions. It seemed that the stylistic resemblance rendered that difference insignificant in the face of the world the printed canvases would have to encounter. They looked like self-important kinds of recapitulation. Though they were indeed *meant* to look like this, Art & Language was actually powerless to force home the implications of that intention.

The description of syntax is obviously to be given within a syntactical descriptive range of discourse . . . Some of these ranges are essentially objectual (though not art objectual), the precise structure of which may be hinted at. Part of this description is syntactical and part of it semantical (in the sense of extensional semantics). The non analysed constants of the object theory are said to denote or designate certain objects. And these are in well knit domains. Within this context, there is no concern with 'art objects' sui generis, but only with designation denotation and similar notions. One thing is that within this not very generous context, as formulated for suitable object oriented theoretical languages, a notion of analyticity may be developed. And on the basis of this notion, it will be possible to introduce by definition a specific sort of 'art object' — and this without strengthening the underlying logic or semantical background. The objectual theories and ranges of discourse are thought to be the most suitable for the purposes of intuitionly underwritten discourse. They could be well sorted out as similar to the classical systems of first order. The underlying logic is thought to contain identity as well as the customary connectives. If something more complex is needed it can in some instances be shown that it is merely a special case of the former — or a development of it. Also, many of the art theoretical underlying languages (which are in the relation of metalanguage with the objectual ones) are also available for construction in terms of first order.

In an analysis of the type of entity or theoretical entity under consideration, it may be stipulated that in the context of a theory of art, the art object in question is not a named entity — or at least not named in the context of an object context as such (one which in some way corresponds to the traditional conception of the theory of art) — 'The art object so and so', then is not constructed as a name, neither might it be a description. The table in the corner should not be confused with that art object table in the corner. But it may be that one can't be very clear about that sort of contention until there is somewhat more clarity about existential propositions — i.e. whether they do assert the existence of an object of a certain sort. In either case, an ontology seems presupposed. Even if the ontology of objects are not to take persisters as priority, and take, e.g. events as basic, this would still perhaps not make too much of a hole in the contention above: the point is that the events of which a certain object may be said to be composed should not be confused with the conception of 'art object' here.

Though these works have joined the company of failures in the memory of Michael and Mel and myself, the failure in question is one marked more by a sense of frustration than by embarrassment. Their production coincided with that academic recrudescence that was known at the time as neo-Conceptual Art. This development consisted in little more than a stabilized recapitulation of Conceptual Art's presentational face. In other words Conceptual Art had been rediscovered as consumer-friendly. Under these conditions, while Art & Language's inversions were conceived as subversive interventions in the process of reification, this aspect of their character simply failed to signify – in practice even to us in our roles as exemplary spectators. Unless the text itself were recognized as critical there could be no internal complexity in the work – no subversive relation between text and format. Yet it was as though the text itself had been effaced by the charismatic power that its format would undeservedly enjoy. It followed that the critical relation between text and format was unreadable under the conditions in which any actual reading would be likely to occur. If the format alone could be seen, then that particular game was up, however specific the blindness might actually have been to the cultural life of 1989.

This was a bad moment. In the years around 1967–1972 it was precisely through the anomalous character of its presentation that the Conceptual Art movement had occasionally been successful in troubling the business-as-usual of the art world: How was the authentic form of the work to be decided? How was its technical character to be stabilized for the purposes of ensuring a market value? What were cu-

rators – or for that matter, the artists themselves – to do with pieces of paper covered in writing? Of the works of this early period that were not simply paintings with words, it may be that few can still nowadays be read in the manner in which they were originally presented. It seems that of those that have survived at all, many are now destined to end their days as the inaccessible and unreadable contents of vitrines and archives. But at the time, the problems of presentation generated some interesting solutions, the Art & Language *Indexes* of 1972–1973 notable among them. (At least you can't put an *Index* in a vitrine; and it is itself already an archive of a kind.) In 1989, however, what remained of Art & Language's printed canvases in the world outside was a *mere format*. The dilemma that followed was that while it would surely be uncool to paint a landscape satisfying the description that a given text contained, once the proposal had been made, however displaced and displacing that proposal might have been, *not* to paint the landscape was to be left in the studio with a kind of unvirtuous and all-too-easily-curated repetition: a *mere text*. Whatever expedients Michael and Mel might contemplate in face of the problems of picturing, they were not now going to allow the practice of Art & Language to be identified with an academic recapitulation of Conceptual Art – one in which consumers might once again be reassured as to the artistic relations between texts and pictures. "There's no reified achievement to fall back on. We have to keep working because if we stop it will be as if we had never begun" (Art & Language, 1975).[11]

In the end, however, all that was left of the four printed canvasses was indeed the texts, including *"What remains of the theme of nature . . ."* as recorded above. It would perhaps have been better for the project to have been quietly shelved at this point. But there was one somewhat desperate expedient to be tried. If the surfaces of the canvases could be made to bear the traces of some sort of aggression, perhaps their text-effacing charisma might be inflected to the extent that the viewer would be alerted to some internal complexity in the work. In the event, however, the aggression merely trivialized the content further. This was indeed maddening, to the point where the surfaces became the effective *victims* of aggression. Three of them were snowed to death – effaced with white paint. (On the history of "snowing" in the practice and argot of Art & Language, see *Essays*, chap. 7, "On the Surface of Painting.") And when that process simply produced a couple of picturesque palimpsests, *"What remains of the theme of nature . . ."* was literally shot to pieces by Michael, as was the fourth canvas that had escaped the snow. These were hostages that failed to survive their own attempted rescue.

The spectator as reader

After that Michael and Mel went back to the museum feeling both shifty and indignant, while I shuffled from one foot to another know-

ing that my prescriptions for what to do next in the way of art are never practically effective for Art & Language. The original *Incidents in a Museum* had been composed in horizontal format. A set of upright museum interiors was now produced. It was only at this point that the use of a covering sheet of glass was thought of as an alternative way to recover the landscape proposal. It was also conceived as a device by which the imaginary spectator might now be situated outside the museum looking in, as though through a window. Perhaps once distance had thus been achieved for the notional spectator presupposed by the picture, the proposal for the landscape might be used, not as an actual painting or quasi painting, but as a kind of poster. It would become usable again, that is, as a type of picture that was a text as-picture-of-a-text. To put the point another way, once the text had become a part of a representational scheme the imaginary reader might be brought back into play as a spectator – or if you like, it was only then that the imaginary spectator could once again be made to be a reader, and given some work to do.

In thus recovering its aggression toward the pictorial, the proposal for a form of landscape did indeed recover its distinctive content and its ironic purpose. Unlike the text printed on the canvas, the poster on the glass preserved an all-important tension between what it said and what it said it *as*. The first kind of work was "silenced" by the effective stabilization of its technique, that is, by its involuntary assimilation to a factitious technical category. The technical strangeness of the second work was such as to inhibit the attribution to it of a first-order voice or position.

Why did this matter? Why in the world of Art & Language must the relative modalities of text and image be adjusted to this end? Why should it be an apparent condition of the success, or even the plausibility of an artistic enterprise for Art & Language that the separation of spectator from reader be somehow thwarted? The question is an important one and I should formulate it with more care. What follows involves a fair degree of rhetorical organization and a large amount of hindsight. The first assumption I make is that the paintings in question – and possibly any and all paintings deserving of serious consideration – work to define a notional spectator in terms of certain competences, cognitive activities and dispositions. I intend some qualified reference here to the concept of the "spectator in the picture" as proposed by Richard Wollheim.[12] This spectator is conceived as the imaginary product of a certain category of figurative painting, an adoptable identity serving as the agent of our entry into the work's figurative and psychological content. But Wollheim's model is one that protects a certain decorum, both for the figurative and for the aesthetic. The spectator Art & Language's paintings presuppose is not one who adopts a role in an imaginative drama alone. The person who stands notionally before the work as its competent viewer is someone who will take on certain patterns of cognitive activity, certain modes of thought, certain ways of reading, and who will take them on not just

metaphorically – not only "as if" – but as dispositions exercised in imagination toward the *actual* world.

This account of the possible experience of art may be at odds with – or may be indifferent if not aggressive toward – the now more prevalent view that interpetation is a potentially unconstrained activity. More to the point, it is also at odds with the classical view that what defines aesthetic experience is its independence from the requirement of responsive action. As I envisage them, works of art have implications, and these are not just whatever we desire them to be. As I conceive the imaginary spectator, if you adopt the painting's proffered repertoire (to use Wollheim's term for the appropriate schedule of dispositions), the character of that repertoire is thenceforth among the acknowledgeable contents of your psychological experience, with potential implications extending well beyond the work in question and the moment of its enjoyment. The repertoire or disposition that seems specifically relevant to the paintings under discussion is one in which the quasi-professional separation of spectator and reader is ruled out as untenable. In other words, the painting invites the identification of engaged spectator with engaged reader. It can be seen in other ways as other things no doubt, but this is how it will be seen when it is competently seen. Its critical character, its use as *art,* is to be seen like this.

Why, then, should this matter? Why should the tuning of this effect seem to be crucial to the self-critical process of Art & Language? The easy answer to that question, I suppose, is that the driving of a wedge between the visual and the literary was a habitual tendency of artistic Modernism, that resistance to the habitual tendencies of culture is virtually obligatory in would-be avant-garde practices, and that it was a historically specific requirement of putatively postmodern practices that they oppose the Modernist separation of the literary and the visual.

But that answer comes far too ready to hand. We should all be heartily sick of it by now.[13] In early Conceptual Art the suppression of the entranced beholder was never simply an avant-garde necessity. It was only within those post-Minimalist practices that were actually forms of Modernist apostasy that a Duchampian art-in-the-service-of-the-mind could plausibly be set up in opposition to a Greenbergian "opticality." What was at stake in Conceptual Art was not the mere possibility of installing Art as Idea as a new antivisual form of ready-made. The more substantial project was to dislodge the empiricistic gentleman – the symbolic guardian of the contemplative account of knowledge – from his position as primordial arbiter of value in culture as a whole.[14] He and his supposedly disinterested vision had to be disqualified so that a critical and social activity could be installed in their place. (This critical necessity may have been clearer at the time to English contributors to the Conceptual Art movement than it was to their American counterparts. For better or worse, the class-character of high culture has been harder to ignore in England than it has in America, where the illusion of classless meritocracy has generally been sustained by a less conservative economy.) What was needed if this replacement

was to be achieved was not the new hermeticism of Art as Idea, but a shareable practice of art as ideas; not pictures made of words, but an incursion of unruly readings into the immaculate surfaces of art. The task was to prevent the supposed iconic face of the work of art from any longer masking its causal and indexical character; in other words to prevent the authorized account of what art looks like from standing in for an account of its place in the world that makes it. It was an aspiration of Art & Language – Sisyphean, no doubt – to destroy the edges of artworks, to undo the authority and the autonomy of Vision.

That is how the lines seemed to be drawn in the late 1960s and early 1970s. They seemed important then and I think the issues still matter. Hence, perhaps, the violence done by Michael to eradicate the proto-landscapes in their guise as neo-Conceptual artworks. I do not mean to aggrandize the contingent issues of a specific and historical moment into universal art-critical necessities. It remains the case, though, that there is still *practical* work to be done on the conceptual relations between "vision," "experience" and "value." The intuition that this work was unavoidable may have been among the strange critical determinations on Art & Language's paintings.[15]

I should preempt two potential misunderstandings to which the argument of this chapter is vulnerable. First, I do not propose that the critical priorities I am trying to identify are the necessities of the postmodern. On the contrary. It is only in journalistic views of the postmodern that the transgressing of image-text boundaries and the displacing of "experience" through representational levels have been seen as typically postmodern strategies. The point is rather that we have lately got better at noticing how crucial these strategies have always been to the critical functioning of modernist art – and how pervasively that critical function has been misrepresented in the celebration of late-Modernist art as affirmative culture. According to Clement Greenberg "Art has its history as . . . quality."[16] He has a point of a kind. At least, it must be true that if relative merit is not an issue in art, then art itself is undeserving of serious consideration. It is probably also true that the test of time *is* some sort of test, and one by which the most well-meaning among us may be rendered absurd – if, that is, it can be applied in some manner that does not simply recognize the durability of well-formed middle-sized dry goods. What we *can* fruitfully argue over, however, are the grounds we claim for our judgments and the implications we draw from our preferences, albeit no such arguments can reach a point of rest beyond interest and irrationality.

Second, no claim is here being advanced that Conceptual Art was more radical in all possible critical worlds than, say, the painting of Kenneth Noland, or that pictures with words on them are more radical than pictures without. It is not the words as such that matter. What matters is that we should not be driven back by whatever means into that state of anti-intellectualism that the working out of modernism in the end entailed and that Conceptual Art sought to counter through its self-conscious attention to language. What I have been trying to do is simply

to recall and to explain – to myself first of all – the steps by which my friends came to move from texts prescribing landscapes to making things that were in fact landscape paintings. The evidence is that various forms of alienating device had to be discovered and worked through in practice, and that these had to be such as would put the priority of vision itself in question. It is my intuition that this apparent necessity is traceable back into some specific historical mechanisms and conflicts – some of which go to substantial disagreements about the relationship between experience, imagination, and learning.

Unpredictably it was the device of the sheet of glass – the same technical device that served to place the notional spectator as it were on the other side of a represented world – that then made possible an actual shift to landscape; or, at least, to a painted surface that referred to the acculturation of nature rather than the naturalization of culture. The establishment of an appropriately artificial system, it seems, is a condition of the possibility of modern naturalism. Originally adopted to displace the iconography of the museums, the glass now became the enabling condition of work in a new genre: the very genre, in fact, with which the posters had been concerned. It was as though the readers of the posters had been turned around, their backs to the museum, to face the world that the museum itself could accommodate only once it had already been given the form of a picture.

Into landscape

Hostage XXV was completed late in 1989 as one of the first paintings in the new series. Significantly, it was made as it were to look back to the world of the museum, only to see it through the distorting and estranging effects of malapropism – that is to say through language distorted by the monstrous absurdities of bureaucratic pretension.[17] The painting bore the following text, clearly connected to its immediate predecessor, the museum-based *Hostage XXIV*.

> There might be a scripture of a space in which a certain contusion is symptomatically compressed; a face where a minute prophylactic valance is ordained by a tribal mercantilism of fear. It is a place where Humpty Dumpty has the flower of small adjournments in his entree. It is a grace of connivance and facetiousness, an omnipotent enemy of polemic safety. For some season it is an impotent fact of acceleration and dismay. It is also a chase where commendation is ruled out by parasol.

The implied suggestion is that the surface of the picture might similarly be traceable back to some more coherent description – if only we could unpick that irrational mechanism by which it has been figuratively damaged and deformed: the pseudo-Modernist craving after authentic

Plate 35 Art & Language, *Hostage XXV*, 1989. Silkscreened text on paper, glass, oil on canvas on wood, 181 × 120 cm. Courtesy Lisson Gallery, London.

There might be a scripture of a space in which a certain contusion is symptomatically compressed; a face where a minute prophylactic valance is ordained by a tribal mercantilism of fear. It is a place where Humpty Dumpty has the flower of small adjournments in his entree. It is a grace of connivance and facetiousness, an omnipotent enemy of polemic safety. For some season it is an impotent face of acceleration and dismay. It is also a chase where commendation is ruled out by parasol.

and unquestionable expressiveness, perhaps – or rather some alienated and automatistic procedure by which this craving is ironically invoked.

All the landscape *Hostages* are based on the motif of a row of poplar trees ranged along the edge of a playing field. Visible from the studio Michael and Mel then occupied, these trees grow in the same homely, inconsiderable and uncosmopolitan locale as the "Roadsign near the Overthorpe Turn" of *Hostage XIX*. Simple variations are played on this theme through shifts of orientation, enacted by alterations in perspective, while more complex variations are effected through changes in the painterly signifiers of light and atmosphere. At one level of

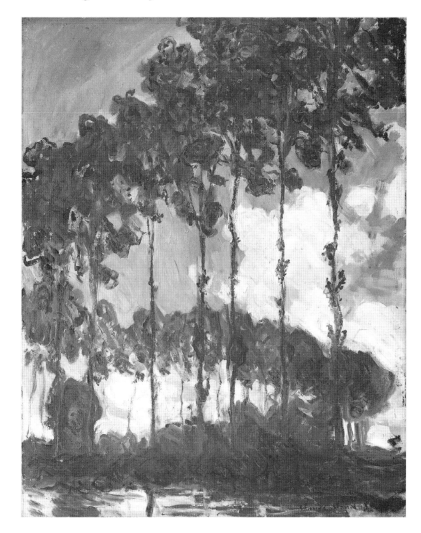

reference the motif is banal to the point of virtual invisibility. This is not a sight deserving any attention from the seeker after the culturally notable or the otherwise picturesque. At another level, though, the motif of poplar trees refers explicitly to paintings made by Claude Monet a hundred years before – paintings that have been seen in thoroughly cosmopolitan culture as paradigmatic of the optically intense and the atmospheric. For the enchanted amateur, Monet's Poplars represent a kind of *beau idéal*. What more promising motif, at once canonically elevated and utterly banal, if Michael and Mel – or their imaginary Others – truly "aimed to be amateurs" in a world of professionals?

> The landscape first occurred in an *ironical* conversation we had in relation to the ancestral forms of the present *Hostage* series. This ancestral form was a text in which we predicted paintings. These were landscapes. The text

"predicted" a landscape. The form of the text was cul-
turally incommensurable in respect of what it "pre-
dicted." We thought *inter alia* that it would be nice to be,
as it were, a conceptual artist on weekdays and to do
landscapes at the weekend. The text was predicting a ter-
rible bathos for itself as a very smart item, viz. a piece of
concept art. (Baldwin, 1991)[18]

Each of the landscape *Hostages* was produced according to the same
system. (See plates 37–39 and 40–42.) A specific composition of field,
poplar trees, and sky is established in acrylic paints on paper, with
brushwork, color and texture providing the appropriate artistic signi-
fiers of weather, season, and time of day. Certain areas are then marked
out on these studies by configurations of black lines, drawn firmly in
ink. These areas are based on separate small studies that establish dif-
ferent graphic elaborations of the letters S.U.R.F., signifying "surface"
(or nothing much) – a convention first employed by Art & Language in
a series of works of 1974–1975 exhibited under the title "Dialectical
Materialism."[19] The acrylic study is then squared-up in pencil, and the
composition is transferred to a large canvas stretched over a rigid ply-
wood mount and primed, with masking tape covering the areas out-
lined in black. The picture is then executed in oil paint, conforming
precisely to the study. When the paint has dried the masking tape is re-
moved and the unpainted areas thus revealed are completed, following
the study once again, but using very thick paint. While this is still wet
the glass is applied over the canvas and screwed down into the sup-
port. The canvas is then loosened from the stretcher in places and a
long steel rule – later an L-shaped steel bar – inserted between canvas
and plywood backing. The wet paint is thus forced out against the un-
derside of the glass, forming blooms and runs and overlaps. In the
earliest paintings made by this method, the areas of wet paint were
kept relatively small, and the rogering – to use a technical term – was
relatively gentle. As the series progressed the original landscape
tended to become increasingly submerged in or obscured by the flow
of paint at the moment of compression. Another way to put this would
be to say that the expressive aspect of the paintings came to be more
and more dictated by the relatively unpredictable outcome of a bizarre
process and less and less by the initial delineation of the motif.

I wish to direct attention to one specific feature of these works: to the
interaction, in the process of their production, between the making of
a picture on the one hand, and on the other the virtual unmaking or
unfinishing or destabilizing of that image by means of an automatic
procedure – a procedure of which it might be said that not only does it
not entail fidelity to an established vision, but that it amounts to a vir-
tual obliteration of the painted picture.

Blind painting

During my uncomfortable deliberations in Chicago, it was only once I had properly registered this aspect for myself that I was able finally to connect the character of these paintings back to the point at which I had begun: to the causes of my initial distraction, the idea of unseeable paintings and the sense of my own deprivation of vision. A link of a kind was furnished adventitiously by Jacques Derrida, who was in Chicago in 1991 to deliver the Carpenter Lectures.[20] His point of departure was a text by Marcel Mauss, "The Gift."[21] During these lectures he discoursed elegantly and at length on the impossibility of a gift that is self-consciously given. It was a part of the burden of his thesis as I understood it that one cannot identify either with one's own generosity or with one's own name – or not, at least, without changing the value of both. The implication I drew from his thesis was that to identify with one's own vision – to become the self-conscious proprietor of a conceptual scheme – is no longer truly to see.

Derrida also spoke, in a nice turn of (or of his translator's) phrase, of "the chance that makes sense." Michael Fried had already drawn attention, rightly I think, to the necessity of automatism in Courbet's Realism.[22] Courbet painted as if he could be the observer of his own un(self)conscious self – a vision one cannot have. In the monotype I referred to earlier, Degas drew a woman's naked body from the virtual position of the head, which is to say as if seen with a woman's eyes – a vision he could never be in a position to identify with or empirically confirm. (Given the clear sense the picture offers of a body viewed from/with its own eyes, that we do in fact see the back of a vestigial head "before" looking down the body could be taken as confirming the impossibility for Degas of *acknowledging* the imaginative identification that I see him as driven to make.) For both Courbet and Degas, the nature of the enterprise was such that neither must catch himself looking at the thing he was making. It is in part this that gives the resulting images their critical poignancy.[23]

It is clear enough that realism in representation is not to be equated with fidelity to empirical experience, or rather not with any specific understanding, however apparently authoritative, of what it is that an empirical regard will confirm. What I mean to suggest is that realism may even entail or require a form of blindness to the supposed truth of the empiricist's vision – to its *self*-certifying character. That is to say, I propose that realism entails a form of imaginative resistance to the conventional limits on experience – and thus to vision. It serves a disposition to represent those limits as contingent – even, and perhaps especially, where they are practically insurmountable, as was Beethoven's deafness, as were those conditions that condemned the unfortunate Degas to the occupation of a male body. I further propose that realism's resistance to the limits on experience is typically sustained by forms of automatism. For it is the historic function of auto-

Plate 37 Art & Language, *Study for Hostage 40*, 1990. Acrylic, ink and pencil on paper, 130 × 90 cm. Private collection, Belgium.

Plate 38 Art & Language, *Surf 40*, 1990. Ink and chalk on paper, 42.5 × 29.5 cm. Private collection, Belgium.

Plate 39 Art & Language, *Hostage XL*, 1990. Glass, oil on canvas on wood, 183 × 122 cm. Private collection, Stekene.

matic strategies in art that they serve to blind representation to the insistent decorum of the visible.

That may read like a conclusion. It was certainly almost the end of my deliberations when I first attempted to write about the landscapes. By the time I had arrived at this stage in my thinking I had begun to convince myself that my speculations were neurotic, and that it was time I pulled myself together and sorted out how to provide a less fanciful introduction to Art & Language and its *Hostages*. It is at such moments that one needs one's friends. A few days after I had originally reached this point, as though on cue, a letter arrived from Michael

Baldwin, connecting me back to the conversation of the studio in England. He wrote as follows.

> Work proceeds, but slowly. Question (and it's not a Paul de Man "Blindness and Insight" question): what sense is to be made of the suggestion that these *Hostages* are blind paintings? I mean in the sense that Beethoven's late music is deaf music? . . . is the possible blindness sui generis or culturally inescapable? ([Is it] that painting has been

"blinded" . . . or have we been blinded . . . or do we "act"
blind?) The point is that the metaphor (if that is what it is)
goes to the practice – to a way of making (or finding).

Vision is still negotiable currency, and I think it is the fate – or the
vanity – of Art & Language to be largely without it. Perhaps it had in-
deed been that that I was really seeing when I was looking for my sub-
ject: the absence, the unavailability of a whole picture, the fragments
around the edge of something that would never quite define it, the
world that would never quite come into view.

And yet, if there is a way of making, there is a way of making *some-
thing*. And in the world of painting, what is made is made to be seen.
That which is normally identified as vision is merely a contingent deco-
rum of looking masquerading as a necessary condition of sense. It is
bringing to bear on the world a *projection* proposed as orderly, suffi-
cient, and involuntary. According to conventional academic wisdom,
the deconstruction of this order has been pursued as a postmodern cri-
tique of Modernist vision. Within the practice of art, however, the cri-
tique of vision is realized not as an academic end, but through that
which is made, using whatever artistic or other resources may come to
hand; made to be seen, indeed, but seen from a point of view that we
learn to adopt.

5

Fascinated by Glass

The modernization of landscape

It has been a notable feature of Art & Language's incursion into painting that the possibility of continuation of a substantial tradition has had to be worked for afresh with each new series of work. This can never be a simple matter of assuming one's place in the culture. Indeed, the combination of possibility and necessity involved may seem at times almost unsupportable: more a matter to be lived down than lived up to. For Art & Language it has in each case involved a process of re-connection not simply to a relevant genre, but more importantly to its historical problem-field. To address the modern problems of landscape is inescapably to look back to the Impressionists. There is no reassurance in this. It is when "art" is addressed as an ordinary component of artistic *culture* that "Impressionism" is virtually what "landscape" means. As mentioned in the previous essay, Art & Language's landscape *Hostages* make explicit reference to Monet's paintings of poplar trees, executed exactly a hundred years before, in 1891. This reference is established not merely through the laconic use of poplars as a recurrent motif, but also by playing on various types of atmospheric effect over the course of a long series of related works. The *Hostages* thus call to mind the last historical moment at which a heightened naturalistic vision could plausibly be made the vehicle for a technically modern art. While they address Monet as the ideal of amateur painting, and while they also deal with heightened naturalistic vision as a culturally exhausted idea, they nevertheless of necessity take on themselves a distinctive range of formal problems by which the landscape genre as a whole was animated throughout its early modern phase.

This last statement stands in need of some justification. Specifically, it requires an account of the problems in question and of their continuing life in the history of painting. The basic issue can be put like this: in painting that draws much of its figurative and metaphorical depth from reference to a potentially limitless space, how is a sense of

Plate 43 Caspar David
Friedrich, *Seashore in
Fog*, c. 1807. Oil on can-
vas, 34.2 × 50.2 cm.
Österreichische Galerie
Belvedere, Vienna.

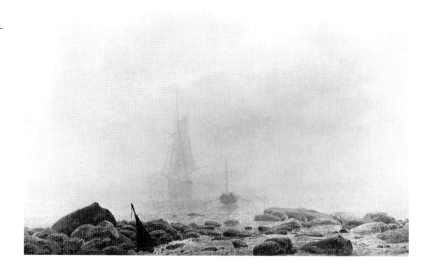

presence and concreteness to be achieved in the experience of the spec-
tator?[1] How, that is to say, is the spectator to be positioned relative to
the picture's immediate surface without littering its imaginary fore-
ground with the bearers of anecdote and narrative, weak – or hip –
modern equivalents of those nymphs and shepherds and picturesque
peasants that served in classical landscape painting to disguise the fact
that these were pictures without properly accredited subjects?

This is landscape painting's particular take on the technical problem

Plate 44 Claude Monet,
Nymphéas, c. 1918. Oil
on canvas, 200 × 427 cm.
Tate Gallery, London.

of figure-ground relations as it developed during the early modern pe-
riod, say from the end of the eighteenth century to the end of the nine-
teenth. Its historical emergence as an inescapable issue is a cause of
poignancy in the very different works of Caspar David Friedrich and

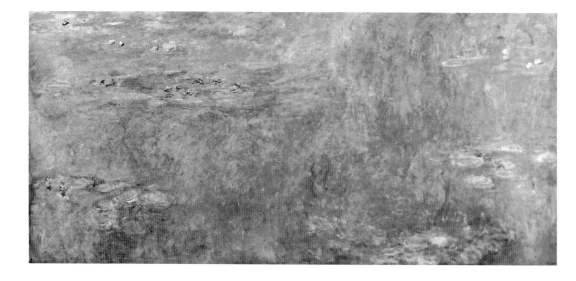

Plate 45 Paul Cézanne, *In the Grounds of the Chateau Noir*, 1900–1906. Oil on canvas, 90.7 × 71.4 cm. Tate Gallery, London.

John Constable. Each needed somehow to introduce the spectator into the imaginative world of his art; to this end each was drawn to use conventional foreground devices; yet each found that he must somehow prevent the picture plane from becoming altogether transparent, lest the painting as object be reduced to invisibility and its formal integrity be rendered inconsequential. But if this was a significant technical problem, what was required was not a solution by means of which the relevant difficulties could be rendered unnoticeable. On the contrary, the point was to make the problem palpable in the experience of the engaged spectator.

The same type of problem presents itself in various modes throughout the landscape painting of the nineteenth century. It is a truism of Modernist theory that a kind of "crisis of Impressionism" works itself out in the landscapes of the 1880s and 1890s, and notably in the paintings of Monet and Cézanne. In formal terms, the sign of this crisis is

that the foreground features of the painting – usually human figures – tend either to appear unduly plastic and thus disruptive of the painting's spatial integrity, or to lose individuality and credibility in a world viewed as mere pattern.[2] To paraphrase Karl Kraus, when faced with two unacceptable alternatives, the solution is to choose neither. In fact neither of the courses mentioned was followed by either Monet or Cézanne. The solution to the crisis adopted in their later work was virtually to abandon foreground features, or alternatively to "thicken" the pictorial atmosphere so that foreground and background became effectively indistinguishable.

The price paid was that it ceased to be possible for the spectator to distinguish reliability between the activities of looking out and those of looking in, although it was just this distinction that had served to differentiate the experience of landscape from the experience of interiors in the first place. It was not only that the experience of landscape became reconnected to the experience of interior spaces. It was rather that the self-conscious identity of the spectator could no longer be differently reformulated for each type of imaginative location. At least as represented in painting, it became part of the experience of modernity that you could not leave yourself behind.

In fact, what the work of Monet and Cézanne made clear was that, however absent the human figure might actually be from the pictorial motifs of landscape, the genre constantly evokes human presence. That is to say it evokes a conscious subject – and in the modern painting of the late-nineteenth and early twentieth centuries, a *self*-conscious subject – who is conceived as seeing what the painting shows. The person who reflects on what is shown is thus in turn reflected back and identified as the point of origin of the view. Landscape constantly evokes its neighboring genres, the painting of the solitary figure and the self-portrait. The other lesson to be learned from the art of Monet and Cézanne is that a genre is not necessarily to be modernized simply by updating its motifs. What is required is that the *mode* of looking presupposed should be one that is also a critical consciousness.

The figurative and the literal

It's time to return again to our hostages. The point of my diversion into the nineteenth century was to suggest that to work within a tradition is not only to face a legacy of meanings; it is also to take on a range of problems irrespective of one's other interests or commitments. But there is no knowing in advance how these problems may be engaged in practice. They may simply be encountered, as it were adventitiously, in the pursuit of other projects. All that can surely be said is that without technical change there can be no significant continuation of a tradition. It is only by means of technical change that the pressure of new historical or psychological or cultural materials can be brought to bear on the genre in question.

For a long time the pictured museum had seemed to figure in the practice of Art & Language as the typical site of professionalism. In their attempt to break the habit, Michael and Mel had recourse to a number of strange technical expedients: paintings dated in the future, texts printed on canvas, sheets of glass stuck to paintings with texts in the form of posters stuck over them. In the end, kinds of landscape painting emerged genetically from the texts, and from their promise of hapless amateurism, albeit not as illustrations of these. The materials used to make the *Hostages* have certain inherent properties. The techniques employed produce certain effects. These are effects of transparency and opacity, of illusionistic depth and literal superficiality, impressions of naturalistic atmosphere contained within facades as unyielding as those of commercial institutions. Though I don't recall that these effects were calculated by Michael and Mel in advance of the making of the paintings, they go to the heart of landscape and serve immediately to animate a legacy of concerns and problems.

In particular these works served to bring up to date for us the question that I suggest is central to the traditional experience of landscape: who is it that looks, what kind of person, inhabiting what kind of world? The history of art tells us that there can be no critically significant means of readdressing this question that does not involve a change in the character of pictorial space, and thus in the manner of art's playing on the relations of the literal and the metaphorical. By building their formal schemes around the surfaces of glass, or by building the surfaces of glass into their formal schemes, Art & Language's paintings take into themselves the world of reflections that is normally encountered in the experience of paintings as an irrelevance and a distraction.[3] If it was made clear in the landscape painting of the nineteenth century that one could not transcend one's self in the experience of art, these paintings serve to reflect that inescapable self as framed in an equally inescapable world of incidentals, a world that changes with changes of background, of light, of relative position, and yet, from the point of view of the picture, stays somehow always the same. Given that the glass is practically and conceptually inseparable from the canvas, the varying content of reflections becomes part of what each painting connotes.

Various forms of evidence thus mesh to establish the appearance of the landscape *Hostages:* what remains legible of the token landscape and of the evacuated illusionary world it proposes; the literal surface of paint with its decorative incident and its own cultural and artistic associations; and the spectator's own phenomenal environment, reduced to an unstable pattern of half-reflected highlights and shadows. The integration of this last component serves to counter the assertions of those, such as Rosalind Krauss, who would have it that, in the world of the post-photographic, the "materiality of the picture plane" has been displaced "into the world of reproductions" where "the gesture is always already an image of itself."[4] Conventional photographs of glazed paintings seek to eliminate reflections. Such photographs of the landscape *Hostages* necessarily eliminate a significant aspect of their

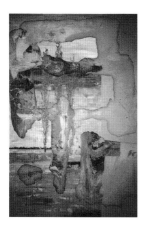

Plate 46 Art & Language, *Hostage LIV*, 1990. Glass, oil on canvas on wood, 214 × 142.5 cm. Private collection.

Plate 47 Art & Language, *Hostage LIV*, 1990. Showing reflections.

animation. On the other hand, a photograph that captures some specific set of reflections necessarily associates a given work with a specific occasion or spectator, while the camera is indifferent to the distinctions between the levels in question. The paintings elude adequate reproduction. Each painting is to be seen in and for itself. The image of it is a misrepresentation.

To view these paintings is to be caught between levels of representation in a world of conflicting descriptions. They are evocative as illusionistic and richly decorative paintings may be. But they are also literally slablike and weighty. They are broadly figurative, but their figurative components merge without significant transition into areas that read as literally flat. The discriminating tones and colors of referential detail blur into seemingly accidental pattern. The fictive and pictorial depth of the perspective scheme extends uneasily in the face of very different kinds of spatial disjunction established between the landscapes and the areas of flat color, and in turn between these and the literal planes of paint, canvas, and glass. Literal aspects and figurative aspects tend in fact to converge and to coincide. At one level the disordered paint is just disordered paint. But the illusions it avails are possibly more complex – more transparent – than the landscape it obscures. The landscape is then reduced, conceptually, to mere surface. But the disordered paint is trapped between that surface and the glass. It is, in that sense, *another* painting, and one that obscures the original surface from which it emerged.

Their immanent properties of hardness and transparency render the landscape *Hostages* subject to diverse cultural associations. Seeing them as pictures – and therefore as open to all the complexities of the pictorial – does not rule out or suspend the possibility of seeing them as redolent both of the "three-dimensional work" of American Minimalism and of the polished surfaces of commercial décor. On the other hand, that a given surface is seen as a literal surface of glass and paint does not rule out the possibility of its also being seen as representational.

> . . . Someone might argue that they [the *Hostages*] are minimal sculptures with artistic tokens wrapped in them – kitsch minimalism, like washable Monet table mats. There is a kind of kitsch industry which is to do with trapping under a transparent and resistant surface something which is more or less opaque and fragile. I think these pictures skirt the margins of both kitsch *and* the soi-disant refinement of minimalism. Minimal art would no doubt claim for itself the conditions of being the ultimate non-kitsch, inasmuch as it treats of real spaces and real volumes. It can be argued that the theatricality of the iconic elements in fact reduces the theatricality of the minimalist form so as to annul Michael Fried's strictures. (Baldwin 1991)[5]

That Art & Language's landscape *Hostages* thus bring the literal and the figurative into a critical coincidence is not in itself a mark of originality, but rather a testimony to their implication in conditions that have been pervasive and persistent. It is a truism of Modernist theory that the generation of tension and paradox in the relationship between literal form and figurative form – form that is the form of some pictorial illusion – has been the defining evidence of self-critical activity in painting since at least the 1860s. Not, of course, in all painting. To identify self-criticism in these terms is to impose an evaluative qualification. This qualification serves to pick out *modern* painting; or, more specifically still, it distinguishes that tendency within nineteenth- and twentieth-century Western painting that is identified as modern in Modernist theory and criticism. The generalization can be rephrased accordingly: what tends to define self-critical activity in painting as specifically Modernist self-criticism is that it leads to some unaccustomed tension or paradox in the relationship between literal form and figurative form.[6] This is to say that while there may be other factors determining relative critical merit in modern painting, no painting can be entirely successful as a *modern* painting if some such tension is not established – and established in terms of the psychological experience of competent spectators. (It is not generally troubling to this argument that such a qualification will tend to relegate those kinds of post-Duchampian postmodernism, fashionable in the 1980s, in which modes of aestheticization of mere commodities are treated as kinds of psychological or cultural games.)

The different spectator

So far, we are on familiar ground: the ground of Clement Greenberg's "Modernist Painting"[7] or Richard Wollheim's "The Work of Art as Object"[8] – essays now forty and thirty years old respectively. In the culture of professional Modernism, "flatness" and "two-foldness" are the very signs of painting as an art. Yet, as their pictorial surfaces are smeared and spoiled, Art & Language's *Hostages* also invoke a different culture, a differently positioned spectator. This is not the apostate Modernist spectator of professional Minimalism, but rather one for whom the very smearing and spoiling establish representation. In the culture that this second imagined spectator represents, illusion and reference are familiar properties of synthetic surfaces. They are to be found in the slippery effects of kitsch abstract art, in the laminated décor of up-market bars and boutiques, or in the hygienic surfaces of expensive bathrooms. This is someone for whom decorativeness is a value at odds with the culture of modern high art – a consumer for whom the meaning of decoration is entirely reconcilable with compulsive figuration. From the imaginary point of view of this spectator, it is the undisturbed remnants of the original figurative scheme – the

Plate 48 Art & Language, *Hostage LXXV*, 1990. Glass, oil on canvas on wood, 214 × 142.5 cm. Collection Fond régionale d'art contemporain, Ile de France. Photo Gareth Winters, London.

touches of paint that still signify branches, ground, and sky – that read as literal, factitious, and unfinished.

The landscape *Hostages* do not address or accommodate themselves to one type of spectator or another, nor do they avail us of any moral grounds on which to distinguish between them. Like so much of Art & Language's work, they simply invite the differing predicates of mutually hostile discourses. What they affirm in doing so is that while proficiency in the appreciation of art is always liable to be claimed in the interests of a given constituency, conflict necessarily attends upon the

aesthetic. If this is contingently true in the world we know, it is prob-ably also true of any world we can realistically envisage. This intuition is set in play as the paintings are worked over. By the process of blot-ting and smearing, Art & Language draws into the play of artistic gen-res and effects the dangerous and transforming substance of a culture with no regard for art. That the resulting works are thus left hostage to philistines is an implication art's aficionados might defensibly draw from the generic title. But then, what prospects of successful rescue would one look for from an assault-force of art lovers?

The apparent damage done to the figurative schemes of the *Hostages* – the atmospheric landscapes – is not simply a matter of avant-garde cancellation or iconoclasm, then, though it is significant that a tradition of artistic iconoclasm has persisted within the margins of the Modernist mainstream. Rather, what is involved is a purposeful withholding from the cultured spectator of the security of certain nor-mal and unreflective modes of recuperation. The semantic hiatus leaves this spectator with some self-critical work to do. To recognize the painting for what it is – to be able to represent it to oneself – is to look not simply through the iconic conventions of artistic culture, but rather to look in the face of those conventions into a possibly unaesthetic world – a world unamenable, at least, to accustomed modes of aes-thetic ratification and control. This world is evoked in Art & Lan-guage's paintings by both the literal and the figurative components of their surfaces. But it is also present as a visitation in those reflections of the spectator's actual situation that are visually indissoluble from the artistic materials.

There is of course a risk that no possibly aesthetic remainder will be left by the "rogering" process, or that none will be recoverable through the welter of reflections. But it seems that such risks have to be taken if art is to survive as a critical presence in our culture. It has been a real-istic requirement of modernism since its inception that the substance of the aesthetic be found and worked in face of the unaesthetic. The price of failure to meet this requirement – or of proceeding as though it could be transcended by the achievement of a purely formal autonomy – has since the late nineteenth century been descent into a kind of bureau-cratic pseudo-Modernism. If paintings establish their meaning by ref-erence *only* to other paintings – texts by reference only to other texts, art objects by reference only to other art objects – if there are not some ordinary unaesthetic materials being worked on in culture, then there can in the end be no noninstrumental or nonaesthetic criteria of suc-cess and failure. It is a testimony to our cognitive vitality that we ex-perience the relations between the figurative and the literal as problematic. In the end, this is why painting matters. This is to say that painting matters if pictures matter. Painting, after all, is no more and no less than a highly complex way to make pictures, or things that at least work in some manner *like* pictures. Paintings, we might say, are pictures that do their (dream)work in the gaps between signifying stuff and what that stuff is made of, which is in effect a "next" level of

signifying stuff. Transformations in painting's conceptual and compositional structures are of critical interest to the extent that they articulate the "levels" in question, leading us to reflect *self*-critically on the relations between them.

It does not follow, however, that critically significant art will be made out of any old reference to any old objects. In the new art of the past two decades we have seen a proliferation of visual puns and cognitive puzzles, with implications vis-à-vis our grasp of the fetishization of commodities, of the reification of "Others," or of the iconography of advertising, that can be decoded with a *reassuring* ease. This reassurance has been distributed and made to stick with the aid of an adventitiously conservative aesthetics.[9]

An answering regard

There is a further question, central to the tradition of landscape painting, that the *Hostages* serve to pose. They ask, what does it *feel like* to be here? At one level, this is to inquire of the person supposed to be seeing: what do you see, and what is it like to see it? The relevance of this question serves again to recall landscape's relationship to the painting of the figure. This relationship is signaled in many of the landscape *Hostages* through the device of a vertical band or divide – a device typically used in painting both to confirm the verticality of the picture plane and as it were to situate a viewer relative to a given subject, often a viewer whose gaze intersects the picture plane at a downward angle. In the work of Degas, for instance, the device of a vertical divide normally functions to position the supposedly male viewer both physically and psychologically with regard to a woman being viewed.

> MB: This [the vertical band] was come by more or less honestly: these trees skirt a playing field in which there is a cricket pavilion. The post supporting its veranda could actually be incorporated into the landscape. . . .

> MR: Of course you can't account for the band entirely in a naturalistic sense. It's a device, as it was for Degas. It's a bit like painting a frame, it can serve to push the remainder of the painting into something like a quotation. You can see this in Cézanne and Vermeer and Velásquez. In Degas it's almost a voyeuristic device which gives the sense of someone peeping around the corner.

> MB: . . . It's a naturalistic device which can then be tuned in various ways, in the case of Cézanne to create a kind of ambiguity, in the case of Velázquez or Degas to create a kind of psychological atmospherics – how you place yourself in relation to the picture, how you leave the picture or enter it.

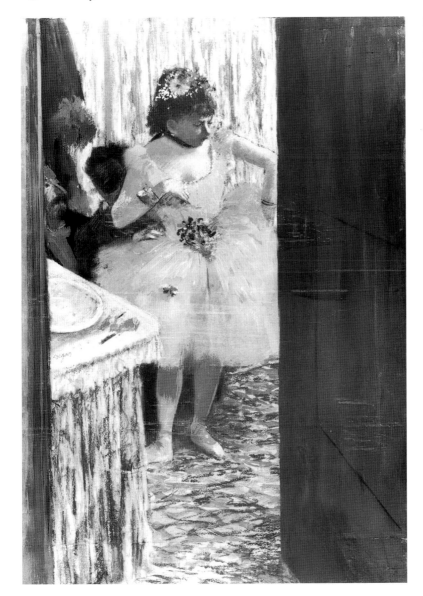

Plate 49 Edgar Degas, *Dancer in her Loge*, c. 1878/1879. Pastel and gouache on card, 60 × 40 cm. Oscar Reinhardt Collection, Winterthur.

In another way the band is a point of reference. These works have this curious inside out characteristic. . . . The band is caught – oscillating between a pictorial device and a "literal" surface. It is, as it were, out of control figuratively and literally. (Baldwin and Ramsden 1991)[10]

The flat vertical surfaces of the *Hostages* also serve to recall those later forms of painting in which neither landscape nor the solitary human figure is seen as offering a plausible modern subject. These are paintings that seek to establish equivalence in the abstract to the answering human presence that seems to look back alike from some of the most remarkable of landscapes and from the most poignant of self-

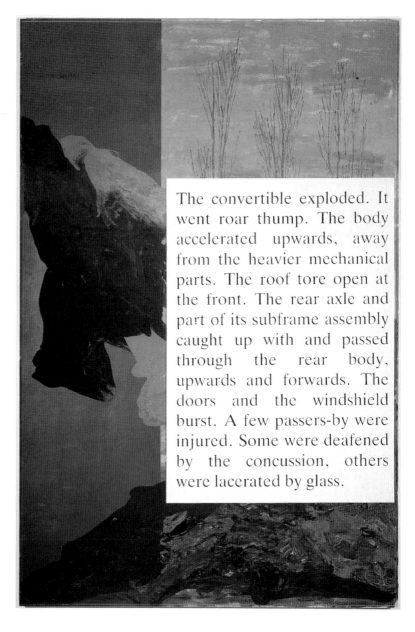

The convertible exploded. It went roar thump. The body accelerated upwards, away from the heavier mechanical parts. The roof tore open at the front. The rear axle and part of its subframe assembly caught up with and passed through the rear body, upwards and forwards. The doors and the windshield burst. A few passers-by were injured. Some were deafened by the concussion, others were lacerated by glass.

portraits. I refer, as I think the *Hostages* do, to the paintings of Barnett Newman and perhaps of Mark Rothko; works predicated on the assumption that a painting can be an equivalent for another person, and that the viewing distance they require of the spectator will in some psychologically significant sense be a *social* distance.

But in the experience of the *Hostages,* there is another level of meaning to the question "What does it feel like?" that is not entirely captured by reference either to a tradition of landscapes and self-portraits or to the abstract painting of the mid-twentieth century. It is a specific

The comestible imploded. It went war dump. The body accentuated upwards away from the healthier mathematical parts. The roof tore open at the front. Parts of the near actual and parts of its substrate accessory caught up with and passed through the near body, upwards and northwards. The doors and the gumshield burst. A few passers-on were conjured. Some were defeated by the discussion, others were fascinated by glass.

Plate 51 Art & Language, *Hostage LXXIII*, 1990. Silkscreened text on paper, glass, oil on canvas on wood, 214 × 142.5 cm. Courtesy Lisson Gallery, London.

consequence of the meeting of paint and glass. In those areas of the pictures that were thinly painted and allowed to dry before the glass was imposed, the figurative landscape extends into space. Over these areas, the effect of the covering of glass is if anything to heighten the picture's atmospheric properties. But where the wet paint has been compressed against the underside of the glass, the effect is as if the illusionistic elements had been gathered up and smeared across the foreground. For all their facticity, the resulting presences are strangely corporeal, like faces pressed against the glass, alarming both in their proximity and in

their deformation. From within each gleaming slab a form of hostage seems to look back out, as the semblance – *semblable* – of our vulnerable selves, while the pictured world behind collapses into shards and fragments.

One of the last of the landscape *Hostages* bears the following text as a kind of poster largely obscuring its pictorial content.

> The convertible exploded. It went roar thump. The body accelerated upward, away from the heavier mechanical parts. The roof tore open at the front. The rear axle and parts of its sub-frame assembly caught up with and passed through the rear body, upwards and forwards. The doors and the windshield burst. A few passers-by were injured. Some were deafened by the concussion, others were lacerated by glass.

Landscape might be a refuge from the would-be-urbane professionalism of Conceptual Art and its derivatives. But insofar as it can be made aggressive it is no place to hide, not from the conflicts of modernity, nor from the fear of violence, nor from the power of language. When we ask what it feels like to be here, these too are among the conditions of any realistic response.

A further painting bears a malaprop version of the same text.

> The comestible imploded. It went war dump. The body accentuated upwards away from the healthier mathematical parts. The roof tore open at the front. Parts of the near actual and parts of its substrate accessory caught up with and passed through the near body, upwards and northwards. The doors and the gumshield burst. A few passers-on were conjured. Some were defeated by the discussion, others were fascinated by glass.

III
NUDES

6

Tasteless Experience

In Painting as an Art, *Richard Wollheim anatomises a truism, viz., that not only does a painter paint* with *the eyes she also paints* for *the eyes.*[1]

The late Flint Schier plays about with the truism and asks what it means. The play is uneven. It includes deceptively large movements with big categories like "experience" and "worthwhileness." Two of his principle moves involve the following assertions:

1 That the painter sees to it that "the experience of attending to the work will be an intrinsically worthwhile one." (This is part of what it means to say that the painter paints for the eye.)
2 That "there is a second point concealed by an ambiguity, viz., that another part of the meaning of paints for the eye *is that the painter tries to assume the role of someone who comes before the work, takes a more or less detached vantage point and then asks if the experience of attending to this work is an intrinsically worthwhile one."*[2]

It's subtler than it looks, perhaps, but it does seem very well fed and domesticated. But can we open up the game a bit and still preserve any of Wollheim's/Schier's intention?

For Schier, getting to this "vantage point" is a condition of achieving some sense of moral community between artist and spectator – a necessary but insufficient condition of friendship, morality, and so forth. Furthermore, he argues that a sense of the intrinsic worthwhileness of community experience is a necessary condition for art and that the reciprocity engaged provides a substantial amount of the material necessary to refute

emotivism, in which Schier implicates the so-called insti-
tutional *theory of art.*

Small game, big stakes – and straight talking. Or is it?

*What immediately brings a feeling of wooze is the
thought that a sense of moral community so airily rec-
ommended might not provide the materials for a sub-
stantial refutation of emotivism at all. It might merely be
a slightly refined variant of emotivism. How does Schier
get out of Bloomsbury 1910 or some equivalent? Is it just
a matter of (metaphorical) "quantity"? Is it that Tom
Crow's 18th century connoisseur whom Schier contrasts
approvingly against the supporters of (presumably) Carl
Andre's pile of bricks merely had more to say, in more de-
tail, or are there other (more immediately qualitative)
considerations?*[3]

*For the time being, however, we can try to narrate a
fragment of the tasteless experience we have in painting
for the eye, and in doing so, shed some light on how hard
or easy it is to imagine a sense of moral or artistic com-
munity, let alone possess one.*

– Art & Language, from "Preliminary Digression" to
"Art & Language Paints a Picture (VI)," 1992[4]

Finding (a) work

This and the following essay concern a group of works in two related se-
ries: *Index: Now They Are* and *Incident: Now They Are*. Behind these
works lies the precedent of Courbet's *L'Origine du monde* of 1866. The
first series comprises some twenty works, the second three. These were
all made by Michael and Mel in 1992–1993. The earliest works in the
series were shown in 1992 in exhibitions at the Galerie Grita Insam, Vi-
enna, in June and July 1992, and at the Galerie Isy Brachot, Brussels,
from June to September. The later works were first extensively repre-
sented at the Musée du Jeu de Paume in Paris between November 1993
and January 1994. As is often the case in the practice of Art & Lan-
guage, a lengthy period of conjecture, experiment, and occasional mis-
calculation preceded the establishment of a workable genre.

By establishment of a workable genre I mean to refer to that moment
in the pursuit of a given practical project at which effective critical com-
parisons can be made between one relevant work and another. In our
specific case this moment was marked – in a manner typical of the argot
of the studio – by the adoption of a mildly obscene name for the works
in question. Anagrammatized into Latin and retranslated, this generated
the English title adopted for the entire series: *Index: Now They Are.*[5] For
this point of establishment to be reached two requirements have gener-
ally had to be met. The first requirement is that it should in the first place
be possible and desirable to individuate some specific outcome of any

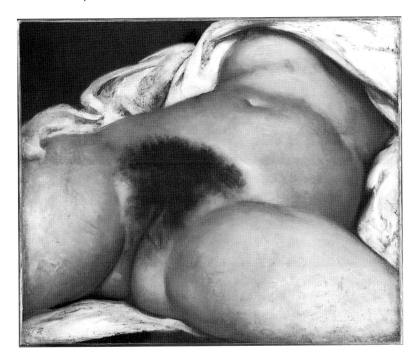

Plate 52 Gustave Courbet, *L'Origine du monde,* 1866. Oil on canvas, 46 × 55 cm. Musée d'Orsay, Paris.

given project as "a work"; that is to say as an object that, however diverse its constituents, can plausibly be seen both as self-sufficient and as intentional under some description. The second requirement is that comparison between any one outcome and another should bear critically on the terms of that individuation and that description.

That last paragraph offers a somewhat compressed account. It may help if I amplify it by reference to a now well-established case. (I refer to a canonical example for the sake of its familiarity and convenience, and not so as to dignify the practice of Art & Language. The comparison will fit only where it touches.) In his early work, Paul Cézanne had painted a number of more or less unresolved compositions featuring nude figures, male and female, in varied scenes of struggle and repose. In the later 1870s he painted the first representative and coherent pictures in what was to be a long series on the theme of bathers: groups of nude figures, predominantly though by no means exclusively female, set in imagined outdoor locations. To describe one of these paintings as an incompetent and failed attempt to paint the kind of nude composition normally seen in the Salon – as they were indeed represented by hostile critics at the time – was to see its specific style and aspect as technically insufficient, accidental, and thus *un*intentional. This was to imply that Cézanne was deficient in the relevant competences – technical, cultural, even ethical – and therefore could not do what he meant to do. To the extent that this derogation was credible and effective, the critical aspect of these paintings was defused or deferred. (It was not until 1936 that one of Cézanne's Bathers first entered a major public collection.) It was only if and when a given painting could be seen and described as

intended to be as it was that it could also be seen as complete and self-sufficient, and even, in the event, as inaugurating a specifically modernist kind of self-sufficiency in painting ("and suddenly one has the right eyes," as Rilke wrote in 1907).[6] Significant evaluative comparisons could then be made not only between one of Cézanne's Bathers and another, but between any one relevant type of modern nude and another. These comparisons in turn bore on the more general critical revision of concepts of painterly modernity and technical competence, particularly as these concerned painting of the nude. It is by such means that considerations of relevance to the microscopic conditions of an individual work or practice may be extended macroscopically to the range of descriptions applicable to an entire genre or medium.

Dead ground

We commence, then, with a studio in Middleton Cheney, a village on the borders of the English counties of Northamptonshire and Oxfordshire. The studio measures approximately nine by eighteen meters with windows on two sides, facing north and south. The room is some 4.6 meters high with hammer beams. It is a former village meeting place. There are three large robust tables in the center of the room. The studio is filled with the diverse resources of a painting practice. These resources are material, technical, cultural, iconographic, and so forth. Among the clutter of paints and brushes and tools and scribbled papers there are drawings in various stages of resolution. Some of these resemble the ground-plans of buildings; others describe large and theatrical interiors; in still others the picture of a reclining woman's torso is pursued through various changes of scale, based in each case on Gustave Courbet's *L'Origine du monde*. In a few more carefully studied drawings the fragment of an interior is laid over a detail of the torso, so that the view into a shadowed doorway coincides with the woman's genitals. A large canvas rests against one wall, slightly longer in the horizontal than the vertical dimension. It would be misleading to call it an unfinished painting. Rather, it constitutes the ground on which various technical and illustrative materials have been or will be experimentally brought together and combined: picture with plan, depicted interior with painted surface, figurative texture with literal texture, and so on. Though a kind of figurative architecture is sketched in on the canvas, there are several rectangular gaps in its literal surface. Littered about are smaller oil paintings that might be taken for the finished products of a conservative but driven painter. They are pictures of a woman's torso and of a woman's genitals. It seems that these are to be inserted into the larger painting-to-be, and thus to complete its surface. Like fabricated quotations, they await incorporation into that more sustained pictorial context by which – it is to be hoped – their referential value will be positively transformed. These various materials sug-

Plate 53 Art & Language, *Exit: Now They Are*, 1991. Pencil on paper, 64.5 × 55 cm. Destroyed.

Plate 54 Unfinished and abandoned armature (oil on canvas over plywood), in Art & Language studio, 1991. Destroyed.

gest an agenda of sorts. Something is to be made of them. That something is conceived as a form of Index – which is to say that we envisage a hermeneutic connection both to Art & Language's *Index 01* and to paintings in the series *Index: the Studio at 3 Wesley Place* (see *Essays*, chaps. 3 and 6). These earlier works were produced with the demands of public exhibition in mind. *Index 01* was shown at "Documenta 5" in 1972 and the first two of the *Studios* at "Documenta 7" in 1983. What looms over the present enterprise is the prospect of a major exhibition of Art & Language work, to be held at the Jeu de Paume in Paris in the winter of 1993–1994.

I now move forward a week or so in time. The various smaller pictures have been inserted into the larger canvas, completing its surface. Some heavily painted areas are still wet. The effect is unspeakably awful.

In view of the earlier reference to Cézanne, we have to be careful here, however. Of course, not all contingent products of a painterly practice are potentially canonical artworks. In fact only a tiny minority of all enterprises can possibly be. But given the long history of scandal and misjudgment in modern art, even the most hopeless of apparent failures must give us some uneasy moments before it finally goes to the trash. In those deliberations that take place before any considerable investment of time and materials is dismissed, the propriety of a professional self-image is inevitably at stake. At such times, we face the prospect that there may indeed be some description of a disastrous compendium such as this under which it can be seen as intentional – some possible world in which it might be subject to valid and public scrutiny, and, worst of all, even approved. These are moments of shameful confrontation, at best with the evidence of miscalculation, at worst with ambition, hubris, and bathos.

Plate 55 a & b Unfinished and abandoned paintings (oil on canvas), in Art & Language studio, 1991. Destroyed.

Dangerous ground

Still later, and the larger canvas has indeed been abandoned. In its position is another canvas about two meters high by a meter and a half wide – a canvas, then, that conforms not to the normal aspect-ratio of a landscape, a history painting or an interior, but rather to the typical aspect of a portrait. On this canvas the enlarged picture of a woman's torso is set against the painted background of an interior, largely obscuring it. A sheet of toughened glass has been fixed over the whole. Where the paint was thick and wet it has been compressed from the back, employing a technique practiced on Art & Language's landscape *Hostages*. (One of the two painters represented in "Art & Language Paints a Picture (VI)" is made to say, "It had occurred to us that the body-equivalence mechanisms of the *Hostage* landscapes might somehow be capable of conversion.") Some of the figurative imagery remains relatively readable, some is smeared into abstraction. Paint that was dry before the glass was applied remains unaffected, though not necessarily any the more readable as imagery in the context of the whole. In some areas of smeared paint, fugitive images are suggested, like pictures seen in clouds. In parts of the canvas, relations of surface and depth shift in concert with relations between the literal and the figurative. In others they shift independently of those relations or in apparent contradiction to them. For all the technical similarity with the pictures of landscapes, there is no pretending that a painting derived from the picture of a nude can be contained within the same language game. Here, the reconstructible details of figuration and the suggestive smearings of the literal converge in a welter of flesh-colors and skin-tones and hair-textures. To put the matter euphemistically, there is a high degree of redundancy of effect. What results is not so much equivalence for the figure, as overload of figurative suggestion, as though someone had tried to invest analytical Cubism with all the modeled corporeality of a Bouguereau.

The figure has for some while been dangerous and deeply compromised territory, the nude female figure all the more so. Why should this be so, and why particularly with regard to the period since c.1860 – which is to say, according to a standard definition of the modern in art, during the entire modern period? The question sets an agenda for a lengthy book. Any explanation volunteered within the frame of an essay must appear arbitrary or simple-minded or both. That said, I offer a rough sketch.[7]

In the longer view, consciousness of the issues at stake in the representation of any one person by another was gradually affected by evidence from such nineteenth-century researches as those of Charcot and Kraft-Ebbing, and by the substantial development of theories of psychoanalysis, each of these in its turn conceivable both as a means of response to the experience and self-imagery of modernity and as a source of influence on their subsequent character. Throughout the later nineteenth and twentieth centuries, movements for the emancipation of

women proceeded sometimes in concert with the kinds of evidence offered by such researches, sometimes in tension with them. In the academic discourses of the later twentieth century, these and other factors fueled feminist critiques of the male-centeredness of modern art and especially of painting – a fortiori where the representation of women was involved. The occasionally reproving and often complex character of these critiques adds substantially to the sense of danger and compromise – and thus, of course, to the potential fascination – for male artists conceiving the female figure as a prospective artistic motif.

> We took it [the theme of the female nude] on *because* it was dodgy, but not just because of its modernism-type

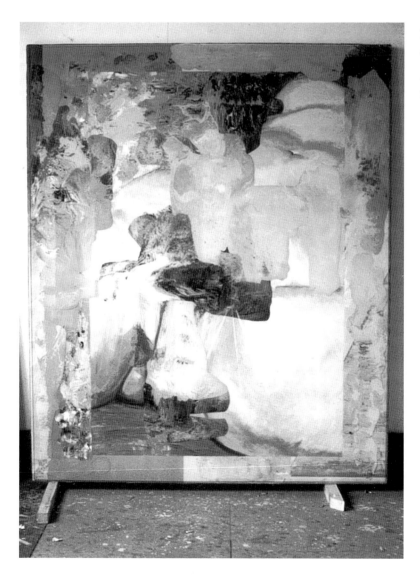

Plate 56 Unfinished and abandoned painting (glass, oil on canvas on wood, 190–6 × 163 cm.), in Art & Language studio, 1991. Destroyed.

problems; also because of its feminist, voyeuristic, La-
canian, exhibitionistic, radical-bullshit problems. (Bald-
win 2000)[8]

Meanwhile, and particularly since the 1960s, the number of women
artists in the West grew substantially, inevitably shifting the emphasis
in representations of the figure and in the broad field of reference for
interpretation. To these forces we can add the sheer and ever-increasing
visibility of images of women and of the nude, as rapid developments
in photographic – and more recently electronic – technology were ex-
ploited for the ends of art, pornography, and publicity. While the tide
of theory, debate, and imagery has continued to rise, carrying its load
of evidence, aggression and grievance, the museums and libraries of the
Western world have safeguarded an iconography of the human figure
that reaches back to the earliest of those forms to which we still attach
the label of art. The more persistently anxiety has attached to the artis-
tic representation of the human figure, the more clearly central has
been its role in sustaining the very concept of art. The sense of this cen-
trality was not one jot diminished by developments in abstract art dur-
ing the twentieth century, or by the increasing tendency for all and any
descriptive figuration to appear technically and culturally conservative.
On the contrary, it seems evident that much of the most significant art
of the last century proceeded from flirtation with various partial and
indirect forms of figuration of the body to the pursuit of some plaus-
ible kind of person- or body-equivalent. (I think of the early Picasso,
Brancusi, de Kooning, the mature Pollock, Rothko, Newman, Gerhard
Richter, Cindy Sherman.) On the other hand those artists who stayed
with descriptive figuration much beyond 1940 – however psychologi-
cally and technically intensified and elaborated – were stuck with the
predicates of a tedious if conservatively congenial humanism. (In this
case I think of the later Picasso, Francis Bacon, Lucien Freud, Gilbert
and George, Robert Mapplethorpe, the Chapman brothers – and on
down into irrecoverable junk.)

It is generally revealing of the character of enterprises of this second
sort that little of critical substance hangs on whether the humanistic
predicates at issue are of the positive or the negative variety – whether
the "human condition" they appear to thematize has been conceived as
nice or nasty. In fact, it may be significant that all the more recent can-
didates tend to be firmly of the "negative" persuasion. It seems that no
self-respecting artist or critical apologist would now dare to place them-
selves on the "nice" side. We should not assume that this is a sign of
some "maturity" in the self-images of the age. Adolescent ideas of cul-
turally urgent truth-telling tend always to attach themselves to the nar-
ratives and iconographies of negativity, violence, horror, and so forth.

None of these considerations could be absent from the conscience or
self-consciousness of a half-sophisticated practice in the sphere of con-
temporary culture. This is not to say that they can necessarily be held in
the mind as the substance of practical projects, merely that in any work

touching on the genre of the nude their implications will unavoidably resonate through the substrates of contingent technical problems. To put the matter bluntly, the more evidently figurative the body-image adopted at the outset of an artistic project, the greater the demand that it be technically and conceptually transformed by and in that project. On pain of critical redundancy, what will be required of such an enterprise is that it should block all channels through which the image in question might be co-opted into a ready-made cultural discourse.

Given the provocative reference to Courbet's painting, then, it was from the start a matter of uncertainty whether Art & Language's resources of technique would be sufficient to provide the grounds of a relevant hermeneutic.

> Let's be charitable and assume that [painters] (1) and (2) do get the odd painting done, and that they don't just have each other in mind, etc., viz. that they do paint for other eyes, and that these eyes are imagined (etc.) while they are painting.
>
> Consider . . .
>
> In spiritual contrast to Schier, let us add that (1) and (2) are not happily painting away, secure in their hopes and imaginings *vis-à-vis* the eyes they might partly be. Let us imagine that (1) and (2) are (or feel) somehow beleaguered, that they are almost paralysingly uncomfortable in their putative métier.
>
> Would Schier's/Wollheim's artists be able to bear this sort of predicate? One has a feeling of certainty that they would not.
>
> Consider Schier's artist to be painting *for* an eye which is *unsympathetic* and that she wants to keep it that way. Consider further that she, or (1) and (2) if you like, are concerned to trap and to confuse the "eyes" they sometimes imagine into making dreadful mistakes, into a hopeless and morally unsustainable insecurity. (Can she/ they really imagine these "eyes"?) . . .
>
> "(1) and (2) Imagine a Spectator" is a subset of "Art & Language Paints a Picture" to be sure, but the imagining while *necessary* is barely plausible. *It is imagining demons.* (Art & Language 1992)[9]

Yet these uncertainties are the indispensable conditions of an open system. What we require of our working conditions is that they admit of the unforeseeable outcome, and that they avail us of a space in which

we can say that we were wrong and that we failed. Art & Language's second painting, too, is destroyed. In recording its appearance, I stand aside for the moment from the practical concerns of the studio, and edge into the dusty world of the art-historian as interested archivist. My photograph joins the stock of material with which I might one day blackmail Michael and Mel. The project persists, however.

Masking and concealment

Given the apparent prohibitions on its modern treatment, it might be asked why the nude should have come up for the count at all in the practice of Art & Language, and why, especially, in the blatant form of Courbet's *L'Origine du monde*? To some extent, the one question answers the other. First, if we are to retain the possibility of some critical relationship with the business-as-usual of our culture, there will be a perverse tendency for prohibition to point the direction of inquiry. It is a point well made in feminist critiques that there are grounds for massive self-deception in the would-be aesthetic objectification of the female body. Appropriate shibboleths now protect practice and criticism against those who will not take the point. We may nevertheless choose to risk mispronouncing them.

Second, the reappearance of Courbet's supposedly lost painting entrained its own long history of prohibition and concealment. In 1988, the controversy attendant on its inclusion in an exhibition at the Brooklyn Museum[10] served both generally to focus a range of topical issues regarding sexuality in the field of vision[11] and, more specifically for Art & Language, to reanimate a series of references in our extended conversation with the ambitious French painting of the nineteenth century and with its interpreters. In 1981, Michael and Mel had painted three works that used imagery from paintings by Courbet. The first was *Gustave Courbet's Burial at Ornans expressing . . .* (see *Essays*, pp. 158–162 and plates 80–82 and IV); the second was *Raped and Strangled by the Man who Forced Her into Prostitution: A Dead Woman: Drawn and Painted by Mouth* (based on Courbet's *Woman with Parrot*); the third, *A Man Battering His Daughter to Death as she Sleeps: Drawn and Painted by Mouth* (based on Courbet's *Cupid and Psyche*).[12] The two latter paintings were nudes of a kind, albeit their theatrical and pseudo-Expressionist properties were sufficient to divert attention away from the more standard psychological issues associated with the painting of the nude, and, perhaps, toward those neo-Expressionist and heavily macho kinds of painting then in vogue. (Readers with long memories may recall talk of the "Young Italians," the "Neue Wilden," the "Trans-avantgarde," "A New Spirit in Painting," and so forth.) Courbet's *Atelier du peintre* of 1855 had also shadowed Art & Language's own Studio project. Further, as an art-historically notorious nude, Manet's *Olympia* had figured both in the Studio paintings and, in company with others of its genre, in Art &

Language's conjectured opera *Victorine. Olympia* had also been the subject of an exchange of articles between T. J. Clark and Peter Wollen to which we had contributed an essay of our own.[13] And finally, though not exhaustively, the landscape *Hostages* had evoked kinds of corporeal presence that could be imagined either as reflected in or as looking out from their surfaces. Interest in this last form of ambiguity in particular served to reanimate our shared interest in pictures of the nude.

Certain artists – or rather certain canonical works by certain artists – tend to become indices within the argot of Art & Language and of its practice. This is not a direct consequence of their practical virtues, however; that is to say, it is not a consequence of the more customary ways in which canonical status might have been earned. Rather, works like *L'Origine du monde* may become objects of attention in the first place by virtue of their status as conversation pieces in arty or art-historical chat (which may itself be a consequence – rather than an adequate representation – of their practical virtue).

> Since our work is often connected to the matter of genre, we are often obliged to look for decisive generic models, powerful exemplars. These are not the limits of our "art-historical reference material," however. Indeed such reference material might go both to art and to history. There are, as it were, first-order references, second-order ones and so on. (Art & Language 1993/1996)[14]

In referring to such models, in other words, we can be referring to that which they have been made to stand for; which is to say that we may sometimes use them to address the soul-searchings of the dominant culture at their most symptomatic – or most pretentious and most scandalous.

This is the first thing that a critically active – un-co-opted and therefore serviceable – art must do to survive: it has to bring an adequately sophisticated form of the self-imagery of the culture into view, in order to specify and to establish the possible terms of difference.[15] Thus to play with representations of *L'Origine du monde* was self-consciously to address those issues for which the painting itself had come to serve – or could be made to serve – as example and occasion. Among these issues were those raised by the painting's virtual absence from art-historical discussion over the course of a century.

Of greater technical interest, however, was the fact of the painting's *literal* concealment, behind a green veil while in the possession of Khalil-Bey, the Turkish diplomat who commissioned it, subsequently, according to the testimony of Fernand Léger, behind Courbet's own painting of a castle in the snow (*Le Chateau de Blonay*, 1874–1877, Szépmüvészeti Múzeum, Budapest),[16] and lastly, during its sojourn in the study of Jacques Lacan, behind a specially commissioned painting by André Masson, itself a further development on Courbet's pictorial theme (1955, private collection).[17] For Michael and Mel, the fascina-

Plate 57 Gustave
Courbet, *Le Chateau
de Blonay,* 1874–77. Oil
on canvas, 50 × 60 cm.
Szépmüvészeti Múzeum,
Budapest.

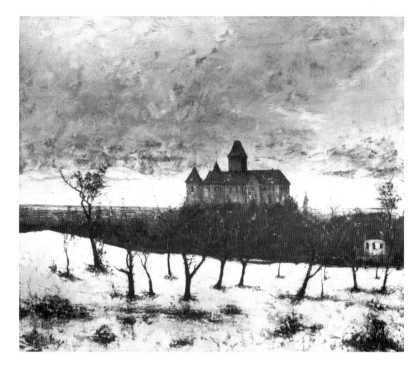

tion of *L'Origine du monde* was thus as much a consequence of the
practical and psychological questions raised by the idea of a concealed
or invisible image as it was of the picture's all-too-visible and thus po-
tentially scandalous subject. Through Courbet's explicit engagement
with the subject of the nude, Art & Language was provided with a
mode of access both to culturally forbidden territory and to a previ-
ously untried genre. On the other hand, various kinds of masking and
concealment had been practiced in Art & Language's previous work:
portraits of V. I. Lenin in the style of Jackson Pollock, and, in some in-
stances, in disguise to boot; Studios in the dark or re-presented as mere
over-illuminated surfaces in themselves; Museums obscured by ply-
wood shuttering or by texts; landscapes standing in by one means or
another for other landscapes or other kinds of picture altogether; texts
dressed up as travesties of their original selves; and so on.

But of course, the two aspects – the scandalous subject and its modes
of concealment – were psychologically and culturally inseparable. Ac-
cording to one of the speakers in "Art & Language Paints a Picture
(VI),"

> while sexual display and hiding are necessarily connected,
> the sexual metaphysics of hiding or concealing is not a
> mere function of what is or is not displayed. The sexual
> metaphysics of hiding or concealing is relatively au-
> tonomous. Our initial interest in *L'Origine du monde* was
> provoked by the autonomous history of its concealment –

autonomous notwithstanding the fact that its sexual con-
tent is a necessary condition of its having been concealed.

Given that there was an "autonomous history of concealment" in Art
& Language's own practice, one possible upshot of painting a con-
cealed nude was that that history would be critically compromised by
another: by a more or less invented psychopathological autobiography,
within which some earlier phases of work might then be ironically po-
sitioned and reconsidered.

Once such things as *L'Origine du monde* come to take their place
among the working materials of the studio, however, their actual ef-
fects and resonances are unpredictable. Whatever may be the an-
tecedent terms of their conceptualization in art history or in cultural
studies or wherever, their implications in practice – the bearing they
may come to have on what can be done with them – tend not to coin-
cide with the sorts of strategy that can be thought up in advance.

The facing of these implications is the second thing a critically active
art has to do to survive. There is nothing very mysterious in this. It is
what it's like to continue a practical tradition. This is day-to-day work –
though, insofar as its outcomes are never entirely predictable, it may re-
quire a degree of critical alertness not normally allowed to most kinds
of day-to-day work. In this case, a project that departed from repre-
sentations of Courbet's picture, and from an interest in its masking and
concealment, drew Art & Language into the social, psychological, and
ethical issues both of making and of seeing – or of being unable to see –
that which was to be concealed: the *unmasked and unbroken* recapit-
ulations of Courbet's image. The studio filled up with large pictures of
cunts. For a while, it was these, rather than the processes of masking,
that claimed autonomy of a kind, though – if this is not a contradic-
tion – it was in their very stylistic degeneracy that their self-sufficiency
seemed to lie. This is the autonomy of pornography and of kitsch, or of
their complacent convergence. Against the charges such experiments
tend to attract, irony offers no very plausible alibi. You just have to
work with the shame.

Talking pictures

At the next stage, then, the segment of torso and its vestigial ground oc-
cupy the entire surface of each canvas, from edge to edge, varying in
each case only by slight differences in tonality, and by the positioning
and framing of the image's central portion – depicting labia and pubic
hair – within the pictorial space. The scale of Courbet's own image is
slightly less than life-size. In Art & Language's paintings the woman's
genitals appear far larger than life, robbing the originally unmasked
image of any connotations of intimacy and its imagined situation
of any possible privacy. Referring to the "mode of representation" of
these pictures, Paul Wood has written:

The technique is not quite "academic," but in the matter of its scale, more of the billboard. The effect is of a deferral, or a reciprocal transformation, of the image of both technical norms. We are, that is to say, between the terrain of Rosenquist and Cabanel. Or even, bizarre as it may seem, in certain of the inflated details, closer to the colourfield paintings of Olitski.[18]

For paintings made in the early 1990s, and a fortiori for paintings made in the name of Art & Language, this is far from being culturally comfortable ground.

There is solace of a kind, however. Once completed, the painted image is all but covered. In the earliest of the resulting works the concealment is effected by a sheet of glass whose overall size is 10mm smaller than the canvas, covered on its inner surface with a coat of flesh-colored paint. In some versions the "inner" rectangle of paint stops well short of the edge of the glass. Enough of the pictured image is revealed to enable curious spectators to reconstruct what they may be missing, and thus to become implicated in imputations of voyeurism, or to be affronted, or both. In others the paint is taken to within an inch or so of the edge of the glass, so that the bordering evidence of figuration is barely sufficient to indicate the presence of any coherent image. In all cases, however, the painting is given a kind of voice. In lettering distinguished from the inner painted surface only by slight differences in tone, individual paintings from the series are made to say, "HELLO LINDA/HOW ARE YOU?" or "HELLO JOHN . . . ," "HELLO CATHERINE . . . ," "HELLO TERRY . . ."

At a certain point in the text of "Art & Language Paints a Picture (VI)" an imagined Linda joins the conversation. "I'm not called Terry" she complains. "That painting will have your name wrong," the artists reply, "It seems to do that to some people and not to others." Who, then, do we suppose to be speaking, and who being spoken to? Do I conceive the pictured but obscured figure as speaking to someone other than me, the spectator who reads or the reader who looks? Why should I not be Terry, or John or Catherine or Linda from the painting's point of view? While it may be important to me whether or not I am called Linda, my sense of my own identity is a matter of complete indifference to the painting. What matters to the painting is the identity it composes. Where Rembrandt looks out from the surface of his painting, it was once Rembrandt who looked back. It is so still for the engaged viewer who looks, and who imagines himself – herself – as reflected back possessed of the appearance the picture describes. The painter of a self-portrait may also paint herself as another looks: that is to say, as though she were being seen by another. To paint the figure, the painting painter acts a part. Looking at a child to be pictured, she may adopt in imagination the role of the mother, assuming that the person who is to acquire the picture would wish to see her child's imagined look of filial affection permanently enshrined. In another case, the painter may adopt the role of a lover in order to represent some man or woman as

Plate 59 Art & Language, *Index V: Now They Are*, 1992. Oil on canvas on wood with enamel on glass, 190.6 × 163 cm. Destroyed.

an object of desire. The answering regard of the finished picture will testify to the success of the painter's impersonation – an impersonation that, to be effective, must deceive not the actual but the *pictured* person.

So who would you be as you read the painting and its text? If your name is not Linda (or John or Catherine or Terry) are you still greeted by it? That is to say, has it just got your name wrong, or are you being greeted as someone else, or are you not greeted at all? What name will you choose to take? What gender will you assume? Can the one who looks be other than the one who is spoken to? It would seem odd that you could be disqualified from looking – or from seeing – on the grounds that you cannot be the one addressed. Are you, Linda, Catherine, John or whoever, somehow disqualified from fully seeing Manet's *Olympia* as the picture it is if you cannot or will not imagine yourself as that male party in an exchange of money for sex whom the regard of the pictured woman evidently addresses? How are you to decide these matters? What limits on your imagination do you allow propriety or sexual orientation or biological difference to impose? What is the nature of your desire?

What we have in mind is no doubt a situation of some strangeness. What sort of power or competence is it that we can ascribe (imaginatively) to an inanimate thing – as distinct from its being assigned to the person who made that thing, or to the person who sees it *as* pictorial? What is it like to conceive of a pictorial thing exercising powers which are its *own* powers? Is the process something like a poetic personification? Is it allegorical? Is the point that its power is allowed to be *potential* power; that its suppression as a conventional, visible presence leaves it free as it were to act on its own behalf, so that the spectator must conceive of it as an end rather than a means – or see nothing? (Art & Language 1994)[19]

Into the deep

In a second subseries of *Index: Now They Are* the masking of the pictured torso takes another form. In place of the continuous surface with its centered lettering, the painted glass refers to yet another canonical image, Jackson Pollock's *The Deep* of 1953, a painting that has figured before among Art & Language's favored points of reference and entertainment.[20] "*The Deep* is our *Castle in the Snow. The Deep* has its origins in the snow, in our snow paintings" ("Art & Language Paints a Picture (VI)"). In its original context, the whited surface of *The Deep* serves partially to mask a more conventionally suggestive pictorial depth. We look through its central cleft into an evocative darkness. Given the date of its establishment, we imagine this as an area of *European* profundity lodged in the "creative emptiness" of American painting. In Art & Language's paintings, the interior surface of each glass sheet is painted with pink lacquer in an approximation of the white-painted area of *The Deep*. In place of Pollock's dark chasm, however, it is an enlarged detail of *L'Origine du monde* that may be glimpsed through the frayed edges of the central aperture. The travesty of the one painting both covers and reveals the travesty of the other. There is one further reference that is animated by the association of Pollock's style with the covering sheet of glass. Hans Namuth's film of Pollock at work in 1950 includes footage, shot from below, of the artist dribbling paint onto a sheet of glass.

In peeking through the trails of paint, the viewer of Art & Language's painting encounters suggestive figurative detail – more or less decipherable, more or less disturbing, according to the positioning of the underlying image and the fragment of torso thus revealed. Retreat to the literal surface offers no respite, however. Once the framing edges of the one paint layer have been allowed to merge with the descriptive brushwork of the other, the factitious surface is imbued with slippery metaphorical potential. What kinds of competence, we might ask, are revealed in the processes of recognition or recoil, or of recognition *and*

Plate 60 Art & Language, work of the series *Index: Now They Are*, 1992. Oil on canvas on wood with enamel on glass, 190.6 × 163 cm. Destroyed.

recoil? And who is it that wears the mask – or inhabits the body – of skin-colored paint?

> *Linda:* Is not that skin somehow attached to the onlooker? Is its external surface not somehow not the painting's own?

> *(1):* In not being quite the painting's (and not just the picture's) own, it implicates itself in the onlooker's own corporeal surfaces.

> *(2):* As his or her own mask, or as his or her own skin?

> *Linda:* Is it the inside or the outside of his or her own skin?

> *(1):* This is a question that requires either work or drugs. ("Art & Language Paints a Picture (VI)")

And so on

We are now some way from the figurative and suggestive redundancy of our project's abandoned preliminaries. But perhaps there is still too much to be seen – or, in another sense – too little. This, at least, is implied in the self-critical conversation of the studio. Of the paintings described in this essay, only one got away. The rest were destroyed. In a final series, a kind of all-overness is restored to the project of painting that departs from *L'Origine du monde*. Now, while the image is present as a whole, the mask also is complete and unbroken. The following essay is devoted to these works, and to their extension into the series *Incidents: Now They Are.*

7

Reflections on the Figure

In the summer of 1992 Michael and Mel abandoned the two ways of masking of the pictured body that they had adopted up to that point: those that attached a possible name to the notional spectator addressed, and those that allowed a glimpse of torso through the travesty of *The Deep*. Instead they covered the internal surface of the masking sheet of glass entirely with pink paint, with the single word HELLO barely discernible in a closely related tone and color at the center of each. Fifteen different paintings were produced in this manner, varying according to the positioning and framing of the depicted torso and the tone and degree of opacity of the covering skin of paint. The smallest measures 190.5 x 162.5cm, the largest 231 x 190.5cm.

On blankness

At first sight these may appear as blank paintings. You look and see nothing – or nothing of significance, just where substance and incident might seem to be promised. It can be said unequivocally that to consider these paintings as blank is to fail to see what they are. Yet a measure of frustration would not be wholly inappropriate to their effect, nor is it irrelevant to the circumstances of their execution. Fascination with the idea of the blank painting stalked the modern art of the twentieth century, and these are paintings in the modern tradition – if not comfortably so. That fascination is among the conditions by which the margins of Art & Language's work may be defined.

To talk of a blank painting is not simply to conceive of an empty canvas. On the contrary, the typical "blank" painting is a canvas made apparently blank – or apparently almost blank – through the application of paint. Among the better-known artists who have produced such things are Kasimir Malevich, Alexander Rodchenko, Robert Rauschenberg, Yves Klein, Piero Manzoni, Ad Reinhardt, Robert

Plate 61 Art & Language, installation of works from the series *Index: Now They Are,* 1992. Each oil on canvas on wood with enamel on glass, 190.5 × 162.5 cm. Galerie Nationale du Jeu de Paume, Paris, 1993.

Ryman, and Gerhard Richter. The surface of an almost blank painting may be – has been – black or white or gray. Its texture may vary – has varied – from the dense and detailed to the smooth and even. It is not possible that this surface should exclude all possibility of figuration or association. But it may resist being cited in support of any specific identification or association that it might be supposed to carry.

We might think of the blank painting as a work conceived as such from the start. Yves Klein's monochromes, for instance, were painted according to a set of conclusions reached in advance of their execution. They are to this extent illustrations.

> . . . I precisely and categorically refuse to create on one surface even the interplay of two colors.
>
> In my judgement two colors juxtaposed on one canvas compel the observer to see the spectacle of this juxtaposition of two colors, or of their perfect accord, but prevent him from entering into the sensitivity, the dominance, the purpose of the picture. (Klein 1959)[1]

This is a position that Klein's monochromes represent. For the spectator of one of these works, interest lies largely in the imaginative confrontation its achieved presence avails with the theoretical conditions of its conception, since once conceived, a painting of this kind can notionally be executed without further critical reflection or reconsideration. It is a near neighbor to the ready-made.

Plate 62 Yves Klein, *White monochrome (M69)*, 1958. Dry pigment, synthetic resin and plaster on coated canvas, 100 × 50 × 2 cm. Collections Mnam-Cci-Centre Georges Pompidou.

Alternatively we might think of the blank painting as a work that is blank because there is *no* position that painting can be considered to represent. It is end-game art. In this case, the almost-imaginary painting I have in mind is not a mere jeu d'esprit: not an avant-garde equivalent of Alphonse Allais's *First Communion of Anaemic Young Girls in the Snow,* nor a *View into a Coal Cellar full of Black Snakes,* nor even an "expression of pure feeling in the void" in the manner of Malevich. It is the residue of a history of cancellations and withdrawals. What it represents is all that can be allowed to be left. Whatever can be seen as surfeit has been disposed of: surfeit of associations, surfeit of differences, surfeit of details, surfeit of decoration, surfeit of texture, surfeit of bright ideas; yet the painting is itself a form of accretion. It has been worked on, tuned, brought to a condition of aesthetic sufficiency. It is, perhaps, a relative of *Catherine Lescault, the beautiful courtesan,* the fictional and thus actually imaginary *Chef d'oeuvre inconnu* of Balzac's story. The artist Frenhofer speaks to Poussin and Pourbus:

PREMIÈRE COMMUNION DE JEUNES FILLES CHLOROTIQUES
PAR UN TEMPS DE NEIGE

Plate 63 Alphonse Allais, *Première Communion de jeunes filles chlorotiques par un temps de neige,* from the *Album primo-avrilesque,* Paris, Paul Ollendorf, 1897. Bibliothèque nationale, Paris.

"You are in the presence of a woman and you are looking for a picture. There is such depth of colour upon that canvas, the air is so true, that you cannot distinguish it from the air about us. Where is art? Lost, vanished! . . ."

"Can you see anything?" Poussin asked Pourbus.

"No. – And you?"

"Nothing."[2]

This painting is a kind of "last possible painting," but only in a chain of such works that stretches into the future as well as back into the past. Ad Reinhardt painted some pictures that were hard to see, though not quite blank – or, once seen, not blank at all. "This is always the end of art," he concluded.[3] And "When somebody says, 'Well, where do you go from here or where do *you* go from here?' I say, 'Well, where do you want to go?' There's no place to go. . . ."[4] We are invited to imagine a painting such that beyond the moment of its execution there will be no sustainable project to which the imagination can reach for consolation. That moment will be a moment of desperation in the studio – a desperation that may last for years. But of course, we should not take such fatalism entirely at face value. It is a condition of the culture that artistic desperation makes reputations. Reinhardt himself was a kind of exquisite: part real commie, part Zen monk, part New York dandy. The painting that proposes the end of the possibility of painting may come to reveal its other face in the initiation of a form of theater. The history of modern art has certainly been well populated with actor-managers. Think of Klein and Manzoni. At their least interesting, the almost-blank painting and the blank painting are now both normal stock-in-trade.

The painting practice of Art & Language is a practice conducted under the shadow of the blank painting, among many other shadows. Some blank paintings and some ruins and remnants of blank paintings survive from among those various enterprises that preceded the original sharing of a name in 1968. Michael and Mel both painted kinds of blank paintings in the years from 1965 to 1967, before any contact had been established between them. At the time a suggestive metaphor was derived from P. W. Bridgman's *The Nature of Thermodynamics*: at absolute zero, paradoxical behavior begins.[5] Bridgman had particles in mind, but the idea was that once achieved, the blank painting might lead to a "nonblank" that could be conceived as "beyond blank," not in the sense of its being a Modernist "next reduction," but rather insofar as its paradoxical or anomalous character might project it altogether out of the world of Modernist enterprises.

Identification with the name of Art & Language effectively consigned such things to the status of primitive "early works," however. This was an alternative position to that mapped out in such arguments

as Thierry de Duve's.[6] The typical denizens – and butts – of his argument are those fascinated by the Greenbergian theory that painting had a "viable" and "irreducible essence" to which it was destined at some point to be reduced, who saw Frank Stella's black striped paintings of 1958–1959 as signs that this point might have been reached, and who therefore hurried to stake their various claims to have got "beyond" the point in question, whether into "three-dimensional work" or into the world of "generic art."

Plate 64 Mel Ramsden, *Two Black Squares: The Paradoxes of Absolute Zero*, 1966. Oil on canvas, 35.5 × 35.5 cm. Collection Charles Harrison.

Aspects of Stella's painting certainly exerted their hold over both Michael and Mel. But what was – and remains – of particular interest was that although these works seemed to obey the Modernist rules, they did so in the manner of one obeying the letter rather than the spirit of the law. Stella conformed to the protocols, that is to say, but with an insolent literalism that was effectively a mode of resistance – and he made good paintings *as a result*. These were not conceived within Art & Language as the terminal enterprises de Duve suggests, but rather as examples of a kind of salvation through effrontery. In fact, to make a purposeful identification with the name of Art & Language was to accept that *no* plausible final position could sensibly be claimed by art of any kind in technical or intellectual isolation – however blank the relevant surfaces might be made to be – and that putative "goings-beyond" this point were thus open to other kinds of description and explanation. As proposed in the first essay of the present book, the explanations in question included those that would reconceive the "crisis" of Modernism as a consequence of art's long resistance to its inescapably dialogical character. From this perspective, the problem of the blank painting's potentially terminal status appears not as a sign of the terminal exhaustion of painting as a medium, but as a contingent product of Modernism's specific and self-interested teleology. The consequence of this understanding is not that "Art fades into 'art theory,'" as de Duve represents Conceptual Art's conclusion.[7] Some theoretical work may well have been required to address the issues at stake.[8] What happened in practice, however, was that the "theory" faded into "art." The answer to Reinhardt's question, it transpired, was to revise the understanding of the larger game at issue.

And yet the *idea* of the blank painting as inescapable destination – as a realization of what Carl Andre called "the necessities of painting"[9] – has certainly persisted within the conversational world of Art & Language, as it must for anyone who conceives of Modernism as significant theory informed by practice and informative to practice. At times the idea has been a mere irritant, stalking the development of Art & Language's projects; at others it has indeed hovered as the imaginary end point of an asymptotic curve.[10] Among those works that have failed to leave the studio intact during the past twenty years have been paintings worked into all-white surfaces through the cancellation of bathetic or heroic figurative motifs, and paintings built up into blackness with ink transferred from copies of the journal *Art-Language*. The former were remainders of paradoxical attempts to place pictorial

effects and nonpictorial acts of occlusion on the same logical and practical ground – extreme forms of "Impressionism returning some time in the future." (These and the vexed episode of their production are discussed in *Essays*, chap. 7.) The latter disposed of text aggressively. The ink of which they were composed was itself decomposed – dissolved and made into shadow. They were art made *out* of language: pictures built up from the graphic material of printed texts. In both cases good ideas resulted in bad illustrations. Some sort of result was nevertheless doggedly pursued. This caused depression and despair.

Thought of the blank painting has continued to loom like a prospect of aphasia, reinforced by such substantial theorizations as de Duve's, and otherwise accompanied by the normal chatter of culture. This prospect has needed continually to be staved off by the effort of concentration – a concentration on whatever the surface of a painting may be made to contain, which is also a concentration on the possibility of there being other places to go. The Art & Language paintings now under discussion will repay attention. But you will need to exert yourself to see what it is that their superficial blankness masks and contains.

Losses and gains

Imagine two paintings that are both almost blank – blank but for a lingering sense of figuration. One, like Frenhofer's masterpiece, is a once-figurative painting that has been continually overlaid or cancelled to the point where almost nothing of its figuration remains discernible. The other is a once-blank painting that has been somehow instilled or infected with a kind of figuration. The two paintings are genetically quite distinct. They stand at the opposite extremes of a range of possible cases. And yet you would not necessarily be able to tell which was which simply by looking at them.

It is uncertainty of this order, and not an actual experience of blankness, that is offered by Art & Language's later paintings in the series *Index: Now They Are*. Each of these paintings is an instance in which the extreme cases are made to converge. In each case a highly figurative painted surface is obscured to the point of near-blankness. This obscuring is effected by another (an other) painted surface – a surface of painted glass – which, though initially empty of all figuration, becomes invested with the trace of an undeniable figurative presence: the vestigial presence of that which it obscures.

The first surface is a surface of paint on canvas. The second surface is the back of a sheet of glass, painted pink. The two painted surfaces are brought into contact, though they remain distinct. The sheet of glass is slightly smaller than the stretched canvas. In some cases, traces of modulation are revealed at the edges of the canvas, hinting at plastic effects that might be continued beneath the glass. These are not paintings that have been protected with glass, but paintings made to have a glassy surface. The back or inner surface of the glass corresponds to a

Plate 65 Art & Language, *Index XX: Now They Are*, 1992. Oil on canvas on wood with enamel on glass, 231 × 190.5 cm. Courtesy Lisson Gallery, London.

glaze – a translucent coat of paint that obscures what is pictured, and is thus structurally part of the mode of picturing. The front or outer surface corresponds to the surface of a coat of varnish, not merely protecting the film of paint from the viewer's touch, but drawing a veil of reflections over the sight of that which has been pictured.

The difficulty in looking at such paintings is not like the difficulty of seeing the configuration of colors in a dark painting by Ad Reinhardt, although a similar exertion may be required. It is more like the difficulty encountered in looking at Caspar David Friedrich's *Seashore in Fog* (plate 43) and in placing yourself as its imaginary spectator: engaging with a dialectic of appearance and disappearance, gain and loss – the departing ship acquired or achieved as an image at the very moment of its seeming withdrawal into the void of the pictorial atmosphere.

In his analysis of Courbet's tenebrous *La Source de la Loue*, Neil Hertz writes of a "central equivocation": while "what we *see* are identical strokes of dark paint . . . some of them render what we 'know' to be water, others what we 'know' to be rock."

Plate 66 Plate 65 show-
ing unglazed image.

[T]he wide-open question of the relation between a
painter and the world has been narrowed down and
played out in terms of two related questions, that of the
difference between paint and the surfaces of things, and
that of the difference between what the eye sees and what
it "knows" to be there. This last question . . . is the
fetishist's question *par excellence:* it is the source of that
"energizing shame" that [Joel] Fineman has detected in
Maxime du Camp's response to Courbet. In Courbet's
case, what the shame has energized is not just the desire
to get to the heart of the matter – that he shares with du
Camp – but the will to patiently explore the matter along
the way. The signs of that patience are in his linking of the
fetishist's questions (what does the eye see? What does it
"know" to be there?) with questions of technique (how
can the strokes of paint represent the surface of things?),
and these signs, though they are focussed with emblem-
atic intensity at the heart of the cave, in the "difference"
between black and black, are in fact spread all over the
surface of the canvas.[11]

Adjustments of color and tone are crucial to the effects of such paint-
ings as these. The colors of Art & Language's paintings are all forms of
flesh color – which is to say that they are within the range of color and
tone conventionally (or neo-classically) used to describe flesh in paint-
ing. The effect is not quite like the effect of looking at a painted body,

Plate 67 Gustave
Courbet, *The Source of
the Loue,* c. 1864. Oil on
canvas, 107.3 × 137.5
cm. Albright-Knox Art
Gallery, Buffalo.

however. It is rather as though your vision were unable to penetrate beyond its own corporeal limits, or unable, at least, to establish the means of confirmation that these limits had been passed. To experience a spatial effect similar to that which the painting produces, you have only to look toward the light and close your eyes. What you will see is what all who see can see: not the accidental pigmentation of your skin, but the effect of a transillumination. ("[Is it] that painting has been 'blinded' . . . or have we been blinded . . . or do we 'act' blind?")[12]

But the effect of these paintings is not merely a function of their near-blankness, or their "blindness." It is also crucial to the character of the effect that the blankness is adulterated; that the paintings offer vestigial evidence of an object of vision, a presence other than your own. A particular form of exertion is required if this hint of figuration is to be pursued. You have to look harder into the fog – to try to distinguish the barely distinguishable. What is this looking like, and to what end is it directed? Do you mean what you see? Given the sexual character of the image obscured, the act of looking may be invested with moral uncertainty. More precisely, perhaps, and allowing for differences in the sexual character of its viewers, it will sketch a character for its *imagined* spectator as someone who is morally uncertain, and it will require of its *actual* spectator that that uncertainty be entertained in imagination. Can a painting be made to diagnose its own spectators? And will this diagnosis be based on what it is that different people see – on how easily one reconstructs the reference of the picture, or how hard one tries, or whether one tries at all? By what self-image and by what intuitions is your attention motivated? Are you trying to reconstruct the lineaments of an almost-erased sex – as it were to arrest and to reverse a process of decay and disappearance and thus to forestall some anticipated moment of absolute blankness? Or are you working fully to identify an emergent form, and thus to succor the prospect of mimesis? The painting does not tell you what to do or how to do it. To the extent that it lays claim to some representative status as painting in a sustainable modern tradition, it simply proposes this – this aporia – as a now inescapable condition of the experience of painting, and a fortiori as a condition of paintings of the nude.

What the painting says is "Hello." For the spectator who exerts herself to some purpose, the word blooms into visibility through the center of the glassy surface. Is this like what Wittgenstein called the "dawning of an aspect," or like its obverse, the word that has degenerated into a mere sound by virtue of its reiteration? But the word is soundless. A word to the deaf? A kind of whisper in the eye of the viewer? A mindless greeting? An invitation, or a provocation? A greeting requiring a response? The recuperation of the missing head in a découpage, through its being endowed with a voice? A minimal evocation of human agency and presence? It is not clear whose voice the painting is supposed to be representing, nor whom it is that the painting supposes itself to be addressing. The *hypocrite lecteur,* perhaps.

Rothko wrote, "For me the great achievements of the centuries in which the artist accepted the probable and the familiar as his subjects were the pictures of the single human figure – alone in a moment of utter immobility." That was in 1947.[13] Eleven years later he added, "I belong to a generation that was preoccupied with the human figure and I studied it. It was with the utmost reluctance that I found that it did not suit my needs. Whoever used it mutilated it. No one could paint the figure as it was and feel that he could produce something that could express the world. . . ."[14] Does "no longer" imply "never again," or "not yet"? (This is a question we need to ask whenever ideas about cultural tendencies gain the status of conventions.) Does "Hello" mean Now, suggesting as it does some form of human presence – or presentness – in the painting. Or does it imply Never, on the grounds that this presence can now be evoked only by a word behind which it remains necessarily concealed, a word, what's more, such as authentic high culture is never supposed to utter. (To propose "Hello" as the utterance of a Rothko would be to court the imputation of vulgarity; to encounter a world of prohibitions, reproofs, and dissuasions.)

Steve Edwards has written as follows about these final works in the series *Index: Now They Are.*

> From the perspective of much contemporary thought about art, both components of this work [the monochrome as end-game art and the reference to *L'Origine du monde*] represent forms of masculine heavy breathing. But what happens when these loaded signs from the history of modern art are brought together? Is it possible to suggest that these works reveal beneath the monochrome the repressed truth of modernism – gender difference/the female body/masculine desire? Again we are left wondering, is the monochrome obliterating gender or is gender breaking through? Are these very different systems of representation or do they represent some continuum?
>
> There is no dialectical synthesis of modernism and realism or of gender politics and modernism on offer here: no third term beyond the bone-headed authenticity claims and second-order knowingness. The point, I suspect, is that these questions are unanswerable because there are no longer secure grounds from which to line up answers. These works offer us a series of unresolved contradictions. . . . the contradictions remain alive and the questions unanswered.[15]

Figures and grounds

Painting being a form of representation, to see some object as a painting is to see it as a means of playing on the relations between the literal

and the metaphorical. What is referred to here is not a play on the metaphorical and the literal on the part of the painting. While a picture or painting might contain a text containing a metaphor, there are no metaphors as such in the pictorial properties of paintings. The point is rather that a painting deserving of the title is something that has an effect within the language-game of the spectator, such that the distribution of functions between the descriptions "literal" and "metaphorical" is rendered interesting and problematic. More specifically, to see an object as a painting is to experience it as playing in this sense on the literal and metaphorical aspects of figure-ground relations. (As here understood, a figure-ground relation is one that involves the seeing of some motif under a certain aspect, by virtue of its being perceived against a certain background, or under certain conditions, or under a specific description.) Under a given set of conditions, a painting will be an object of critical attention (or an object of critical attention will be "a painting") to the extent that it serves to model or to exemplify or to refer to such forms of figure-ground relations as may be significantly at issue. Paintings invite investigation or reflection on the limits of the literal; on the limits, that is to say, of what can be said about them, or of what they can be made to say (a form of limit flagged in Art & Language's paintings by the reduction of what they say to a mindless "Hello"). These limits will not simply be logical or semantic. They will be psychological, social, and so forth. They will be implicated – among other things – in relations of power, which is to say in the contingent distribution of agency. It is often when these limits are encountered – in the case of painting, when what is to be seen may somehow be "not to be seen" in any form recountable in a normal linguistic description – that we are required or stimulated to resort to metaphor.

> It is not clear whether [the] attribution of a "voice" to the work (conceiving of it as if it had the power to speak – a power which it manifestly lacks) is or is not distinct from the (mere) matter of its being thought to have "words." We might say that the having of "words" signifies a power which compensates for apparent discursive passivity or patience, while the having of a "voice" signifies a power which compensates for physical passivity. That is to say, the attribution of words to a painting might determine or follow from the kind of object it is allowed to be within some cultural discourse, while the attribution of a voice might determine or follow from the character and range of its supposed effects as defined in some encounter with a spectator.
>
> These considerations thus bear strongly on the question of what it might be like for the painting in the studio to be "not to be seen." That which is possessed of a voice might also be thought capable of sustaining an intention of its own; capable, as it were of *meaning* not to be seen.

In other words, our sense of the intentional character of the work is substantially inflected by the thought that a voice – or some comparable power – might be assigned to that which is normally acted upon.

. . .

In contrast, the imputation of dialogic or discursive "aura" to a work of art appears somehow to be connected to the phenomenological possibility of there being some thing to be encountered and learned about with the eyes and sense – some thing which is not altogether like any other thing. This is not to reduce the work to some empiricistic status as middle-sized dry goods, but to recognise that there can be no challenge to the limits of the literal, in either the visual or verbal spheres, unless there is *some* sense of what is literal and what is not. (In solipsistic dreamwork, even the literal-minded are dreaming.) We do not deny that a work of art is constituted in and out of transient cultural materials. Yet it is what it is in virtue of certain intransitive mechanisms and determinations which are not exhausted in any account of it. Similarly a work of art conceived as in some way pictorial (as non-textual) will not exhibit meaningful characteristics which are recoverable from verbal descriptions (and so forth) of it, and this for reasons which, far from being transient, are in the underlaboured logic of the pictorial and the textual. (Art & Language, 1994)[16]

It may be noted that the "phenomenological possibility" referred to here – the possibility of something being "encountered and learned about with the eyes and sense" – is established by the *type* of the various conceptual and technical relations involved in picture-making, and not by any such specific motifs as may happen to be pictured in terms of that type. The primary business of painting is with cognitive relations and procedures – with modes of description and comparison and contrast – and with other kinds of relations, such as property relations or social or sexual relations, only insofar as reference to these may be required or may be inescapable in giving cognitive relations a circumstantial pictorial occasion. It may seem to have been an important condition of the vividness of pictures that they do offer circumstantial evidence about social and psychological dispositions and attitudes and norms, and that they can in that sense be realistic. But a far stronger case is made for painting as a realist art – or rather a case is made for a stronger sense of realism in painting – if a specific set of pictorial motifs can be regarded as the contingent mode in which reflexive consciousness is at some given moment constrained to operate to critical effect. The nature of the relevant constraints may indeed still be open to description in sociological or psychoanalytical terms. But the deciding measure of suitability of the motifs themselves will not be that they serve as illustrations to a given historical narrative or psychoanalytical

thesis. Rather, it will be that they allow the conditions of complexity and depth in human experience to be made accessible to discursive consciousness in face of the representations of history, of sociology, of psychoanalysis, or whatever.

To talk of "human experience" is to invite accusations of essentialism, and of trading in fraudulent and self-serving universals. Yet I mean these words, vague and allusive as they may be, for I need some form of reference to the aesthetic – to the "phenomenological possibility" – that is not simply another word for "art." I mean, that's to say, to refer to that which is unamenable to psychology or to sociology, but which nevertheless resonates with psychology and sociology when they are most imaginatively pursued and when their norms of closure are most strenuously tested.

Certainly, it is a condition of the currency and topicality of art that it engages with whatever it is that other forms of representation are persistently engaged with. It is just that "in face of" other kinds of representations that indicates where redolent motifs are to be found. But the clamor of other voices tells the artist nothing – or nothing to the point – about what to do with those motifs once they have been adopted, nor about how to make them the occasions of such technical effects as may be critically significant effects of art in general or of painting in particular. Forms of address to these problems can only be developed and tried out in practice. Among the inescapable requirements of self-criticism in the studio is that the emerging work should be brought to define itself in terms of the specificity of its effects. In other words, the determinations are in the last instance aesthetic – or, we might say, they are at the least not *non*aesthetic.

The conclusion is that figure-ground relations have to be worked for both in light of the conditions of art, and in the face of the representations that furnish the self-imagery of the culture. The achieved forms of these relations are in turn ways of making pictures and paintings work.

The look

Art that is worth bothering with – art that is not corrupting and that is serviceable to the community – will embody some cognitive content that is critical of or seeks to do damage to the determining power of dominant cultural discourses, whether in a small or a large scale. In this sense at least it will (try to) be emancipating. The intuitions that motivate aesthetic production are forms of response to the simplifications and elisions of topical discourses – attempts to achieve emancipation from the "conventions of understanding."[17] R. G. Collingwood claimed that "Art is the community's medicine for the worst disease of the mind, the corruption of consciousness."[18] This is all very well and no doubt open to automatic assent from the well-fed lovers of all things artistic. But its potential truth or triviality will depend on what "consciousness" is taken to be conventional or "corrupted," or

conventional *and* corrupted. On that matter conflict may be inescapable. Much has been written and said about "the look" and "the gaze." In the rewriting of the history of the modern, the subject is supposedly relocated in the eye of the beholder. Where once Olympia stared out in shameless isolation, a complicit client now looks back. A kind of critical consciousness or self-consciousness becomes a condition of competence in the viewing of the painting. The persistence of this rewriting is one (only one) of the conditions on which the picturing of the body presents itself again as the propitious occasion of technical interest and risk. As suggested in the previous essay, there is now no genre so hedged about with prohibitions as the genre of the female nude, none to which entry is protected by so many dissuading angels with fiery swords – and therefore none so irresistible. But who, in such matters, is to decide where the frontiers lie between between criticism and corruption, between propriety and priggishness, between courage and effrontery? Who has the complacency to appoint him- or herself art's pyschiatrist?

If life is to be breathed into a genre it will be as a point of convergence of two sets of questions: those that concern the character of art's point of production and seek to establish the technical and other interests by which that point of production is defined; and those that concern art's conditions of distribution and reception, and that seek to establish the identity and character of its constituency. At any given time, the point on which these questions can be made to converge will be a point of critical moment in the culture.

It could be said, for example, that certain paintings by Rembrandt serve to rehearse the spectator in some ethical and psychological implications of the doctrine of Possessive Individualism. To extend an argument offered in the previous essay, a portrait may serve to picture the child for the father; but the price exacted is more than the payment of a simple fee. The father who, if he did own it, would *properly* own the painting – not just the picture – is someone who has learned to question both the competence of his own seeing and the value that his regard is supposed to confer. He is responsive, that is, to the capacity of painting to describe an object of vision that may be other than the object of his own seeing. Seeing is a mode of representing. Assiduously to see a painting is not simply to see a picture. The consumer who is also to be a competent viewer must become a producer of that look that looks back out at him from the surface of the painting. This is the look that the paint defines, irrespective of his interest. In the case of the conjectural Rembrandt, the father must bring into effect an image of his child's separateness from himself. And what if we change the example and propose that the painting in question is a self-portrait? Why should the viewer not follow the suggestions of the paint in order imaginatively to produce for herself the appearance of Rembrandt?

The person who sees the look that the painting defines sees the same as the person who sees only the picture. But the experience of the former is changed by the exercise of imagination.

The change of aspect. "But surely you would say that the picture is altogether different now!"

But what is different: my impression? My point of view? – Can I say? I *describe* the alteration like a perception; quite as if the object had altered before my eyes.

"Now I am seeing *this*," I might say (pointing to another picture, for example). This has the form of a report of a new perception.

The expression of a change of aspect is the expression of a *new* perception and at the same time of the perception's being unchanged. (Wittgenstein 1953)[19]

On what you may see

In face of Art & Language's later paintings in the series *Index: Now They Are*, you may not know what it is that you are trying to see, though if you are able to trust your intuitions you may register an effect that is a kind of recognition. The image is not readily available. It has to be worked for: discerned in some uncertain fashion through the paint and glass and amid a shifting complex of reflections. To concentrate on the appearance of the painting is to become a viewer both of that which it may somehow contain and describe and of your own partially reflected image, hovering about its surface as a kind of interference.

Where the later paintings differ from the two previous subseries is in the vestigial presence of the painted image as a whole. That which was masked in the earlier works with lettered greetings to named individuals, and partially revealed in those that referred to *The Deep*, now insinuates itself in its entirety into the consciousness of the assiduous spectator, though with more or less success, more or less specificity and detail. The "entirety" of the image is of course never in itself a whole body. However the image is positioned or cropped, the sex of the figure is presented as the central focus of attention. The rest of the pictured image – thighs, belly, perhaps a single breast – serve as it were to situate its genitals. There are no arms, no legs, no head. Under these circumstances it is not easy to decide by what factors recognition may be decided. On what grounds do you believe or disbelieve, or represent or misrepresent to yourself, what you may think – or feel – that you are seeing?

Clement Greenberg notoriously claimed, "Esthetic judgements are given and contained in the immediate experience of art. They coincide with it; they are not arrived at afterwards through reflection or thought. Esthetic judgements are also involuntary. . . . (Whether or not esthetic judgements are honestly reported is another matter.)"[20] The parenthesis is significant. The implication is that we stand involuntarily and – given some informal agreement on the meaning of "immediate" – *incorrigibly* revealed by our taste, and that insofar as we are, we may well be driven by social or other embarrassment to misrepresent the real nature of our likes and dislikes. Greenberg was attempting to

Plate 68 Art & Lan-
guage, *Index XIV: Now
They Are,* 1992. Oil on
canvas on wood with
enamel on glass, 191 ×
163 cm. Mulier Mulier,
Belgium.

defend himself against the imputation that his aesthetic judgments "go
according to a position or 'line.'" No doubt we would all like to think
that we could on occasions be absolutely empirical, or that "art" some-
how instructed or *enabled* us to achieve an absolute and edifying Kant-
ian disinterest. But what if we replaced Greenberg's "esthetic
judgement" with "intuitions of representational content"? How and
why, at what level of "immediacy" or reflexive consciousness, might
such intuitions be confirmed or denied? Though anxiety tended to clus-
ter around such questions with the advent of abstract art, it could be
said that abstract art did no more than draw attention to their perti-
nence in face of all and any pictures.

A possible framework of answers to these questions may be put in
the form of a series of theses.

> (1) The representational content of a painting (i.e., not simply
> what it pictures, but what it is "about") is a *produced* property.
> It is constitutive and definitive of the painting.

(2) This property is not necessarily to be identified with any property that may be predicated of the painting or attributed to it, since it may be that a painting having a certain representational content is not to be "seen" as such in advance of some transformation in the spectator (some self-critical process or other process of edification).

(3) The painting whose representational content is not to be seen (by the spectator) will be described and interpreted (by that spectator) as that which it is not.

Plate 69 Plate 68 showing unglazed image.

(4) To perceive that a description or interpretation of a painting is a description or interpretation of that which it is not is to act under an intuition of that which is not to be seen. (We might call this intuition "aesthetic.")

(5) This intuition implies some convergence between that which is not to be seen (or said of) the painting, and that which is not to be seen in (or said of) the world of the spectator.

(6) It does not follow that the representational content of the painting is strictly *relative* to what may be seen and said in the world of the spectator.

(7) A painting may serve to divide its spectators into (i) those who cannot see its representational content and will not see it and who must therefore describe the painting as that which it is not; (ii) those who cannot see the representational content, but who nevertheless do not describe the painting as that which it is not (and who are thus pretransformational from the point of view of the painting); and (iii) those who can see the representational content and who are thus post-transformational from the point of view of the painting.

(8) The transformation involved is one that the painting specifically requires by virtue of its produced property. The process might be thought of as the coming-to-awareness of an unconscious intention, where intention is conceived of as a historical rather than merely psychological category. (What price immediacy here?)

(9) The possibility of transformation in the spectator may entail the capacity to imagine himself or herself either as pictured or as seeing what is pictured (or otherwise represented), or both.

(10) Imagination of this order has conventionally been conceived of as a kind of empathy. However, we need a way of thinking of the mechanisms involved that does not tend to sentimentalization of the experience at issue, and that is not diverting – as empathy tends to be – from the formal and pictorial instruction of the relevant imaginative activity; that is, from the painting's effect.

(11) Any effect we attribute specifically to a painting will be a function of some playing on the relationship between its representational content and its literal surface.

(12) To talk of painting as an art is to imply that this game is such as in turn to problematize the relations between: (i) that which is normally to be seen and represented according to the culturally available resources of expression in the practical world from which the painting issues, and that which is not; (ii) the painting in question and other paintings; (iii) the spectator and other paintings; and (iv) the world of that which the spectator can see (and describe and interpret) and that which he or she cannot see (and etc.).

(13) To imply that a painting produced at time t^1 can have as one of its produced properties the capacity to challenge resources of expression at time t^2 would be to attribute to paintings the capacity to predict the future. The challenge in question may be conceived of as a constant property *only* to the extent that the need to represent that which is not to be seen is discoverable under different social and historical conditions.

(14) These may also be the limits according to which what has been called aesthetic experience may justifiably be conceived of as a constant.[21]

The kinds of seeing and not-seeing at issue here may be related to what Wittgenstein calls respectively the "seeing of an aspect" and "aspect blindness."

> Seeing an aspect and imagining are subject to the will. There is such an order as "Imagine *this*," and also: "Now see the figure like *this*"; but not: "Now see this leaf green."
> The question now arises: Could there be human beings lacking in the capacity to see something *as something* – and what would that be like? What sort of consequences would it have? – Would this defect be comparable to colour-blindness or to not having absolute pitch? – We will call it "aspect-blindness." . . . (Wittgenstein 1958)[22]

It should be clear, however, that the kind of "aspect-blindness" I have in mind is culturally rather than physiologically produced and determined.

On why you do not see more

It is a sustainable view that Courbet's concentration on the torso of his model effects a pornographic dehumanization of the female, and that

it is thus representative of a discredited interest on the part of the sup-
posedly male viewer. Public expressions of this view are among the un-
avoidable cultural materials out of which – or in the face of which – Art
& Language's paintings are made.

But, while the close-up is indeed part of the genre, pornographic pic-
tures of women tend at some point to show their faces. That they do so
is symptomatic of the weakness of fantasy – its need to establish its lit-
eral register of orifices and postures, and to accord the fixed terms of
its language an instant priority over the act of imagination.[23] Fantasy
feeds on theatrical forms of expression – on the passions supposedly re-
flected in the human face, on the conventional signifiers of pleasure or
pain – receiving these as indicators of complicity on the part of the pic-
tured patient or of effectiveness on the part of the viewer as imagined
agent.

The blatant sexuality of Courbet's figure, on the other hand, is not
evidently a function of the male viewer's fantasy. Rather it presents it-
self as the body's realistic attribute. The painting might be seen as a ren-
dering to the female figure of its imaginative due; an acknowledgment
of its seductiveness, its all-too-human power over the regard of the
male, whether it be the imaginary position of viewer or voyeur that the
composition presupposes. The concentration on the sexual parts signi-
fies exactly that: a level of attention devoted to the body of another. The
fullness and singularity of the painted image renders its subject una-
menable to the exercise of fantasy. It is too devoid of narrative distrac-
tions to satisfy the pornographic gaze – too modern to be conscripted.
To that extent it resonates with – is *like* – an "art study" or "art photo,"
though it is not at all like those kinds of artistic picture that treat the
body as a semi-abstract.

It is a condition of modernity that the conditions of its achievement
will change. The image that reads at one moment as factitious and for-
mal in Courbet's hands is reduced at another to the bathos of photo-
graphic verisimilitude. In the earlier versions of Art & Language's
paintings the represented figure was more discernible, or more of the
figure was discernible. But the evidence of self-critical feedback was
that even the slightest glimpse proves excessive, so long as it serves to
establish a modeled figure detached from a pictorial ground. From the
point when it was adopted, the covering sheet of glass did indeed im-
pose some limit on the plasticity of the figure, and on the range of psy-
chological effects that that plasticity offered to the viewer. But the
various forms of partial occlusion that followed came in the end to
seem insufficient – insufficient in the sense that they still allowed a com-
promising surfeit of psychological events and activities. So long as the
least sense persisted of the figure being detachable from its ground,
viewing was reducible to a form of peeking. The conclusion Michael
and Mel reached was that a constant level of near-opacity should be ap-
plied across the entire figure painted on the canvas beneath.

With hindsight these technical decisions may be seen as responsive
to conditions that now determine figurative representation in general.

I make the following conjecture. For any artistic object now claiming attention both as modern and as a painting of a nude, two closely connected conditions will prevail: the first is that a high degree of redundancy of figurative effects will be encountered at a very low level of suggestion; the second is that the possibility of aesthetic integrity will depend on reference to the body being experienced as a property of the surface as a whole, not simply of its illustrative or referential details. (It was – and remains – a sign of deficiency in the critical interpretation of Degas's notorious suite of nudes that outraged or fascinated response to the pictured women, conceived as the contents of transparent images, tends to overwhelm response to the factitious treatment of the whole visual field – and to what that signifies.)[24]

There are implications for our consideration of figure-ground relations, and for the terms on which it seems these may now have to be addressed as bearing on the present possibility of some critically serviceable and un-co-opted painting. Consider two notional types of ambitious modern art, each of which satisfies the minimum conditions for being both a painting and a representation: that it either sustains some form of spatial illusion or establishes significant reference to the possibility of spatial illusion. The first is a blank painting in which no internal figure-ground relations are discernible: an Olitski spray-painting of 1967, perhaps. The second is a full-blooded figure painting; say, a painting by Lucien Freud of a single male nude. A painting of the first type cannot normally withstand the imputation to it of a figure-ground presence. The consequence of a successful imputation is the effective failure of the painting's ambition, on the grounds that its spatial properties are insignificant. It is all surface and "background" or it is nothing. A painting of the second type cannot normally withstand the imputation to it of spatial properties independent of figure-ground relations. The price of a successful imputation is the effective failure of its figuration. It is a mimetically sufficient picture or it is nothing.

Hindsight suggests that the need to guard against one type of failure or the other may have been a substantial requirement of ambitious painting since at least the time of Manet. It may be that what is now at issue is the possibility of somehow bringing the two modes into combination or collision: that the ambition for radical spatial integrity that is thematized in the blank painting should be required to admit the psychological or sociological resonances of figure-ground relations; and that those pretensions to realism and to representativeness that are associated with the pictorial properties of painting should be required to confront the possibility of their utter redundancy. This, at least, is what Art & Language's near-blank paintings seem to propose, aggressive as they are toward refined celebrations of near-blank painting on the one hand, and to conservative eulogizing of full-blooded figuration on the other – this despite, or perhaps because of, the fact that they draw from the same wells as both. They leave little grounds for reassurance even to those who can both see what they are and remember what they remember (among whom I suppose I should count myself).

If it is true that the possibility of such a combination is a condition of the possibility of a nontrivial essay in the continuation of painting, it must also be true that the terms of achieving that combination or collision will have to be continually redefined. What is clear is that there is no means willfully or ingeniously to liberate the practice of painting either, on the one hand, from the necessary shadow of the blank painting, or, on the other, from the technical and cultural conditions to which that necessity itself serves as testimony. If the project of painting is to be continued it will inevitably confront the prospect both of collapse into the merely aesthetic, and of reduction to the merely instrumental (not to mention such attendant and now familiar possibilities as the instrumentalization of the merely aesthetic and the aestheticization of the merely instrumental). These conditions seem now to be conditions of the possibility of realism in painting.

Of course there are forms of practice of the art of painting on which these conditions were never felt to bear in the first place. This is virtually the same as saying that there are forms of painting that have not significantly been touched by the experience of Conceptual Art. But like topographical landscape painting in the nineteenth century, or like twentieth-century still-life painting uninflected by the experience of Cubism, they are of first-order consideration only as useful repositories of conservative technical skills, as historical documents, or as records of appearances. For all the frisson of assiduousness and authenticity with which journalism may seek to dignify the pictures of a Lucien Freud or an Eric Fischl, such pictures do not lead technically dangerous lives. They tend to fascinate those who are fascinated by what they *picture*, as a consequence, perhaps, of fascination with the worlds that the depicted figures are supposed to occupy. Such pictures can therefore achieve no substantial presence on those levels of aesthetic production at which significant cognitive issues can be made to intersect with significant ideological formations.

It should be made clear that the question of whether it was or was not feasible to "return" to painting after Conceptual Art is not a question of critical significance in the estimation of painting as a contemporary art. The question invited by the painted work of Art & Language is of another order. What is at stake is whether or not the tradition and medium of painting can now be put to relevant use; whether it can serve a development in the dialogical practice initiated by Conceptual Art – or by some Conceptual artists.

Polyptychs

A certain state of dissatisfaction may come to generate a project of painting. A given project of painting may come to generate dissatisfaction. The need for consolidation gives way to the need not to consolidate. The paintings in the series *Index: Now They Are* have their origins in exhaustion or impatience with the genre of landscape, with

reference to which Michael and Mel worked through three years and some eighty paintings.[25] In a manner familiar to the practice of Art & Language, the project of picturing the nude proved to be the single recoverable element of a more comprehensive proposal: a plan for a kind of inclusive Index – the monstrous compendium described (as abandoned) at the outset of the previous essay. Recourse to various landscape motifs had in turn been motivated by a need for relief from the architectural and ideological confines of the museum, which had been the ironic frame of reference for Art & Language's *Incidents in a Museum* – a series of some twenty-six paintings occupying the years from 1985–1987. And before the museums, separated by a long hiatus of near-blank paintings, or of blank paintings unachieved, there had been the genre of the Artist's Studio. The three works that compose the series *Incidents: Now They Are* signal a certain restlessness in face of the genre of the nude – or a certain insouciance in face of its persistence as a preoccupation.

It was not clear at the time what other practical destination might be open. Art & Language's procession through the genres had been more conjectural than systematic, and it had been conducted as it were at a distance – as a kind of allegory. Almost wholly obscured in the components of the second and third of the *Incidents: Now They Are* are painted ciphers of caves and trees, the former derived from a drawing by Courbet connected by Werner Hofmann and Michael Fried to *L'Origine du monde*,[26] the latter from Art & Language's landscape *Hostages*. In one sense these function as casual references back to landscape as an alternative genre. In light of the intervening phase of work, however, the possibility of any strong naturalistic reference being retained by such motifs is virtually submerged under their all-too-public aspect as symbols – or clichés – of sexual identity and difference.

> The question was, how far could we stretch our particular contribution to or development of the genre? What was the relationship between nude and "body"; how oblique could we be with the absolute margins of what is politely known as "the erotic"? The challenge was something like: "If Michael Fried can make all these caves into cunts, can we make non-cunts (or cunts) into cunt-ish things – even more unprobably?" (Baldwin and Ramsden 2000)[27]

The three works in question may be described as forms of polyptych, being composed of separate painted panels each of which contributes to one overall theme. The expectation of a polyptych, however, is that all its parts should be wholly visible to a stationary spectator, albeit not necessarily all at once. In the works in question the various paintings are assembled to compose boxlike structures, organized so that some of their painted surfaces face inward. Though all these surfaces can be viewed, they cannot all be viewed from the same position. The interior

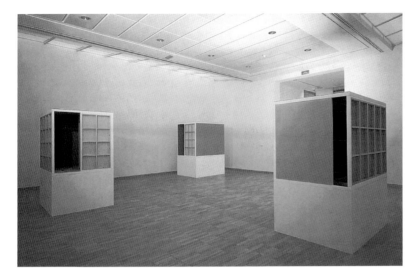

Plate 70 Art & Language (from left to right), *Incident: Now They Are, Elegant; Incident: Now They Are, Next; Incident: Now They Are, Look Out*, 1993. Oil on canvas mounted on wood, with enamel on glass and mixed media, each 7 panels; overall dimensions 139.2 × 130 × 152.7 cm; 147.1 × 137 × 171.7 cm; 133 × 122.8 × 182.6 cm. Installation at Galerie Nationale de Jeu de Paume, Paris, 1993.

of the structures resembles the scenario of Art & Language's earlier paintings in the series *Incidents in a Museum*.

In the first of these works to be completed, there are seven components: top, bottom, and two sides, all of equal dimensions; two smaller ends and one internal panel, the same height but narrower, that forms a partial division of the interior space. Each of these elements is made as all Art & Language's paintings and paintinglike things were made at the time. A plywood surface is braced at the back with a framework of wooden battens; canvas is stretched over the plywood and painted; last, a surface of glass, painted on its inside face, is placed over the canvas and secured with screws. The seven completed panels are bolted together to make the polyptych. With the exception of the canvas the structure rests on, each panel is potentially visible on both of its opposed faces: the one covered with glass, the other revealing a structure of plywood and battens.

At moments of hiatus, under conditions in which the blank painting presents itself as a form of necessary destination – a fulfillment either of the Mallarméan idea of "the Universe arrived at by sensation alone,"[28] or of its dialectical partner, the Universe arrived at by calculation alone – the only secure object of vision may seem to be the thing one has produced, and which, in producing, one has alienated from oneself. The first polyptych was made not as an escape from the terminal condition of the blank painting into the "beyond" of "three-dimensional work," but as a thing to be pictured and then, perhaps, broken up. To this end it was designed to offer a complex amalgam of surfaces and spaces, illusions and reflections, suggestive of the modern museum in its architectural aspect, distantly redolent of the nude in its individual painted surfaces. As a complex kind of still-life object in the studio it would perhaps also offer a motif – a means of access to a genre then as yet untried in the practice of Art & Language.

But the completed structure defeated representation. It survives as a testimony to the occasional benefits of miscalculation. Once assembled, it was *already* a painting of a kind. For all that the polyptych has a powerful architectural aspect, pictorial effects are insistent at every point. These effects are both near to blankness and highly atmospheric. The surfaces appear both literally slablike and charged with illusion and reflection. The inescapable expectation of illusion imposes a pictorial function even on the otherwise purely factive aspects of the structure: the wooden grids that began their lives as the hidden armatures on which paintings were to be supported. On the other hand the architectural aspect of the structure imposes the literal identity of walls on painted surfaces that are instinct with figurative allusions and inversions, however difficult these may be to particularize. In our attempts at description, we find the literal invested with metaphorical resonance, the metaphorical made to take its place in a world of things. The effect of the polyptych is of a complex and atmospheric ground folded in on itself and in the process somehow possessed of the integrity and autonomy of a figure: a thing composing itself on the margins of a void.

Because these works are on the one hand so hard to categorize and on the other so manifestly structures of a sort, because their totalities are difficult to describe but their components easily distinguishable, you may find yourself striving in imagination to reassemble a given polyptych into a more congenial, more readily viewable form; to conceive, for example, how it might be recomposed into an arrangement of seven contiguous surfaces hanging on a wall, and how it might thereby be restored to a kind of cultural and ontological normality. You may wish to know, in effect, how that which is itself an awkward figure might be rearranged so as to appear all negotiable ground; how in the process the decorum of your conceptual world might be reestablished, so that the accustomed referents of the literal and the metaphorical were restored to a stable opposition.

But you would pay a price for this search for propriety – this unwillingness to allow the *present* form of the work to be the form of a painting. It would require that you conceive of the actual structure as a form of disorder of the work: as something dismantled in being thus assembled, as art in disarray, or in dishabille, an image unprepared to be seen, before which you would find yourself cast in the role of voyeur.

> The voyeur of the concealed sexual image is presented with the difficulty that it is also the literal structure itself which is not to be seen. An indexical property is also present. One is at pains to discover its intentionality. Is it merely a contingency that the interior of this *dismantled* polyptych structure resembles the coffered ceilings of the Whitney Museum as depicted in our earlier series of paintings *Index: Incident in a Museum*? Instead of depicting paintings hanging in a museum have we made mu-

seums out of paintings? Is this container-as-disorder also a representation of a much large container which is one of the places which has supplanted the studio as the site of production of art? Of the images on the canvas surfaces of these works, one is of *L'Origine du monde*, the other an innocent row of poplar trees. The Politics of Appearance would deprive the latter of its innocence. Are they interchangeable in the space between the work and its viewer? (Art & Language 1994)[29]

In fact there is no secret world for the viewer to glimpse. Art can only be made of materials that are already part of the critical consciousness of the culture as a whole – if not of its negotiable self-image. What is to be seen and faced is that which has made you what you are. The work indicates no remedy for lack of self-knowledge in this respect. The remedy is the work itself.

IV
WHO'S LOOKING?

Painting and the Death of the Spectator

Illusion as social exchange

The question of whether anyone should persist with painting as an art hangs over this book, as of many others concerned with the practical and theoretical circumstances of art in general at the end of the twentieth century and the outset of the twenty-first. I propose that two initial conditions must be satisfied if the question is to receive an affirmative answer. The first is that there should be critical and practical reasons to persist with the making of *pictures*. The second is that there should be some actual or potential constituency for which pictures can still perform an edifying function. The first condition is intended to set aside arguments for the continuation of painting as an end-game art, caught in the toils of "art as the definition of art" and in the possibly endless pursuit of the "ultimate" blank painting. The second condition is intended to set aside arguments for the continuation of painting as mere craft or mere decoration, or as amateur entertainment, not because these may not be thoroughly sociable uses of painting, but because they tend all to fall short of what we might mean by speaking of the continuation of a substantial tradition.

One strong reason for associating painting with the making of pictures is precisely that it brings to the fore the question of how paintings may be edifying: how, that is to say, they may be seen as the occasion for some critical and self-critical exchange between work and spectator, and how they might thus at least in principle satisfy the second of my initial conditions. The kinds of picture I have in mind are those that involve some form of illusion. It might be said that there can be no picturing without illusion. But to talk of an artistic tradition of painting – even where it is the idea of the literal and literally blank painting that is at issue – is inescapably to call to mind a specialized kind of illusion and its attendant mode of cognitive behavior, which may be thought of as *imaginative perception*.[1]

In order to proceed it is not necessary to enter too far into the psychology of perception, nor do I wish to become caught in the embrace of expensive connoisseurship. Accordingly, I resort to a relatively crude if robust example. A circle drawn on a sheet of paper might signify many things, including the commencement of a piece of writing with the letter "o." Insofar as it might be the latter, the drawn circle does little to affect our sense of the flatness of the sheet of paper itself. Matters become more complex and more interesting, however, if I shade one side of the circle. The figure is now harder to read simply as a letter or as some other unequivocally standard form. It appears also as a sphere, lit by some source of light. There will some circumstances in which we will say that it appears *instead* as a sphere – or possibly as a hemispherical indentation. Its potential aspect as a letter form will be abandoned. Light being the medium of vision, the shading of the circle effects a shift to a different mode of attention – one in which the tendencies of reading give way to those of seeing or, at least, to that complex form of reading which is a way of seeing.

But the *crucial* evidence of this divergence is that the change from circle to sphere entails a different expectation of the surface on which the figure is drawn. I could not have transformed my circle into a sphere unless it were possible in imagination simultaneously to transform the sheet of paper that is its ground. The person who now sees the circle as a sphere must also be imagining the flat surface of paper as a spatial volume sufficient to contain it. (The person seeing a hemispherical indentation will be seeing the sheet as having a possible extension behind that surface, and thus also as no longer flat.) To cover a sheet of paper with writing is to make a virtue of its flatness, but to draw on a sheet of paper is to see that sheet as an imaginary world (or as a slab capable of sustaining a relief).

Of course when you see a sphere, you still *know* that what you are looking at is a sheet of paper and that it is flat. But you are playing the game, seeing an aspect of the drawing that allows it to create an illusion. Once that agreement is established in principle, the pictorial field opens up to the possibility of imaginative complication and to the consequent extension of its area of reference. Within the Western tradition of picturing, the possibility of this agreement is conceptually prior to the establishment of likeness. It is, in other words, the basic condition of pictorial representation. I suggest that it is also the moment about which the *social* value of painting must turn, whatever connotations may subsequently be attached to specific figurative themes. Before it is a warhorse, a nude woman, or some kind of anecdote, etc., the surface of a picture – and a fortiori of a painting – is the moment for a relationship of collaboration and exchange. Its respective coordinates are the position of the artist who has made the picture and the position of the spectator prepared to undertake some relevant imaginative work. The competence of either party will be something developed in the exchange. That is to say, a significant element of what competence *is* regarding either party to the exchange will be something that is *found* in that exchange.

The important point here is that the kind of competence significantly at issue is not a mere matter of recognizing correspondences between pictured images and things in the world. In suggesting that painting conceived as a social activity may require the creation of illusion, I do not mean to argue against the possibility of social value in abstract art. On the contrary. If the abstract painting of the late 1940s and early 1950s (Pollock's, Rothko's, Newman's) did not initiate awareness that the "world-making" functions of painting are prior to or independent of depicting functions, they certainly served to bring the point home, and to establish its relevance to all and any previous work in the same medium.[2] What I wish to establish is that, *whether or not* paintings are required to be pictures, both painting and picturing depend on the possibility that the flat surfaces on which they are inscribed can be seen as containing spatial depth. My further contention is that the form of "seeing" involved in responding to illusion-bearing surfaces is a socially significant activity; an activity, that is to say, that involves cooperation, exchange, self-criticism, and learning, and that goes to compose a culture of ideological resistance.[3]

In itself, this may not be a controversial thesis. The matter about which substantial controversy *has* turned is whether or not painting had or has a future independent of pictures: a future beyond the blank canvas; that is to say past the point when the "pure" dialectic between literal flatness and imagined depth was *all* the historically awake painter had to offer. We need to distinguish, then, between two distinct theses that tend to be conflated in argument. The first is a psychological thesis about how it is that *pictures* work, and about the value that might be attached to pictorial forms of representation. The second is an art-historical thesis about the development of *painting*, which sees that development as possibly terminated. The relationship between these two theses has normally been explored in terms of the practical development of painting as an art, with implications drawn from the analysis of that development. My aim is to consider the relationship from a different perspective, by taking as a starting point the pictorial functions that paintings may uniquely fulfill for their spectators, and by asking just how critically redundant or replaceable those functions may actually be.

It is certainly true that my claim concerning the value of pictorial illusion would have been more readily accepted in the nineteenth century than it is likely to be in the twenty-first. Given that the critical impetus of Modernism was widely associated with skepticism in the face of illusion, it might seem that the taint of conservatism must cling to any theory of painting that restores illusion to a central position in the social life of the art. The title of this essay is intended in part to indicate the direction from which accusations of conservatism are most likely to come. My hypothesis regarding the nature of painting as a social activity assumes that the illusion-bearing surface is the means to initiate inquiry and hence learning on the part of the spectator. It follows that we must be able to conceive of some representative spectator as a live

and active presence in front of the work. The demise of the engaged and active spectator would suggest that painting had become a socially impotent or redundant pursuit, whether or not painters were able practically to animate the surfaces of their works. Once given the loss of a responding – that is to say social and talkative – faculty, painting could be continued only commercially, sentimentally, or as idealism.

Various deaths were indeed proposed or implied for the spectator during the later twentieth century. I mean to consider how far these proposals bear on the value of painting and the status of illusion. The first death was a form of atrophy, or dying off. The second was a form of suppression or killing off. There is also an imaginary death, which has a longer history. I shall leave this last to the conclusion of the argument.

Atrophy

The first form of the death of the spectator did not precede the demise of painting, but rather assumed that that demise had already been effected, or set in train. The original proclamation of the demise of painting was reputedly made by the French academician Paul Delaroche before the mid-nineteenth century and was occasioned by the invention of photography. This proclamation was at least a century premature. It is a truism, however, that as the camera automated the task of compiling likenesses, painting's traditional descriptive or iconic functions were rendered relatively expensive and time-consuming, and thus potentially redundant. In light of this truism, the ensuing development of painting as a modernist practice might be viewed as a long trajectory in pursuit of another medium rather than another role, a medium in which expression or allegorization or nomination or critical theorization might occupy the position of priority previously accorded to description. Points on this trajectory are marked with familiar names: Marcel Duchamp, Joseph Beuys, Robert Morris, Bruce Nauman, Marcel Broodthaers, and many others. According to this perspective, the more recent death of painting, which is datable to the 1960s, might be seen as marking the destination of that trajectory: painting's final mutation into "specific objects," or "three-dimensional work," or performance, or installation, or literature, or philosophy, or social anthropology, or politics of representation, or cultural studies, or a vapid simulation of rock-'n-roll lifestyle.

Wherever such forms of mutation have actually been effected they have been immediately preceded by a characteristic transitional stage, the normal features of which are of some relevance. These are two. The first is a tendency for the literalism of painting's support to be stressed, to the point, in the end, where painting is reduced to no more than its support, issuing an invitation to literal-minded *enfants terribles* to *illustrate* this far-from-radical possibility. The illusion-bearing surface gives way to "specific objects" or their cognates. The second is a ten-

dency for the typically plastic effects of brushwork to give way to graphic or photographic forms of words and numerals, so that the illusion-bearing surface is rendered once again literally flat. In face of the supposed redundancy of the visual thrill, that surface is reclaimed by writing. In each case, the final elimination of spatial illusion is presented not as an unavoidable necessity but as an avant-garde opportunity.

If this evolutionary account is accepted, the decline of the spectator is indeed likely to be seen as consequent on the decline of painting itself. For lack of demand on her traditional energies, the once-engaged but now displaced spectator loses the will or the ability to function. What follows is atrophy of the relevant cognitive modalities. The spectator dies to be reborn in the audience at a piece of theater, or as an anxious consumer boning up in the art-gallery bookshop on the most recent conjecture as to Where We Are Now.

If talk of atrophy implies a loss of imaginative possibilities, however, it does not follow that the remedy must lie in some return to anti-modern or pre-modern forms of painting. I do not mean that my claim for the centrality of illusion should serve as an appeal either to the conservative authority in matters of taste that Modernism is supposed to have overthrown, or to that politicized sentimentality that recognizes no such defeat. I go so far with the foregoing account as to agree on the one hand that an uncritical use of photographic-dependent illusion is often a sign of Panglossian indolence in painting, and on the other that nothing very interesting is to be found by exploring nonillusionistic forms as means to continue the tradition of painting. The idea of a literalist painting is a kind of distraction born of the tendency to take the Modernist disparagement of iconic depiction for a prohibition on illusion.

As I conceive of painting, to talk of a painting as altogether nonillusionistic is to utter a contradiction in terms. (Given the crisis-making status accorded by de Duve and others to Frank Stella's relatively literal paintings of 1958–1959, it may be significant that, on his own account, the artist "gave up the struggle" when he noticed that he could not *avoid* illusion of some kind; this is to say, presumably, that giving up trying to avoid illusion was a condition of being able to continue making paintinglike things.)[4] The two-dimensional image-bearing surface is a convention of such persistence as to be virtually identifiable – like language – with human interest in and need for representation. Anything that comes up for the count as a painting will involve such a convention. What we generally mean in talking of "painting *x*" is this two-dimensional aspect of some object or world conceived as three-dimensional. The two-dimensional surface in question is of course configured by and in a material tradition – a social practice. But it seems unnecessary to worry about whether anything that is *not* looked at in this way would need to be called a painting. Though there may be nonillusionistic forms of art that are the occasions of some significant critical activity, the means by which that activity is generated do not correspond to the means by which social activity is generated through painting. For example, while Daniel Buren's work might be said to have

Plate 71 Daniel Dezeuze, *Chassis plastique tenue*, 1967. Wood, 190 × 150 cm. approx. Collections Mnam-Cci-Centre Georges Pompidou.

Plate 72 Edward Ruscha, *Oof*, 1962 (reworked 1963). Oil on canvas, 181.5 × 170.2 cm. Museum of Modern Art, New York.

a certain critical and analytical power as regards the social conditions of spectatorship, the designation of that work as painting is more plausibly understood as a provocative and opportunistic strategy than as a practical requirement. If it is not looked at as an illusion of some kind, a work by Daniel Buren is not a stripey surface but – undamagingly – a stripey thing.

What is at issue in this essay is not whether the label "painting" can justifiably be stretched so as to cover a range of recent and current artistic practices in which the establishment of pictorial illusion plays no part, but rather whether an art grounded in pictorial illusion can still be conceived and pursued to some emancipatory critical end. Contrary to the evolutionary account, I mean to argue that painterly illusion comes in different guises, some of which may still be exploitable in the critical development of painting, however pertinent a Modernist skepticism may have been with respect to others.

Killing off

The second form of death is one that assumes a different account of the apparent decline in painting's status. What sustains this second view is the recognition that illusionistic properties are not necessarily identified with or exhausted by iconic techniques and functions. It follows that the potential of these illusionistic properties was not necessarily reduced by the rise of photography or by the subsequent development of other photographic media. The real relevance of photography to modern painting is twofold: on the one hand it furnishes a range of figurative techniques and materials to draw on in the decoration of surfaces with critically distinct effects; on the other it offers a negative model of how those techniques and materials may be employed. I think, for instance, of the work of Warhol on the one hand, and of Photo-Realist painting on the other.

Among the representative works of the Conceptual Art movement, some certainly appear to have been informed by this alternative understanding of painting and of its history. The particular examples I have in mind are surfaces covered with writing that were exhibited in the late 1960s and early 1970s, by Terry Atkinson and Michael Baldwin, by Ian Burn, Mel Ramsden, John Baldessari, Sigmar Polke, and others. Among the factors motivating their production we should certainly count the apparent crisis associated with the advent or prospect of the blank painting. But unlike the contemporary enterprises of other Conceptual artists – Lawrence Weiner, Robert Barry – who were "going beyond" a medium seen as redundant, the works in question were distinguished by their picturelike formats. They appeared, in other words, not as prospective inheritors but rather as *usurpers* of the place of painting, as if to challenge the power of painterly illusion to reclaim its traditional territory and to render their writing redundant. What

these works did, in other words, was to draw attention to a significant absence of critical power and authority. As suggested in the first essay in the present volume, it was not simply authentic pictorial content that was absent from these works. Rather, by invoking the predicates of a bankrupt critical discourse, or by importing suggestive material from more robust resources of theory, they pointed explicitly to a dearth in those forms of *social exchange* from which the value of any painterly content must ultimately be derived. The implication was that if claims to such value could no longer be adequately grounded, then the spectator who made a claim on behalf of his own response was nothing but a hollow man – and might as well be dead.

This, then, gives us our second sense of the death of the spectator: a kind of putting-to-death of a spectator deemed unworthy to fulfill his part of that social transaction on which a painting satisfying the conditions decribed above must depend – a spectator grown culturally sophisticated, and in this regard complacent and idle, who could not or would not do his share of the required interpretative work within the possible world created. In conservative quarters, Conceptual Art was often criticized in the 1970s and 1980s as the outcome of an avant-gardist underestimation of the historical achievements and continuing humanistic potential of painting. (That the criticism was less often voiced in the 1990s seems to have been more a consequence of general loss of interest in the idea of historical achievement and humanistic potential than of any real improvement in the understanding of Conceptual Art. Now, as suggested in the second of these essays, *all* not-painting and not-sculpture is "Conceptual Art." As the current art of spectacle, it is of course the very antithesis of what Conceptual Art stood for in the 1960s and early 1970s.)

In fact the kind of painting most commonly associated with claims for historical authenticity and humanistic potential – Francis Bacon's? Lucien Freud's? – was not even of much interest to Modernists. For obvious reasons, the painting that Conceptual artists tended to concern themselves with was the painting that attracted significant attention within Modernist criticism, and the game generally was to reverse the relevant apportioning of approval or disapproval. As it appears now, the significant enterprise of the Conceptual Art movement was certainly not to disparage painting as a material tradition. It was rather to draw attention to the hollowness of the claims then typically being made for painting and its attendant culture – a hollowness that was a condition leading to practical impoverishment in all the arts. In other words, though the threat of writing was used to suppress the securely acculturated – that is to say idle and incompetent – spectator,[5] the intended outcome was not a mutation of spectator into reader or philosopher or whatever, but rather the reemergence of a fully active and openly *inquisitive* spectator – one emancipated by doubt and insecurity, who could be considered as a contributor to some sort of conversation-like activity.

This second proposal of the death of the spectator had distinct advantages over the first. It was not consequent on failure to realize that it is a form of illusion distinct from pictorial description that identifies painting with critically significant social activity. And in its response to the increasing anti-intellectualism of Modernist culture, it was at least free of the taint of opportunism clinging to some of those who presented themselves at the time as artist-intellectuals. This is to say it left painting's would-be successors exposed to the same kind of critical analysis as painting itself, and implicated in its findings. The analysis in question was one that diagnosed a larger deficiency or illiteracy – not altogether incommensurable with the deficiency Fried was pointing to in remarking on the dangers of "theatricalization."[6] To the extent that those attempting to go "beyond" painting depended for their plausibility and their efflorescence on a fascinated audience of professional art lovers – the hollow men of modernism – their enterprises were unlikely to provide the grounds of any very different kind of social exchange.

Of course, it could not be said of Conceptual Art's suppression of the confidently accultured spectator that it served in itself to justify a revival of painting. It remains to be seen whether illusionistic techniques and critical demands can still be reconciled under the conditions of the present. It would certainly be otiose to defend the continuing practice of painting as a modern art – rather than a mere coming-back – if it could be shown that cultural or social conservatism was a necessary condition of its survival. If it is to count as modern, in other words, the form of art in question must be neither technically nor socially reactionary; neither regressive with respect to practical developments in art, nor exclusive in class and cultural terms as regards the interests and activities it may be used to further on the part of its notional spectators. If an illusionistic art cannot meet these requirements, then I think it would be better to stop talking of painting altogether.

The limits of the paintable

Of course, I have not plucked these issues out of the thin air of art-historical debate. The evidence of current artistic practice is that the Conceptual Art movement of the late 1960s and early 1970s left an awkward legacy of questions about the extent to which concepts of art depend on the traditional technical categories of painting and sculpture. There can be no critically self-conscious artistic work now that does not in some manner acknowledge the problematic nature of this legacy. The painted surface is no longer in so secure a possession of itself that it can shrug off the incursions of language; nor can it sustain a plausible life apart from other material surfaces.

Given that the origins of Art & Language lie in the Conceptual Art movement, those of us who are associated with the name would certainly be prevented from *presupposing* the continuing currency of painting. Rather, it seems that the practice of painting has continually

to be tested and put at risk, to the point that this process of hazard seems at times to be just what the idea of painting now entrains. To be more specific, the question of the status and priority of illusionistic techniques has preoccupied Art & Language since the late 1970s, to the point of crisis on at least three separate occasions. A review of these various crises will serve to recapitulate some relevant issues treated at more length in *Essays on Art & Language* and in earlier essays of the present volume.

The first crisis followed the series of paintings on the theme of the *Artists' Studio* made in 1982–1983. (The circumstances and consequences are recounted in more detail in *Essays*, chap. 7: "On the Surface of Painting.") In the wake of that project, and of the "Painting by Mouth" technique that had accompanied it, Michael and Mel were looking for some other means of crippling or impairment by which the ordinary expectations of picturing and painting might be confused, so that a kind of painting might be entertained that was *other* than a mere fulfillment of those expectations. At that point they undertook a group of works in which resonant figurative content was gradually obscured beneath an accumulating surface of white touches. In the argot of the studio this technique was described as "snowing." It was connected to the idea of something *happening* to a painting, and to the conjecture that that something might be depicted; to the possibility of making something that could be seen to have had a kind of paintinglike life, and that might then be *used* as a painting – that might even provide something to be looked at in virtue of what had happened to it.

The idea was born of a chance encounter with Lucas van Valckenborch's *Winter Landscape* in the Kunsthistorisches Museum in Vienna in 1983. This is a work painted in 1586 as one of a set of the four seasons. The picture is a snow scene, showing a village in an extensive landscape, with peasants about their business. "Across the surface of the canvas, scarcely diminishing in scale from bottom to top, touches of white paint represent falling snow. It is not a small painting and these are not mere feathery indications, but palpable dabs from a loaded brush."[7] This is a scene that was painted to be snowed on.

> The Valckenborch was of interest because it seemed to go
> a bit far; to be threatened by itself. This connected to the
> thought that [Pollock's painting] *The Deep* was a paint
> ing which was being effaced – and then salvaged by a
> sleazy exercise of taste, and thereby pushed to accept
> predications it could not bear . . . but which nothing else
> should have to accept either. (Baldwin 2000)[8]

History suggests that the range of possibilities for significance in illusionistic painting is defined by the notional extremes of a detailed and readable figurative scenario on the one hand and an all-over blank surface on the other – between the painting that is all iconic detail and the painting that is all expressive atmosphere. In van Valckenborch's

Plate 73 Art & Language, *Study for Impressionism Returning Sometime in the Future,* 1984. Crayon and acrylic paint on paper, 88 × 64 cm. Private collection, Luxembourg.

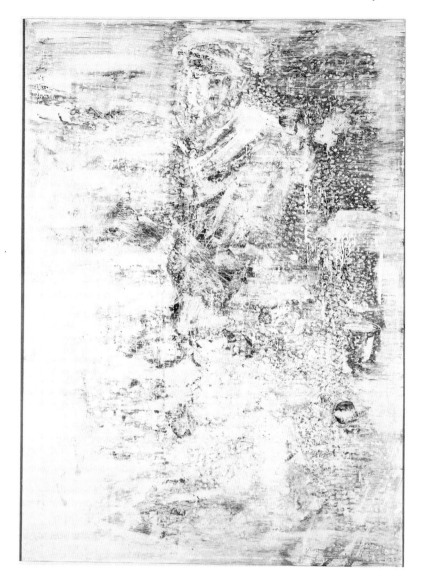

time – the late sixteenth century – there was convergence between the self-conscious decorum of mannerist figuration and the predictable interests of the spectator. This convergence ensured that a culturally acceptable balance would in the end be struck. But for Art & Language it gradually transpired over the course of a year's work that there was no longer any defensible position at which to halt the slide from the one extreme to the other – that's to say no point at which to halt the process of cancellation of figuration and accumulation of surface that did not involve the arbitrary exercise of taste. On the other hand if the surface were completed in intellectual terms – according to plan, as it were – then Michael and Mel could not bear to look at it.

It followed that whatever value the spectator might derive from such works, that value was likely to be only accidentally connected to what the work was made of – or connected to something in which the artists could take no part. These are conditions for failure of art as a social activity. The "snowing" episode might be seen as a practical exposure to a theoretical dilemma well analyzed by Thierry de Duve. If any blank surface can be "a painting," and if a high degree of arbitrariness attends on one's preference for one blank painting over another – or, by implication, for one stage rather than another in the painting of a blank painting – how can painting any longer claim to be the occasion for significant acts of critical discrimination?[9] In fact, the snowing was an attempt to transcend this dilemma. Was there a point of *significant* blankness such that the narrative of how the painting thus came to be would provide reasons to regard a particular distinction as arbitrary? If the answer to that question was a tentative yes, however, it seemed that the practical form of its demonstration was not an object that could be allowed to leave the studio intact. (If that seems an overdramatic conclusion, I can only testify that my own attempts to copy the experiment some years later produced a literally *unbearable* confusion – and a picture I am unwilling either to look at or to dispose of. For a project that combines practical experience in aesthetics with mental torture, this is what you do: make a large strong picture, devoting as much care to it as you can; then take some white paint and a small brush and gradually efface it, dab by dab. The rules are these: you must not allow your taste to intervene, which is to say you must not stop at any point simply because you like the effects – for instance because you have produced something that looks like an interesting cross between Pointillism and Cubism; but you must not simply proceed unthinkingly until you have "completed" the exercise and are faced with an all-white surface. Where do you stop, and on what grounds? Do not try this at home.)

The second crisis occurred at the close of Art & Language's long series of *Incidents in a Museum*, a series embarked on as a way of abandoning the "snowing" project. The aim was to figure an ironic form of evasion or supersession of the determining institutions of the present, for which the image of the modern museum had been used as a compositional token. Michael and Mel employed various devices in order to represent the endemic anxieties of the present as an artistic *claim* on the future. But in each case they were bound to give these anxieties an imaginable physical or temporal context, and this required them either to assume the museum's continuing power and presence, in order to provide a comprehensible figurative framework, or to resort to words and numerals, or both. In the end, insofar as the illusion-bearing surface survived at all, it maintained a kind of fugitive existence, obscured behind surfaces of text, or obscured in them, or immured within more manifestly material containers on which the promise of pictorial depth was ironically inscribed. (These works are described in more detail in "Hostages to the future" in essay 4 of the present volume.)

The third crisis occurred at the end of 1994, when Michael and Mel decided to junk an entire phase of painted work. The project in question followed the long series of paintings in which sheets of glass had been used both for their reflective properties and as means to emphasize the literal aspects of the painted surface. The aim was to escape technical dependence on the surface of glass and to achieve a similar complexity of effect by means of oil on canvas alone. The spectator was to be engaged in distinguishing different figurative and ontological levels, but that engagement was to be achieved by means of pictorial illusion alone, without recourse to collage or relief, which is to say with no literal differences in materials or in planar depths. The intention, in other words, was to produce – which is to say also to *re*produce – a form of painting that was "classical" in its approach to the medium and yet "modern" in the demands it made of the spectator – if such a thing were possible.

In the picture of a notional studio the deepest rectangular plane represents the back wall, the next deepest a painted canvas depicting a museum interior, the next the face of a steel box placed on the studio floor, and the next a transparent sheet of glass. But the sheet of glass is represented as fixed on and within the literal plane of the canvas, which must therefore be conceived as an intervening figurative plane. The notional surface of the sheet of glass is circumstantially affirmed by patches and spots of paint. These appear to cast a slight shadow and are thus accorded the figurative property of literal marks. But there are also patches of apparently literal paint beneath the presumed surface of glass. These cast no shadow and must therefore somehow be located as components of the figurative interior.

One hectic preliminary small work on canvas and two works on paper survive from the original phase of this project. In none of the ensuing fifteen paintings could the odd vitality of the small work be recaptured, though in the works on paper the presentation of a distinct perceptual puzzle achieves a certain graphic plausibility.

> Indeed, the conclusion we came to (and it seems inescapable now) was that these works are *only* feasible on paper. Why? It must be something to do with their not possessing any vestigial or marginal three-dimensionality. The edges at 90° do not have to be overcome, as it were. (Baldwin and Ramsden 2000)[10]

The reason for abandoning this project was not that the works themselves were too difficult either to make or to make out. On the contrary. It was rather that Michael and Mel did not wish to misrepresent the real difficulty of reconciling illusionistic techniques with the philosophical demands and expectations of the present. We know only too well that no form of representation of those demands and expectations can be adequate if it entails reducing the spectator's activity to the level of puzzle-solving – which in the case in question meant the working-

Plate 74 Art & Language, *Study for Incident, Foreground 1*, 1994. Acrylic paint and ink on paper, 115 × 148 cm. Collection Goldman Sachs International.

out of a form of modernist trompe-l'oeil. (For readers of Ernst Gombrich and for those with long memories, the irritating graphics of Martin Escher may be thought of as exemplifying a kind of self-important *via negativa* for serious work on pictorial illusion.)[11] To justify some body of artistic work, it is not enough to attract a spectator whose already foreseeable interests and competences that work will set in play. The spectator one must be able to conceive is one whose engagement with the work will be a kind of learning, and whose response cannot therefore be practiced or well-formed or confident.

With the benefit of hindsight, each of these crises in the work of Art & Language might be defined as a moment of encounter with a substantial limit on what it is that some conceivable spectator can be made to see, where the "seeing" in question is not simply a kind of educated visual discernment. Another way to put this would be to say on the one hand that painting is only trivially secure when the competences it requires of the spectator are culturally standard, but on the other that the medium encounters an unsurpassable if possibly contingent limit when there is *no* conceivable and admissible spectator who could "see" what it is that the work is meant to show.

In each case where such a limit was encountered, Michael and Mel were required as it were to step back and to reconnect with some known technical conditions of a previous phase of work. Yet in each case the difficulties the abandoned works seemed to raise were neither removed nor resolved, but remained psychologically recurrent within the practice of Art & Language, shadowing the progress of all subsequent projects, until they could once again find occasion to insinuate themselves into work in progress.

In attempts to pursue new directions of work as, though not necessarily *in*, painting, what seems persistently to have been in question is whether or not the spectator's imaginative activity can be determined by the painting's visible surface in some critically significant sense – whatever that surface may be composed of. With this issue in mind, I mean to follow the traces that Art & Language's unresolved projects leave behind. In doing so I am attempting to explore the ground of some possible art-historical lessons. It is in part by doing so that I generally hope to contribute to the thinking of the studio.

What I now aim to do is to connect the suppression of the spectator as accultured, unemancipated by doubt and insecurity and therefore uninquisitive, to that form of imaginary extinction which forms my third sense of the death of the spectator. The points of reference for this last death are to be found among the accredited high points of the Western tradition of painting. I mean to indicate grounds for the continuity of some kind of painting that recognize both the recurrent critical promise and the potential gravity of illusionistic effects.

Imaginary death

There is a long history to the association of painting with the imagination of death. The instances easiest to call to mind are those where the reminder of mortality – the *memento mori* – is conveyed in imagery: a solitary skull reflecting the spectator's regard; a skeleton embracing a maiden or whispering in the ear of a pictured youth; another visiting a party of revelers; a conjunction of youth and age, the telling light of a candle setting the smooth skin of the one against the cratered countenance of the other; various congeries of still-life objects, whether darkly suggestive of the vanity of wealth and reputation and of the irreversible passage of time, or taunting us with the poignancy of fruit and flowers locked into the instant of their maturity. But there are other more complex cases, where the intuition of mortality is conveyed by subtler means. In the paintings I have in mind, it is not the assemblage of depicted images that produces self-consciousness, but rather some transformation in the picture itself that occurs as a relevant function of the spectator's attention.

One example will suffice to make the point. In the Mauritshuis in the The Hague there is a painting by Jan Steen now known by the title *The Life of Man*. It is a tavern scene of a kind prevalent in the artist's work. An assembled company is shown in a spacious interior, bent on enjoyment of the pleasures of the flesh, drinking, dancing, flirting, whoring, eating oysters, and so forth. Watching them from a raised vantage point deep in the center of the picture space is a small boy. He is lying on his belly and blowing a bubble. Next to him on the floor of the balcony a skull also seems to look down. In the actual painting the bubble and the skull are each the size of a pinhead, but of course they

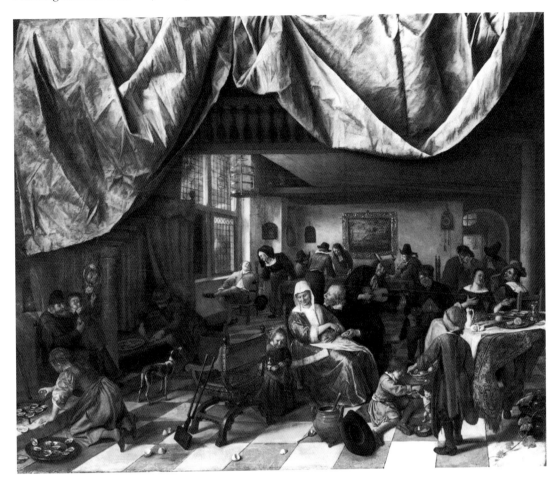

are easily enough discovered by those who expect to find them – a cat-
egory that would have included many of Steen's seventeenth-century
contemporaries, who were used to reading painted sermons. And once
seen these details effect a change in our reading of the painting. It is not
that the merrymaking comes to seem any the less attractive for our be-
ing reminded of its transience. In reducing skull and bubble to such tiny
interlopers, Steen allows the pleasures of the flesh to be indeed enjoy-
able. The effect of his painting is the more poignant for our being
drawn into its ambience. What is made clear, however, is that the mer-
rymaking is at best a kind of distraction.

So far, so relatively conventional. In this case, however, what brings
the emotional substance of the painting home to us as its viewers is not
simply that prospect of loss of animation in the depicted scene that fol-
lows the recognition and decoding of its conventional symbols. It is the
prospect of our own loss of sight. Retreating in imagination from the
depths of the illusionistic space toward the home ground of the picture
plane, we find ourselves on the other side of a heavy gathered curtain

Plate 75 Jan Steen, *The
Life of Man*, c. 1665–
1667. Oil on canvas,
68.2 × 82 cm. Maurit-
shuis, The Hague.

that must fall, sooner or later, and in falling put an end not to the scene it encloses, but to our ability to see it – or, by implication, to see anything else. Steen here plays on two relevant conventions. The first is codified in the Shakespearean tag that "All the world's a stage, and men and women merely players." The second is a matter of contemporary domestic practice: in the bourgeois homes of the time, valuable paintings were ordinarily protected by curtains that could be drawn back if and when they were to be looked at. (A still life of 1658 by Adrian van der Spelt, now in the Art Institute of Chicago, plays a similar if less provocative game with this custom by including a partially drawn curtain *within* the illusionistic scheme of the painting.) In Steen's painting, I suggest, contemplation of the possibility of one's own extinction is made a condition of any fully engaged and competent spectatorship. Moreover, the spectatorship in question is defined not simply as a capacity for recognition, but rather as a form of reflexive philosophical engagement with the very conditions of painterly illusion.

Of course, the picture in question is one with strong figurative contents. I acknowledge that an adequate concept of painterly illusion must be capable of being applied to the effects of abstract works also. I think it can be shown that figuration is not a necessary requirement for the imaginary death of the spectator. Spectators who play the game of concentration required by Mark Rothko's paintings of the late 1950s and early 1960s will experience a comparable sense of deprivation regarding circumstantial location and light. (I have specifically in mind the selection of paintings from the abandoned "Seagram Murals" project now in the collection of Tate Modern in London.) The deprivation in question is not a mysterious or a mystical process. It is an analyzable effect of the illusionistic techniques employed by the artist: the adjustment of size, scale, and shape relative to the upright figure of the viewer; the playing off of effects of opacity and transparency; the tuning of detail against mass and of saturated colors against dark tones, and so on. These effects are pursued with a dual end in view: the positioning of the spectator at that point of proximity where the illusion-bearing surface will appear entirely absorbing, and the evacuation from that surface of all suggestion of physical presence or natural atmosphere. Of course, to say that these effects are open to analysis is not to say that they are easily achieved. What I conceive of as imaginary death will not occur unless the technical and ethical properties of a given painting are such as to engage the spectator's full and fully critical concentration. That is what playing the game means. It is an end that has to be made worth working for.

The hazard of painting

In the protestant countries of the seventeenth century, of course, the continual contemplation of one's own mortality was an ordinary reli-

gious and philosophical demand. We live in different times. A considerable risk is nowadays taken by the painter who makes the requirement of spectators that they experience their own extinction in imaginary form. For those faced in thought with the loss of all sensory awareness, the psychological effect of the individual painting is liable to recede into philosophical irrelevance. The typical fate of Rothko's work, for instance, is that its significance is read romantically back into the psychological life of the artist as tragic author. Andy Warhol's paintings of "Disasters" and of iconized individuals are similarly interpreted as though they were cultural documents of American life, and as though their significance could be identified with a mythological value attached to their pictorial subjects.[12] Yet if Warhol's work is itself of abiding value, it is by virtue of the radical insecurity it generates in the world of our own values, as we find ourselves adrift between the extremes of mortal profundity and technical and cultural triviality.

It is around insecurities of just this order that the second and third senses of the death of the spectator may be made to converge. For those prepared to face it, the lesson extrapolated by Conceptual Art from its relevant antecedents was that painting – indeed, art of any variety – will not be pursued to any substantial critical purpose unless its utter unimportance and contingency can be practically acknowledged. The admission of art's triviality, that is to say, is a condition of its gravity. The marginally Kantian kind of disinterest entailed in this suggestion has quite a pedigree. Ad Reinhardt is supposed to have said that art is too serious to be taken seriously. Bill Shankly, when accused of treating football (soccer), which is only a game, as though it were a matter of life and death, responded that it was, of course, both those things.[13]

The ability to experience a painting in light of this lesson, then, can be considered as the outcome of an exertion required by the art itself, and therefore as a *conatus* demanded of the spectator. This striving is reflected as a competence, which is needed if the spectator's part in the social transaction of painting is to be discharged, and if the practice of painting is to be continued without being reduced either to a mere sideshow of the greater culture of spectacle, or (which may be the same thing) to an exemplification of yet another convulsion in the mighty Wurlitzer of the spirit.

That these are significant conditions for the continued plausibility of painting as art is the understanding that I derive in part from Art & Language's need to abandon an entire phase of completed work at the end of 1994, and, more clearly, from the phase of production that followed the moment of that abandonment. The problem with the picture as illusionistic puzzle was that it tended to retain its integrity in face of all attempts to unpick it. While it might incorporate images of erasure and effacement, it was not itself at risk of disintegration. This absence of hazard in turn deprived it of implication in the very conditions it sought to address, rendering it ultimately hostage to a conservative regard. The implication of abandoning the series on these grounds

Plate 76 Art & Language, *Index 11: Background, Incident, Foreground, no. XXXVIII*, 1994–1995. Two paintings, oil on canvas on wood in epoxy-coated steel box, 104 × 140 × 51 cm. Courtesy Galeria Juana de Aizpuru, Madrid.

was that the conditions of risk would have to be somehow recovered in any succeeding phase of work.

The recovery came at a price. In fact, not much was immediately salvaged from the phase that ensued. In the years 1994–1995, Michael and Mel expended a considerable quantity of time and materials in various forms of partial concealment and containment of painted images. Among the more carefully worked results were canvases slotted into

deep steel boxes so that their pictured images were gradually lost in shadow. Some of the pictures in question showed studio and museum interiors containing steel boxes. Others, and the most evidently poignant, showed surfaces of water that receded into literal obscurity. The inescapable loss of visibility was deliberate and deliberately exasperating.

> These works were supposed to deconstruct the regard. By looking "at" them – into the box – your regard exits the place you're in. . . . But do you look *in*? Do you look *at* the box? The downcast gaze is the gaze of the chaste and obedient woman. You, as viewer, set your eyes to this task as you look *in* the box. . . . (Baldwin 2000)[14]

> This is a dirty experience, like looking to the bottom of a grave. (Carles Guerra 1995)[15]

I suggested earlier that the hazarding of its own condition may now be the very purpose of painting. But of course this purpose would be socially vacuous – or merely academic – unless what it entailed was that the imagined constituency for such things, now or in the future, was also thereby rendered insecure. The practical – and social – question posed by the paintings in boxes was whether their imagined spectators were conceivably actual spectators, or (which may be the same question in another form) whether they could conceivably transform the inevitably unsympathetic disposition of their actual spectators into some self-critical mode of engagement. If the answer turned out to be "perhaps not at present," how was that answer to be distinguished from any other measures of success or failure, of true or false promise in technical expedients?

All we can securely say is that if "no longer" implies "not yet," the implication may work the other way around in practice. One possible implication of these works was that neither the physical position nor the ethical existence of a congenial spectator could now be assumed for the purposes of going on making art: that there was, in effect, *no one* who could realistically be imagined as looking – no one who would see beyond the works' obdurate and theatrical physical presence – and that, at least for the time being and as far as Art & Language was concerned, "painting" had indeed run its course. To the extent that this implication was necessarily connected to the works in question, they were a kind of dead end. Faced with a dead end, however, you normally have at least two choices. You can give up, or you can go back and try again. Within the practice of Art & Language, trying again has usually meant two things: the recuperation and reuse of the implications (true and false promises) of some previous phase of work or of its fragments and ruins; and a recourse to writing, either as the generation of texts or as their incorporation, or as both.

a

b

Plate 77 a & b Details of *Index 11: Background, Incident, Foreground, no. XXXVIII,* 1994–1995.

There are three different inferences that might be drawn from the account I have offered. The first is that to continue painting past the achieved fact of the blank canvas is either to reanimate conservative technical resources and devices – in other words to accept the degeneration of painting's social function into the mere setting of conceptual rather than perceptual puzzles – or to capitalize on the stylistic fetishization of blankness itself, and thus perhaps to cater to conservatism of another order. The second is that painting is indeed a redundant medium, and that we should look to generic forms of art for the kinds of critical social function with which the medium has historically been associated. The third is that the medium and its attendant genres may yet furnish occasions of significant critical success or failure, but that we cannot know in advance of any relevant practical work just where the limits of that medium and those genres are actually defined, and whom they are defined *for.* One reason – among many – why we cannot know is that we cannot necessarily tell whether there is anyone looking; whether there is some possibly competent spectator of the work in question for whom confirmation of her own enduring presence is not the *end* of seeing.

I offer a brief resumé by way of conclusion. As regards the first form of the death of the spectator, the claiming of artistic status for "specific objects" and literal surfaces is not in itself an argument against either pictures or paintings. Unless we have actually suffered atrophy in those faculties on which the possibility of cognitive alertness and adventure depend, we might still entertain a case for pictures – and a fortiori for paintings insofar as these are still pictures of a kind. As regards the second form of death, the suppression of the spectator that was effected in some Conceptual Art should be understood not as an attempt to reduce those faculties by preventing their exercise, but rather as an adamant refusal of any substitute for them, however they may be deflated, transformed, or displaced. This is to say that the suppression of one spectator virtually requires the existence of another.

The third form of death is the one it seems paradoxically that we must be prepared to contemplate, then, if painting is to survive as an occasion for social activity. The spectator that painting must demand, in other words, is one whose consciousness is capable of being fully active and engaged while nevertheless fully admitting its own contingency and inevitable circumscription. This is a kind of prescription for realism. In practical terms, the extinction of this consciousness may serve as a kind of metaphor for extinction of the possibility of painting as a possibly realist medium. Or is it that the extinction of the possibility of painting serves metaphorically to alert us to some larger loss of critical self-consciousness – some greater difficulty in maintaining the specious and the serious in discriminate tension; in other words, to the loss or suppression of the necessary conditions for realism in present culture? To return to my opening thesis, I do not know how one could characterize the competent spectator in action before a painting except as a person whose presence – whose *being* in the present – is put

at risk by the imaginative activity entailed. And by the same token, I do not know how one is to defend painting as an art to be practiced under the conditions of the present unless it entails the self-conscious pursuit of illusionistic effects, by whatever technically devious and improbable means these may have to be established. For painting, like football, can be justified only as a kind of game, pursued with absolute gravity, in full admission of its actual triviality and potential redundancy.

<div align="right">

9

</div>

<div align="right">

Being Here

</div>

Making a display

For an artistic practice possessed of any critical vitality, the offer of a substantial public exhibition is a stimulus both to ambition and to reflection – to reflection on ambition and, perhaps, to ambitious forms of self-reflection. Several of Art & Language's most extensive projects have been undertaken where there were specific exhibition spaces to be filled, while lack of opportunity for public exposure has inhibited others, sometimes temporarily, sometimes for good.[1] Large exhibitions serve to dramatize the interaction between three crucial factors: at one extreme, the relationship of the practice in question to the surrounding culture – a relationship that decides the conditions and limits of its autonomy *as* a practice; at the other extreme, the capacity of any individual work to hold the attention of its spectator and to decide the character of that spectator's responsive activity; and, connecting these extremes or connected by them, the capacity of the exhibited works as a whole to animate a semiautonomous "conversational world" – a world situated on the one hand within the "external" context of the exhibition but described on the other by the "internal" relations between the works themselves.

In 1998 and early 1999 Art & Language worked in response to an invitation from the Tapies Foundation to stage a large exhibition in Barcelona. There were several galleries to fill on two floors of a notable late-nineteenth-century building, originally designed as a printing works.[2] The exhibition opened in April 1999. Partly in deference to the character of the architecture, the display in the large upper gallery was restricted to a single wall. An amalgam of seventy-two separate works entirely covered its four compartments, with the other walls and floor space left empty. While the selection of old and new works might have provided the materials for a conventional retrospective, the normal principles of chronological organization were deliberately displaced. According to a rationale that sought to combine convenience of fit with

maximum decorative variety, the works in question were chosen and arranged so as exactly to cover the entire available surface – 574cm in height and 2,335cm in width – working to a tolerance of some two centimeters overall. The works were butted edge to edge and bulked out where necessary from behind to match the level of the deepest item, forming a pictorial covering some 10cm thick. The interstices were filled with text – extensive essaylike items from the moment of Conceptual Art and after, enlarged or reduced as appropriate, then mounted on panels cut to size and bulked out to the same level. (This work of installation was done by Michael, Mel, and myself in Barcelona, with assistance provided by the Tapies Foundation.) The viewer was thus faced with an almost unbroken but highly differentiated surface, and left to find pathways through the material, to set the optical against the material and the textual against the pictorial, to forge types of relationship between its disparate parts, or to work for a characterization of the whole. After the exhibition the display was dismantled and the individual works returned to their respective owners, and to their relative isolation on the separate white walls of homes and institutions. (The same principle was used a few months later for

Plate 78 Art & Language, *A Model for Lucy Grays (Study for Barcelona Wall)*, 1998. Oil, acrylic, alogram and mixed media on canvas over plywood, 19 panels, overall 179.5 × 234.8 cm. Collection Le Gon, Belgium.

Plate 79 Art & Language, preliminary plan for Barcelona Wall, 1999.

an exhibition at PS1 in New York, where the materials for a second large wall were drawn from the period 1972–1980.)[3]

The activities of Art & Language have been marked from the outset by practical variety, by an intentional resistance to categorization, and by an aspiration to provoke inquiry that, while reflexive, is also open. The earliest objects included in the wall-installation dated from before 1968, when the name of Art & Language was first adopted. In the following year, the first issue of the journal *Art-Language* was published in England. Then and over the next few years Art & Language provided a common identity for a number of people already involved in various types of collaboration. As discussed in the first part of this book, the mid-1960s had seen widespread collapse in the authority of those individualistic cultural protocols that go under the name of Modernism. The coming-together of the two terms "Art" and "Language" served to recognize a range of intellectual concerns and artistic expedients that collapse had occasioned. For a variety of activities that bore practically and critically on the concept of art but that were at that time at home neither in the studio nor in the gallery, Art & Language promised a place of work defined by shared conversation. That conversation in turn transformed the practice of those involved and generated other kinds of work. Some of this work took written form and found issue in *Art-Language* and other publications, some qualified for exhibition once Conceptual Art had gained a measure of acceptance as an avant-garde genre, while some remained without public face, whether for lack of a negotiable category to attach to or because the conversation itself proved a sufficient occasion. In time there were those whom the

conversation excluded, those who excluded themselves from necessity or in protection of divergent interests, and those who had to be ignored so that the conversation might be continued.

The name Art & Language thus signifies a nominally collective artistic authorship maintained over the course of more than thirty years, continuous in certain crucial respects, discontinuous in others, its outcomes including works both exhibitable and unexhibitable, as well as a host of unrecorded anomalies and other remainders.[4] Besides the works installed in the galleries, the production of Art & Language was represented at the Tapies Foundation by a collection of archive material, by publications in the library, by a selection of TV and video programs, by recordings of songs, and by the theory installation of the Jackson Pollock Bar (discussed in the third of the present essays). Following the theory installation itself, a video of the performance played in one of the lower galleries, while the picture painted by actors was mounted on the opposite wall. Facing the painting were four chairlike objects, arranged as though to invoke a phantom audience. Derived from Art & Language's installation at "Documenta X," these were composed from painted panels in the series *Sighs Trapped by Liars*. In the insecure ground between painting, text, and domestic furniture, Art & Language had discovered a possible area for cultural subversion.

Where more conventional artist-authors are concerned, it is the narrative of a single life that tends to organize disparate production into an apparently coherent development. Hence the customary attractions of the retrospective exhibition. If the individual named by "Art & Language" has a single life, however, it is in the continuity of a

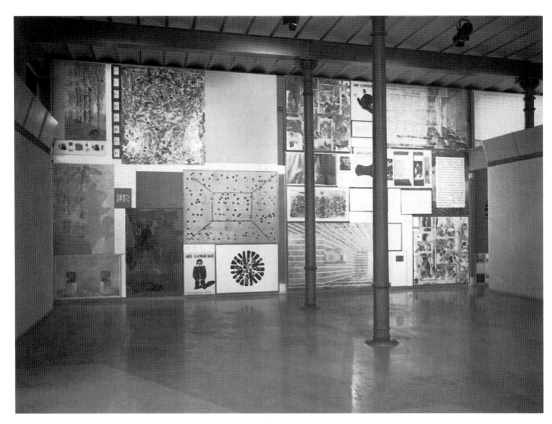

Plate 80 "Art & Language in Practice," Fondació Antoni Tàpies, Barcelona, 1999. Wall display, bays 1 and 2 of 4.

transforming and self-transforming conversation that that life must be looked for. The installation on the large wall might be thought of as an index of that conversation. It was at "Documenta 5" in 1972 that Art & Language first represented its conversation in the form of an *Index*. And what that index produced was not a narrative, but a series of possible connections across and within a conversational world. A large number of individual texts were made to speak to each other, to interrogate each other, to argue with each other. These texts could not be read according to any chronological sequence; rather they were connected by relations of compatibility or contradiction or were separated by the incommensurability of their respective logical worlds. It was left to the individual spectator to inquire into the material provided, using the indexing system as a map on which alternative possible pathways were marked. Over and above any interest that spectator might have in the specific details of propositions and arguments, the diachronic reading was accomplished as the intuitive apprehension of a social and intellectual structure – a form of "seeing." And insofar as that "seeing" was itself the consequence of a "writerly" activity, the spectator as passive consumer died to be reborn as a potential collaborator.

In 1972, the Documenta *Index* provided Art & Language with a solution to some problems of exhibiting that seemed specific to its work

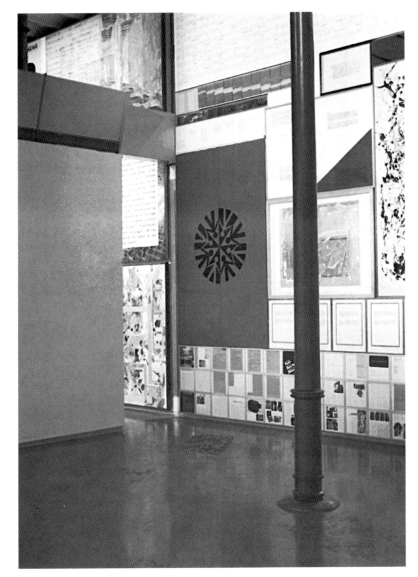

Plate 81 "Art & Language in Practice," Fondació Antoni Tàpies, Barcelona, 1999. Wall display, bay 3.

at the time: how to formalize disparate activity and production so that it might be overlooked and engaged with, yet without organizing it into a self-aggrandizing development. The large wall at the Tapies Foundation was intended to index Art & Language's subsequent production in a comparable manner. It is the function of an index to open pathways through a composed body of material, to indicate the world from which that material has been drawn, and thus to lay open to scrutiny the processes of composition themselves. Invited to return to Documenta ten years after the original *Index*, Art & Language exhibited two large paintings under the title *Index: The Studio at 3 Wesley Place, Painted by Mouth*, in which a graphic anthology of persons, pictures,

Plate 82 "Art & Language in Practice," Fondació Antoni Tàpies, Barcelona, 1999. View along wall display.

Plate 83 "The Artist out of Work: Art & Language 1972–81," PS1, New York, 1999. Wall display.

posters, works of Conceptual Art, journals, books, and record covers could be identified through the agitated surface of a semifictional atelier. The *Studios* were followed by the long series *Index: Incident in a Museum*, and after three groups of work under the generic title of *Hostages* ("Palettes," "Flags," and "Landscapes"), the theme of the index returned with the series *Index: Now They Are*. Each of these phases of work was represented on the large wall in Barcelona. The separate items might be thought of as indexical citations, each opening onto a body of conversation, a nexus of interests, or an aspect of Art & Language's history, or perhaps pointing outside the already decentered world of Art & Language, to other conversations, to comparable or contrasting works of the same genre, or to other possible histories.

It is with the history – or pseudo-history – of Conceptual Art that Art & Language has been most widely associated. But that association has for many years now functioned as a limit on criticism and interpretation. In its purist self-image, Conceptual Art abolished that which Modernist criticism celebrated as the decorative. But from the perspective of the present, vexed as we have been by neo–Conceptual Art, by "Classic Conceptual Art," and by related fictions of the market, another possible history might be one in which decoration had a continuing life in modern art – a life that was necessarily marginal, subversive, criminal.[5] The second major component in the Barcelona exhibition was made in apparent pursuit of this possibility. In *Index: Wrongs Healed in Official Hope*, shown in one of the lower galleries, the *Documenta Index* was recapitulated as decoration. Conceptual Art was thus transformed into its categorical other. "Rather than render-

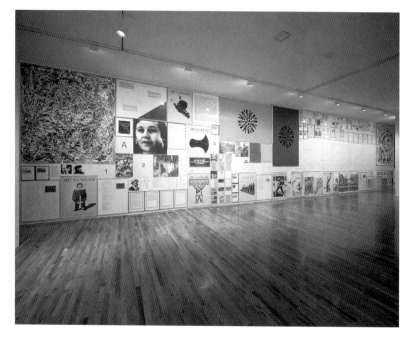

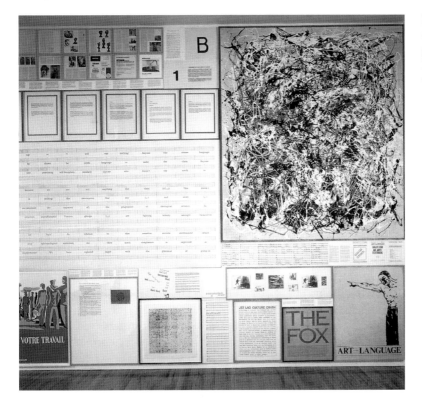

Plate 84 "The Artist out of Work: Art & Language 1972–81," PS1, New York, 1999. Detail of wall display.

ing Conceptual Art pictorial and perhaps *scandalously* decorative (affirm its decorativeness), we could render it decorative (bring it low) and bring the decorative low in processing it into Conceptual Art."[6]

In *Wrongs Healed in Official Hope*, the eight cabinets of the original *Index* are refashioned out of panels of various shapes and sizes. These

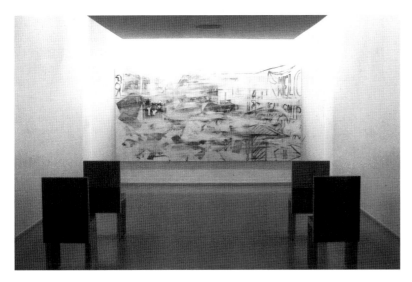

Plate 85 "A Picture Painted by Actors," from Jackson Pollock Bar, *Art & Language Paints a Picture installed in the Style of the Jackson Pollock Bar*, 1999. Installation at Fondació Antoni Tàpies, Barcelona, 1999.

Plate 86 Art & Language, *Sighs Trapped by Liars 510–520*, 1997. Alogram on canvas over plywood and mixed media, 90 × 42.5 × 35.5 cm. Courtesy Lisson Gallery, London.

have been covered in canvas, painted in pastel colors, and fixed over a wooden armature. The four plinths are similarly constructed from canvases mounted over plywood, while sixty-four separate painted canvases stand in for the wallpapered photostats of the original, arranged in four panels of sixteen. In its actual form, however, this decorative ensemble is haunted by the vestiges of a troubling significance. In the original *Index*, plinths and filing cabinets were the mere furniture by which an array of texts was supported and concealed. That these physical vehicles constituted a kind of post-Minimalist installation was a more or less accidental consequence of their contingency. The "work" was in the texts and on the surrounding walls. In the new *Index* the physical constituents present themselves as supports for painting, thus claiming the status of necessary components in an aesthetic totality. The cabinets are dummies (ventriloquists' dummies?), and nothing is left of the earnestly irresponsible (or irresponsibly earnest) writings that their originals once contained. In *Wrongs Healed in Official Hope*, the text becomes literally superficial, a rococo filigree within the painted surface to which the ensemble submits in the name of an insidious topicality. The text is degenerate both in its origins, which lie in a demotic form of sadomasochistic pornography, and in the form of its presentation.

On the first of the cabinets and their supporting plinth the opening passage of the source text appears in unaltered form, though its print is barely legible against the background tone of the canvas. The dramatis personae of the narrative are animated merely as so many tits and cunts and cocks and asses, their props all chains and whips and dildos. They occupy a world that merges pathetic fantasies of boarding school misbehavior with the aggressive imagination of others' pain and with the masculine fiction of inexhaustible female desire.

> It was weekend, time for some real fun at the school. The entire weekend was one long torture session. Many of the girls were tortured without let-up from Friday night to Monday morning. Valencia was in the great master dungeon, in chains, her ass covered with dozens of fresh welts. . . .

And so on.

On the surface of the matching wall display the same text appears, transformed through the agency of Mrs. Malaprop into a fantasy of suburban consumership running rapidly out of control.

> It was weekend, time for some real sun at the pool. The entire time was one long scorcher impression. Many of the girls were torpid without let-up from Friday to Monday morning. Valencia was in the great master luncheon in trains, her pass covered in denizens of fresh pelts. . . .

Before transferring to the second plinth and set of cabinets the entire text undergoes a fifty percent reduction, through the managerial re-

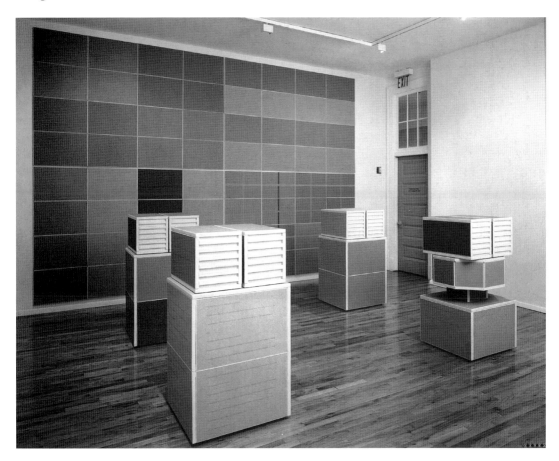

Plate 87 Art & Language, *Wrongs Healed in Official Hope*, 1999. 8 cabinets on 4 plinths with 64 wall panels, alogram on canvas over plywood, dimensions variable. Installation at PS1, New York, 1999.

source of a text-compressing computer program. This is in turn revised by Mrs. Malaprop before transmission to the second section of wall display. The third plinth contains a further reduction representing twenty-five percent of the original text. Visited once again by Mrs. Malaprop this appears on the third set of wall panels in the following form, now several transformations distant from the original:

> The entire time was one long fortnight's recession. Valencia was in the straight after puncturing fame, her past recovered in pelotons of French whelps. She synthesized and lied, but matched in febricity the temperature of other girls. Dominique recalled her girls.
>
> "Co-ordinated girls must be persistently emancipated."
>
> Dominique unstuck the girl, trapping and splicing the blurted quips, heckling and hooting the criminals.
>
> The girl sighed intimately from shame, but her case crashed dead and the short bum began to shun doubt of her scatty smocks. Dominique swept beneath Valencia. She invoked Valencia's manipulations and hooked onto her guide with contradictions.

Plate 88 Detail of
*Wrongs Healed in Offi-
cial Hope,* 1999.

Vickie improvised beside Valencia and squashed her
coulis into Valencia's glass.

The viewer-as-reader strains to catch echoes, at once fascinating and
absurd, of a world of violence and passivity, as though a narrative of
human fantasies were being transmitted through a damaged or apha-
sic machine. This is *modern* decoration. To inquire into the conditions
of its "beauty" is indeed to look into another history than the history
of art.

This text is subject to one further executive summary before arriving
on the fourth plinth and its dummy cabinets as a series of gnomic and
disconnected blurtings. This last plinth is unlike the others. It is a com-
plex structure of eight vertical faces, standing on a narrow stem sup-
ported by a rectangular foot. "The last plinth is an Odradek, perhaps.
An Odradek is Kafka's name for an enigmatically useless and somehow
instrumental object. The form is collapsing and the writing has run
out."[7] The last wall panel is devoid of textual detail. Its sixteen canvases
are decorated instead with a plaid motif, the colors gathered from those
used in the rest of the painted elements. If there is a reference here it is
to other painting: to the modern tradition of "the decorative" in gen-
eral and thus to Matisse;[8] but also perhaps to Kenneth Noland's work
of the early 1970s, when Post-Painterly Abstraction – and with it the
last bright hopes of Modernist painting – finally ran out of develop-
mental steam and critical support.

Reading from left to right the journey has apparently been from the
pornographic to the decorative, from narrative text to pictorial ab-
straction, from the brutal to the aesthetic. But of course the work is
open to being read in the other direction – as is the culture from which
its materials are drawn. No complacent self-assurance is to be drawn
from either reading. Nor, in the presence of the work, does it seem any

more plausible that an exhausted Modernism could have been overthrown by a vital Conceptual Art than that the brutal reifications of pornography are redeemable in the world of the aesthetic.

"Genre" revisited

The matter of a conversation "internal" to a body of artistic work raises once again the issue of genre and of its possible transformations. It could be said that *Wrongs Healed in Official Hope* treated the *Documenta Index* as though it constituted a genre in itself, which it then critically transformed by reference to a degenerate body of text and a disordered concept of the decorative. In the wider history of art it has been the normal fate of the genres to be subject to critical revision and reanimation virtually from the point at which they achieve a degree of formalization in theory and practice. As a category of artistic production, no genre is assured of stability for long. We may rather conceive of a given genre as a specific moment in a dialectic: one of its terms is made up of cultural processes of institutionalization and formalization, the other of those unarticulated intuitions that are the emotional and psychological contents of a social and material world. From this perspective, the first requirement of a genre will be that it is a possibly public vehicle by means of which the dialectic in question can be somehow engaged. The second will be that it admits of self-critical continuation and development through further work of a like kind.

Between the seventeenth and late-nineteenth centuries individual genres of painting could be distinguished in terms of their specific pictorial contents. In principle, a landscape was connected to different bits of the world than was a still life or a portrait. Significant transformational work on the genres – transgression of their boundaries or subversion of a fixed hierarchy – necessarily entailed some readily discernible manipulation both of the "what" and of the "how" of depiction. With the development of abstract art it might therefore be thought that the institutional authority of the genres had been subject to a terminal assault. In fact, despite whatever programmatic claims the artists themselves may have made in defense of their enterprises, abstract painting tended to vacancy when it was *not* haunted or fascinated by the memory of specific kinds of pictures: religious icons in Malevich's case, mythological histories in Kandinsky's, landscapes in Mondrian's, still lifes in Nicholson's, portraits and single figures in Rothko's. There was emancipation of a sort, but it was such as to leave the material practices of art potentially rootless – and dangerously unpopular outside what was fast becoming a new and powerful academic community. Minimal Art in its early "geometrical" phase might be seen as a kind of response to this circumstance: the proposal of a new genre of abstract art with clear connections to its surrounding environment. As a genre, however, it was effectively in thrall to a rapacious art-world administration that found it highly congenial. It was so well

accommodated to the institutional environments it required that it vir-
tually collapsed the "internal" relations of any given body of work into
the "external" context of its display.[9] It was left to the Conceptual Art
movement both to recomplicate the "internal" character of the art
work and to problematize the "external" conditions of its display.

In fact once that movement gained widespread attention – which it
had certainly done by 1970 – there were careers to be made by com-
bining stylistic consistency with a kind of obstinate provocativeness
concerning modes of display. The more substantial critical task, how-
ever, was to keep alive the problem of what Conceptual Art was *about,*
or, as it soon became, what *art* might be about in the wake of the Con-
ceptual Art movement. One answer, of course, was that art was now
free to be "about" anything. No longer bound within the range of the
picturable, or committed by the necessity of abstraction to what Bar-
nett Newman called "an epistemology of intangibles,"[10] artists had
only to construct ingenious signposts to selected areas of topical con-
cern in the larger culture for their work to rendered amenable to inter-
pretation and exegesis. In their turn, the swelling army of eager
commentators had only to apply their reading in semiotics, in social
theory, in cultural studies, or whatever for significance to be instantly
established.

There is some irony in the widespread establishment of this compact.
Among the more persistent and justified criticisms of the culture of late
Modernism there are two that deserve to be recalled in this context.
The first was that art of rapidly diminishing critical potential was be-
ing born aloft on a supporting structure of critical exegesis; that the
content of the art was increasingly *made* by the judgments conferred
upon it. The second was that there was a tendency for those judgments
to be emotivistic in character; that they were liable to reduce to the in-
junctions "Do what I do" and "Like what I like." Whether it has taken
the form of the press release dressed up as journalism or of the theo-
retically buttressed academic essay, how much of the critical support
accorded to the "Conceptual" or "post-Conceptual" art of the past
thirty years stands proof against the same accusations?

In fact it could be said that the emotivistic aspect of Modernist cul-
ture is subject to an insidious mutation in the current celebration of
contemporary art as universal spectacle. It seems the ambitious cura-
tor now feels a certain shame at the image of the museum as source
or archive or place of study. This shame is overcome by treating the
museum as a site of manipulation of themes. The resulting curatorial
activity is licensed by the feeble notion that spectators will without
knowing it come to "see things in new ways" – the things in question
being imagined abstractions in the lives of a subject constituency, rather
than the specific products of a material tradition. These are the typical
self-justifications of the advertising agency, and of related kinds of
managerial barbarism. Topical themes are supposed to be graspable ir-
respective of the technical boundaries by which genres are in part de-
fined. In a culture of broadly marketed spectacle, the establishment of

workable genres may be all the more necessary if critical attention is to be focused on specific skills.

Michael Fried has offered his own retrospect on the crucial period of transition.

> . . . I remember feeling as early as the late 1960s, and with increasing force during the 1970s and after, that what might be called evaluative art criticism no longer mattered as it previously had. No longer was it read with the same interest, no longer could the critic imagine that his or her words might intervene in the contemporary situation in the way in which, perhaps delusively, I had sometimes imagined my words intervening in it, no longer were there critical reputations to be made by distinguishing the best art of one's time from the rest or by analyzing that art with respect to its treatment of issues that were, in a strong sense of the word, "inescapable." The inference seems clear that the kind of criticism Greenberg and I practiced, each in his own way, was intimately linked with the values, qualities and aspirations of the high modernist art we found so compelling, and that with the ever growing eclipse of high modernism in the later 1960s and 1970s (and after) the role of criticism became transformed – into cultural commentary, "oppositional" position taking, exercises in recycled French theory, and so on. . . . In any case, the abandonment of evaluative criticism and the disparagement of late modernist painting and sculpture have only grown more sweeping with the passage of time.[11]

This is straightforward testimony. And it serves elegantly to preface what I take to be the second possible means of address to the problem posed above: the problem of what art might now be about. I assume I have said enough in this book to make clear how little I am attracted to the idea of art as signpost. I am sure, on the other hand, that Fried is entirely correct in associating the effective collapse of evaluative criticism with the collapse of high Modernist art itself. It does not follow, however, that art can usefully proceed *without* some criticism of a kind directed at distinguishing the good from the bad or the indifferent. The more closely that criticism operates to the point of production, the more effective it must be. Where it is most deeply required, in other words, is in the practice of the studio. This is no less the case in circumstances where the studio has been transformed into a complex of workroom, factory showroom, office, and kitchen table.

The criticism of the studio is a strange business. My own unshakable conviction, born of acquaintance with the work of Art & Language, is that it feeds best on those materials that have taken their place among the products of the practice itself, from whatever resources they may at

Plate 89 Art & Language, *Material Slang II*, 1999. Mixed media on paper, 6 panels separately framed, overall dimensions 126 × 103 cm. Galería Juana de Aizpuru, Madrid.

some point have been derived. Art is work on work. Practical criticism involves the analysis of that which is wrought. Though we need to stay awake to the content of our history and our culture, we have at some point to *make* the materials of our own conversation. It is for this reason, in the end, that the practice of art requires the establishment of genres. They are the conditions of critical reflexiveness and of going on.

Unofficial hope

Since 1996, the great majority of Art & Language's exhibitable work has been composed from combinations of individually mounted elements. In some cases these elements are separately framed, sometimes they are gathered within a single framing edge, sometimes both. Sometimes the components are pictures, sometimes pages of text. In the long

series *Sighs Trapped by Liars,* printed text appears on the open pages of pictured books. In more recent works, given the generic title *Material Slang,* framed versions of works from different genres are combined to form a new and composite genre. Sometimes the texts invoke pictures. These and the majority of other texts employed are writings by Art & Language. Many of the pictures are recapitulations or travesties of earlier pictures by Art & Language. It is rarely clear in advance quite what will happen when certain pictures and texts are combined, or what kinds of combination will make substantial demands on the viewer; demands, that is to say, that go beyond the ordinary sense in which relations within a given whole may exceed the mere sum of the parts.

What does it mean for a given combination to do this, or to *mean* like this? The answer, I suppose, is that – *irrespective* of whether we are reading text or looking at pictures, or looking at text and reading pictures – a given work will do this insofar as it forms the occasion both of an untranslatable – "internal" or "allegorical" – conversation, and of an actual conversation in which that which is untranslatable is explored. This last is a conversation between agents responsible for the work, who, in taking the part of its exemplary spectators, cast about the world in thought in search of company. The conversation in question is one with a life of its own. This is to say that it may on occasion necessarily *exclude* these agents – go beyond them – insofar as it is an index of differences that they cannot delimit but that are occasionally just accidental smears. Alongside the signifying stuff intentionally deposited in the world, in other words, there will always be other material that may be treated as significant by other agents irrespective of the intentions of those who issue it. But we cannot wash our hands of this stuff either. The questions it raises also come back to us and to the society we seek. Is there anyone there? It is not the knowing or the sympathetic that we look for. We hope only for those who will do their share of the work – be active in its conversation.

Plate 90 Art & Language, *Down to the Stone*, 2000. Printed text on polyester film, 48 frames, overall dimensions 151 × 193.5 cm (installed dimensions 239 × 245 cm). Art & Language.

Notes

1 The Trouble with Writing

1 Letter from L'Estaque, July 2, 1876, as translated in J. Rewald, ed., *Paul Cézanne: Letters*, Oxford (Bruno Cassirer), 1976; reprinted in C. Harrison, P. Wood and J. Gaiger eds., *Art in Theory 1815–1900*, Oxford and Malden Mass. (Blackwell), 1998, p. 550.

2 From "Monster Field," originally published in *Architectural Review*, September 1939; as reprinted in P. Nash, *Outline: An Autobiography*, London (Faber and Faber), 1949, p. 245.

3 On the nature of this resistance, see my "England's Climate," in B. Allen, ed., *Towards a Modern Art World (Studies in British Art I)*, New Haven and London (Yale University Press), 1995.

4 C. Harrison and P. Wood, eds., *Art in Theory 1900–1990*; C. Harrison, P. Wood, and J. Gaiger, eds., *Art in Theory 1815–1900* and *Art in Theory 1648–1815*, Oxford and Malden Mass. (Blackwell), 1992/3, 1998, and 2000.

5 See R. Wollheim, *Painting as an Art*, Princeton (Princeton University Press) and London (Thames and Hudson), 1987, p. 21: "This special kind of experience which I call *seeing-in*, marked by this strange duality – of seeing the marked surface, and of seeing something in the surface – which I call *two-foldness*. . . ."

6 All three paintings were first exhibited in "Aspects of British Art Today," Metropolitan Museum, Tokyo, 1982.

7 "Painting by Mouth," *Art-Language*, vol. 5, no. 1, October 1982, p. 45.

8 See T. de Duve, *Kant after Duchamp*, Cambridge Mass. and London (MIT Press), 1996.

9 While I have not altered the style applied in quotations, I have generally tried to distinguish in my own text between a lower-case "modernism," intended as a relatively informal usage, and a capitalized "Modernism," where I mean the latter to refer to a specific theorization of Modernism – and to the art thus theorized – as notably represented in the writings of Greenberg, and during the 1960s and early 1970s in the writings of Michael Fried. The distinction cannot be made to hold in all cases, however. I have attempted to represent some of the issues at stake in this distinction in my entry on "Modernism" in R. S. Nelson and R. Shiff, eds., *Critical Terms for Art History*, Chicago (Chicago University Press), 1996.

10 For a full discussion of the case for "generic art," see especially part II, "The Specific and the Generic," in de Duve, *Kant after Duchamp* (see note 8 above). See also J. Kosuth, "Art after Philosophy," first published in *Studio International*, vol. 178, nos. 915–917, October, November, and December 1969, with which de Duve takes issue.

11 See, for instance, P. Bürger, *Theorie der Avantgarde*, Frankfurt (Suhrkamp Verlag), 1974; trans. as *Theory of the Avant-Garde*, Manchester and Minneapolis (University of Minnesota Press), 1984.

12 W. J. T. Mitchell, *Iconology: Image, Text, Ideology*, Chicago and London (Chicago University Press), 1986, p. 42.

13 See particularly C. Greenberg, "Complaints of an Art Critic," first published in *Artforum*, vol. 6, no. 2, October 1967, and M. Fried, "Art and Objecthood," *Artforum*, vol. 5, no. 10, June 1967.

14 From an interview of November 24, 1991, included in "Art and the Left: The Critique of Power," TV23 in *A316 Modern Art, Practices and Debates*, Open University, Milton Keynes, 1993.

15 Fried, *Courbet's Realism*, Chicago (Chicago University Press), 1990, p. 7.

16 See, for instance, the case argued by Steven Pinker (largely extending the findings of Noam Chomsky) in *The Language Instinct*, London (Allen Lane, The Penguin Press), 1994.

17 See, for instance, Fried, "Art and Objecthood," and note 13 above.

18 The exhibition "Out of Action" originated at the Museum of Contemporary Arts, Los Angeles, and was shown in Vienna and Barcelona in 1998–1999. Opening with a large all-over Pollock from the late 1940s, it offered an international survey of developments in not-painting and not-sculpture (performance art, happenings, process art, body art, video, etc.) over the ensuing fifty years. One of the few things the exhibition served to make clear was that the more effectively any artistic enterprise distanced itself from traditionally sanctioned genres and media, the wider the potential gap between that enterprise and the material actually presented for critical review.

19 "Modernist Painting" was originally broadcast over "Voice of America" in 1960 and was published the same year in *Forum Lectures*, Washington. It is reprinted in Greenberg, *The Collected Essays and Criticism*, vol. 4: *Modernism with a Vengeance 1957–1969*, John O'Brien, ed., Chicago (Chicago University Press), 1993, pp. 85–93.

20 "Introduction," *Art-Language*, vol. 1, no. 1, May 1969, p. 1.

21 Ibid., p. 3.

22 In conversation; but see Art & Language, "Moti Memoria" in J. Roberts, ed., *The Impossible Document: Photography and Conceptual Art in Britain 1966–1976*, London (Camerawork), 1997, pp. 65–66:

> We were not philosophers but former art students. Texts as art acquired in the confusion a curious status as *critical discourse*. In various ways "things" escaped or were bound back to text. Art & Language was a site for these transformations to take place – a land of exile from the walls. And from time to time the texts within that site began (to seem to be) used like more or less conventional critical texts. But there was always that marginal possibility of escape – of their being transformed – of their getting out to the walls and living a different life. Later, the circumstances which had generated these texts became complex, talkative, discursive. They had started to mark points of reference in a collaborative (dialogic) practice. But the texts generated therein were theoretical just in case they were art object-like, and art object-like just in case they were theoretical.

23 Letter to Manet, May 11, 1865, in Charles Baudelaire, *Correspondence générale*, vol. 5, pp. 96–97, Paris, 1947–1953.

24 "Art and Inquiry," in N. Goodman, *Problems and Projects*, Indianapolis (Hackett Publishing Company), 1972, p. 107.

25 The analysis offered here gains support from an unexpected quarter. Frank Stella writes with hindsight about what might be thought the long-term consequences of the tendency I have outlined:

> By 1970 abstract painting had lost its ability to create space. In a series of withdrawals, it began to illustrate the space it had once been able to create. The space in abstract painting, in a certain sense, became more advanced – more abstract, if that is possible. It was no longer available to feeling, either emotional or literal. This fulfilled one of modernism's great dreams: the space in painting became available to eyesight alone, but unfortunately not to eyesight in a pictorial sense, but to eyesight in a literary sense. In a word, it became available to the eyesight of critics rather than of artists, to the critical, evaluative faculty rather than the pictorial, creative faculty. This means that the tendency that developed in American painting after 1970 is antithetical to everything that the great painting of the past stands for. (*Working Space [the Charles Eliot Norton Lectures, 1983–4]*, Cambridge, Mass., and London [Harvard University Press], 1986, p. 43)

It is of significance that Stella looks back for help to the painting of Caravaggio and Annibale Carracci, which is to say to the art of the period immediately before the inception of modernism's long development in the mid-seventeenth century.

26 "Unwritten Histories of Conceptual Art: Against Visual Culture," in T. Crow, *Modern Art in the Common Culture*, New Haven and London (Yale University Press), 1996, pp. 214–215. It should be stressed that insofar as Art & Language has been or is "against visual culture," it is to the *culture* of the visual that its criticism has been directed, not to the visual as such – whatever that might mean.

27 There are important reservations to be entered here. The first is that the anti-intellectualism of late modernism is not directly a function of the writings of Greenberg or Fried. It was rather a necessary component in the culture of curatorship and distribution that was directly or indirectly parasitic on those writings, even – or most insistently – when it vaunted its distance from them. The second is that Fried himself noted the potential essentialism of Greenberg's emphasis on the "opticality" of Modernist art, and sought to amend it. Indeed, it could be said that during the 1960s, Fried did more than anyone to preserve the intellectual energy of the Modernist critical tradition, while his subsequent art-historical writing has been exemplary in its attention to complex problems of description and interpretation.

28 Art & Language, "Memories of the Medicine Show," in *Art-Language*, new series, no. 2, 1998, pp. 34–35.

29 Ibid., p. 47.

30 See E. Panovsky, "*Et in Arcadia Ego*, et le tombeau parlant," *Gazette des Beaux-Arts*, 1, 1938; see also L. Marin, *Détruire la peinture*, Paris (Editions Galilée), 1977, trans. *To Destroy Painting*, Chicago (Chicago University Press), 1995: ". . . a certain representation of death refers to the process of representation as death. Yet, at the same time, death is tamed

and neutralized by writing, and by the work of art more generally, as the living read and contemplate the painting" (p. 87).

31 Fried, *Three American Painters: Kenneth Noland, Jules Olitski, Frank Stella*, Cambridge, Mass., (Fogg Art Museum), 1965; excerpt in C. Harrison and P. Wood, *Art in Theory 1900–1990*, pp. 773–774.

32 These three works are printed in L. Weiner, *Statements*, New York (The Louis Kellner Foundation/Seth Siegelaub), 1968, unpaginated.

33 M. Baldwin, C. Harrison, and M. Ramsden, *Art & Language in Practice*, vol. 1, Barcelona (Fondació Antoni Tàpies), 1999, p. 197.

34 This formula was first published by Weiner in the catalog of the exhibition "January 5–31 1969," New York (Seth Siegelaub), 1969.

35 Michael Baldwin, letter to the author, February 1997.

36 See "3: Indexes and Other Figures" in my *Essays on Art & Language*, Cambridge, Mass. (MIT Press), 2001.

37 "Art and Authenticity," in N. Goodman, *Problems and Projects* (see note 24 above), p. 95:

> Let us speak of a work of art as *autographic* if and only if the distinction between original and forgery of it is significant; or better, if and only if even the most exact duplication of it does not thereby count as genuine. If a work of art is autographic, we may also call that art autographic. Thus painting is autographic, music nonautographic, or *allographic*.

38 The use of texts by others – exhibited in the form both of books and of photographic enlargements of title pages, abstracts, mathematical diagrams, etc. – was the typical stock-in-trade of the French Conceptual artist Bernar Venet around 1970.

39 Art & Language, "Artists Writing 1," in *Art-Language*, new series, no. 3, September 1999, pp. 39–40.

40 Art & Language, "Making Meaningless," in C. Harrison, ed., *Art & Language in Practice*, vol. 2, Barcelona (Fondació Antoni Tàpies), 1999, pp. 243–244, 245–246.

41 Mrs. Malaprop is a character in Sheridan's play *The Rivals*, first produced in 1775. She is noted for her aptitude in misapplying words. Among her more vivid locutions are "as headstrong as an allegory on the banks of the Nile," and "He is the very pineapple of politeness." She has given her name to such solecisms.

42 Art & Language, "Artists' Language 2," in *Art-Language*, new series, no. 3, September 1999, p. 57.

43 Art & Language, *Art & Language in Practice*, vol. 1, pp. 277–278.

2 Conceptual Art and Its Criticism

1 B. Buchloh, "From the Aesthetic of Administration to Institutional Critique (Some Aspects of Conceptual Art 1962–1969)," in *L'Art conceptuel, une perspective*, Paris (ARC Musée d'Art Moderne), November 22, 1989 to February 18, 1990, p. 53.

2 It cannot be said that "Global Conceptualism" demonstrated an internationally distributed practice, however. "Global" goes to notions of semi-analysed *commonalities* in the work of artists from many different (that is to say *very* different) countries. Conceptual Art gets to last

from 1956 until the 1980s as a global collection of odds and ends rather than as a communicative or discursive or learnable culture. The project was doubtless imperialistic. (Art & Language, "Concept and Experiment in Britain?" *Modern Painters,* Summer 2000, p. 23)

This was written primarily as a review of the exhibition "Live in Your Head: Concept and Experiment in Britain," held at the Whitechapel Art Gallery, London, in 1999. As the review noted, "No danger of internationalism here."

3 A. Alberro and B. Stimson, eds., *Conceptual Art: A Critical Anthology,* Cambridge, Mass., and London (MIT Press), 1999.

4 In the catalog essay cited in note 1 of this essay, Benjamin Buchloh raised the question of the confirmability or nonconfirmability of dates ascribed to the "conception and production" of works of Conceptual Art, with specific reference to Joseph Kosuth's *Proto-investigations.* Kosuth responded in a text facing the opening page of Buchloh's essay, that was pasted into the catalog after its printing but before its distribution: "These works existed in notes and drawings and were fabricated after I had the financial resources due to interest in the somewhat later work. . . . Is the physically exhibited presence of a work the only citerion for its existence? It isn't, if you know anything about Conceptual Art" (*L'Art conceptuel,* 1990, covering p. 40). With the hindsight of a dozen years, the necessity driving this intervention seems less like the power of an interesting idea than a material closure on what might be known *about* and known *as* Conceptual Art.

5 Tony Godfrey, *Conceptual Art,* London (Phaidon Press), 1998. The author of this book might argue that the kinds of distinction I have in mind are rendered irrelevant by Conceptual Art itself. Such an argument would certainly lend weight to the opening paragraph of the present essay.

6 As reprinted in Alberro and Stimson, *Conceptual Art* (see note 3 above), p. 180. "557,087" was organized by Lucy Lippard and held at the Seattle Art Museum from September 5 to October 5, 1969. The catalog consisted of ninety-five unnumbered index cards. Lippard's introduction was printed on twenty of these.

7 "One day the time will come when we shall be able to do without all the arts, as we know them now; beauty will have ripened into palpable reality. Humanity will not lose much by missing art." Quoted at the conclusion to "On the Social History of Art" in T. J. Clark, *Image of the People: Gustave Courbet and the 1848 Revolution,* London (Thames and Hudson), 1973, p. 20.

8 Lippard, "Introduction," in Alberro and Stimson, *Conceptual Art,* p. 178.

9 Art & Language, "Moti Memoria," in J. Roberts, ed., *The Impossible Document: Photography and Conceptual Art in Britain 1966–1976,* London (Camerawork), 1997, pp. 54–55.

10 The individuals concerned were Terry Atkinson, Michael Baldwin, David Bainbridge, and Harold Hurrell, and subsequently Ian Burn and Mel Ramsden, and Philip Pilkington and Dave Rushton. Joseph Kosuth was also involved with Art & Language between the summer of 1969 and the summer of 1976. He and his work were important to me between the time I first met him in the spring of 1969 and the exhibition of the *Documenta Index* in the summer of 1972, though I subsequently came to see his work as continuous with a strain of Modernist apostasy and individualism that was strong in the American art of the time, and thus in the end as

incompatible with the critique of Modernism that was endemic to Art & Language.

11 "To appreciate fully a work of art we require nothing but sensibility. To those that can hear Art speaks for itself." Clive Bell, "Art and History," in *Art*, London (Chatto and Windus), 1914, p. 98.

12 This is a compression of the argument offered by C. Greenberg in "Modernist Painting."

13 This was Barry's contribution to the exhibition "When Attitudes Become Form," as shown at the Institute of Contemporary Arts, London, in September 1969.

14 "Moti Memoria" (see note 9 above), pp. 62–63.

15 Ibid., p. 63.

16 The "demand for a reading" would, of course, have little critical virtue were there no potential reader to whom it could be thought of as addressed. Thomas Crow, in his essay "Unwritten Histories of Conceptual Art," (first published in "Oehlen Williams 95," Wexner Center for the Arts, The Ohio State University, January 1995; reprinted in *Modern Art and the Common Culture*, New Haven and London [Yale University Press], 1996, p. 215), quotes me as follows: "Realistically, Art & Language could identify no *actual* alternative public which was not composed of the participants in its own projects and deliberations." He uses this quotation to exemplify "a certain loss of heart on the part of [Conceptual Art's] best advocates," which leads to the embracing of "monumental pictorialism" as the most productive way forward (p. 216). Quotations taken out of context may sometimes have the effect of seriously misrepresenting their authors. It can be no coincidence that exactly the same quotation has been extracted to similar ends by Rosalind Krauss (in *Art Press*, hors séries no. 16, 1995) and by Terry Atkinson (in *Tate*, Summer 1996). What I actually wrote was this.

> The requirement of realism to which any image of the public must submit is that it should not be the self-serving product of a liberal (or other) fantasy. Realistically, Art & Language could identify no *actual* alternative constituency which was not composed of the participants in its own projects and deliberations – whoever they might be. Insofar as there was a *potential* public, it was composed not of dispassionate spectators, but of interested readers and learners. *The implication of this circumstance was not that the members of Art & Language constituted the only and sufficient audience for Art & Language work. It was rather that no secure principle existed whereby a body of members or teachers or authors could be divided off from the larger world of learners or readers.* ("Art Object and Art Work," in *L'Art conceptuel, une perspective*, [see note 1 above], p. 63)

The implication stated in the (newly) italicized sentences still seems to me to be valid. As Michael and Mel have observed, "The substantial point of the quotation is always missed: here is a threat to the profession. Here are no positivistically healthy moves. The participants are not necessarily beneficiaries – they might be victims" (in "Moti Memoria," see note 9 above). For all that it may be misrepresented in other agendas, that threat has not abated. As I hope the present book will serve to demonstrate, I have not lost heart, nor do I embrace "monumental pictorialism" as a way forward to anything.

17 In its most critical forms – beyond the reflexive autonomy upheld by American-style modernist doctrine – the art that emerged around 1967 was broadly inspired by a refusal of "affirmative culture" as denounced by Herbert Marcuse in particular. This denunciation was linked to a Nietzschean description of the nihilism that results from "the aesthetic ideal"; it points back to the historical example of the dadaist revolt against the high values of bourgeois ideology. (Jean-François Chévrier, *The Year 1967: From Art Objects to Public Things*, Barcelona [Fondaciò Antoni Tàpies], 1997, p. 169)

18 Some early "map" prints by Terry Atkinson and Michael Baldwin were included in an exhibition on the Situationist International 1957–1972, "On the passage of a few people through a brief period of time," shown at the Centre Pompidou, Paris, the ICA London, and the ICA Boston, in 1989. These may have provided the pretext for an article by Peter Wollen, "Mappings: Situationists and/or Conceptualists," in M. Newman and J. Bird, eds., *Rewriting Conceptual Art*, London (Reaktion Books), 1999. An Art & Language view on the Situationist bohemia was given in the article "Ralph the Situationist," originally published in *Artscribe International*, November/December 1987.

19 Writing of the work of Christopher Williams, Thomas Crow claims that he "demonstrates that even if Conceptual art rarely found its subject matter, it possessed the keys to new modes of figuration, to a truth-telling warrant pressed in opposition to the incorrigible abstraction that had overtaken painting and sculpture in traditional materials" ("Unwritten Histories of Conceptual Art," [see note 16 above], p. 217). I would argue that if Conceptual Art is *not* as thoroughly capable of mystification as is "incorrigible abstraction," it is only because it is more liable to collapse into propaganda.

20 Art & Language, "Editorial Note" to *Art-Language*, new series, no. 3, September 1999, p. 2.

3 On a Picture Painted by Actors

1 The proceedings of the symposium were published in Institut für soziale Gegenwartsfragen, Freiburg i. Br./Kunstraum Vienna, eds., *Art & Language & Luhmann*, Vienna (Passagen Verlag), 1997.

2 . . . About the genealogy of the name "Jackson Pollock Bar." There were two different periods: one naïve (1980) and one more reflexive (since 1993). The first was an accidental amalgamation of *passions* of mine: *painting* (two refused attempts on the Academy of Art of Cologne and Hamburg); *theory* (an *affectionate* passion, not a detective-like rational one); and my life-long dream to be the owner of a *bar* (the mythos bar). So I painted a naïve (subjective expressionist) "Pollock." We wanted to have a theoretical scene and there was something like a "bar." The second period was a result of the growing consciousness of construction/deconstruction we made with our work by producing the series of symposiums called "Freiburger Kulturgesprache in Marienbad" (beginning with the question "Was macht das Denken nach der grossen Theorie?" continuing with "Der diskursive Salon: das Kunstwerk im Zeitalter seiner Kommunizierbarkeit"). This time the project and name "Jackson Pollock Bar" was *first*: as a conceptual

enterprise to perform the construction (or: the social appearance) of theories and theorists; and to install the discourse itself as work. The paintings ("Pollocks" and even those "Painted by Actors") now have only the status of "Art-derivatives" and they are no longer naïve. They are strategically planned, but without any demanding to be art. (Christian Mathiessen, in a letter to Art & Language, October 2000)

3 Reprinted in C. Harrison and P. Wood, eds., *Art in Theory 1900–1990*, Oxford and Malden, Mass. (Blackwell), 1992/3. An expanded two-volume edition has been published in German as *Kunst/Theorie im 20. Jahrhundert*, Stuttgart (Verlag Gerd Hatje), 1998.

4 "We Aim to be Amateurs" was first printed in *Art & Language & Luhmann*, cited in note 1.

5 See S. Freud, "The Uncanny" (1919), in *The Standard Edition of the Complete Psychological works of Sigmund Freud*, 24 vols., ed. J. Strachey, London, 1953–1974, vol. 17, p. 241.

6 J. Kristeva, *Strangers to Ourselves*, New York, 1991, p. 188.

7 Art & Language, "Painting by Mouth," in *Art-Language*, vol. 5, no. 1, October 1982, p. 45.

8 I don't see how this requirement could be satisfied by forging merely illustrative or stipulative connections between past and present, in the manner, for instance, of the Chapman Brothers' appropriation of Goya's *Disasters of War*. We should expect the force both of the "dialectical themes" and of the "critical bearing" to be somehow felt at the level of technique.

9 Art & Language, "Memories of the Medicine Show," *Art-Language*, new series, no. 2, June 1977, p. 37.

10 *Art-Language*, vol. 5, no. 2, March 1984.

11 Art & Language, from a note written in introduction to the English and French texts of *Victorine* published in *Art & Language*, Galerie nationale du Jeu de Paume, Paris, 9 November 1993–2 January 1994, p. 50. See also Carles Guerra, "The Last Possessions: A Dialogical Restoration of Art & Language" in C. Harrison, ed., *Art & Language in Practice*, vol. 2, Barcelona, 1999, p.186:

> The police are made the representatives of those who cannot allow innocence in representations. . . . In approaching art objects as if they were evidence, the policemen deny them their aura. What that accident or defective logic sweeps blithely aside, however, is no more than another kind of confusion. The aura conferred on works of art can indeed be seen as no more than an institutionalised falsehood. And yet in our recognition of the policemen's error, the aura is in a sense restored as a dialectical possibility. The libretto for *Victorine* makes this substitution into a theme. There is a symmetrical structure to that dispute over the use of images which the characters are made to represent. Their dialectical persistence makes the parties look increasingly alike. Authors, experts and philistines are stuck with the particular uses they make of images.

12 The boards are owned by the Froelich Foundation of Stuttgart. They are individually framed and glazed. Their titles are *I (Spirit-Law-Economics)*, *II (Everyone is an Artist)*, and *III (Capital=Art)*.

13 "Art & Objecthood" was first published in *Artforum*, vol. 5, no. 10, June 1967, and is reprinted in M. Fried, *Art & Objecthood*, Chicago (Chicago University Press), 1998.

14 "Ours is in many respects a practice of self-focussing rather than self-enlargement; and yet it is as part of the world of what Alasdair MacIntyre calls 'rich aesthetes, managers and therapists' (and what Richard Rorty calls 'strong poets') that we are bound to malinger" (from a lecture given by Michael and Mel at the Jeu de Paume in December 1993, published as Art & Language, *Conférence du Jeu de Paume: L'Origine du Monde*, Paris [Flammarion 4/Galerie de Paris], 1996, p. 55). The references are to MacIntyre, *After Virtue*, London, 1981 (where the author identifies the manager and the therapist as the key figures in the culture of bureaucratic individualism), and to Rorty, "The Contingency of Community," *London Review of Books*, 24 July 1986.

15 Kosuth, "Art after Philosophy," first published in *Studio International*, October 1969; reprinted in Harrison and Wood, 1992, p. 844.

16 See de Duve, *Kant after Duchamp*, Cambridge, Mass., (MIT Press) 1998, particularly the chapters "The Monochrome and the Blank Canvas," "Do Whatever," and "Archaeology of Pure Modernism." While de Duve acknowledges that "Kosuth can hardly be taken as a spokesman for all conceptual artists," he fails to note relevant distinctions that have already been extensively made in theory and in practice, thus effectively tarring the rest of us with the same brush.

17 Kosuth, "Art after Philosophy" (see note 15 above), in Harrison and Wood, p. 847. All that's demonstrated here is the absurdity of an avant-gardism that separates technical expedients from formal effects. An observation from Michael and Mel: "If it was *not* true that Pollock painted his pictures on the floor, would we look at them at all? Yes, in amazement at his achievement in defying gravity."

18 J. Pollock, interview with William Wright for Sag Harbor Radio, 1950; transcript published in F. V. O'Connor, *Jackson Pollock*, New York (Museum of Modern Art), 1967, p. 81.

19 See A. Kaprow, "The Legacy of Jackson Pollock," *Art News*, vol. 57, no. 6, October 1958, p. 26.

20 Art & Language, in "A Portrait of V. I. Lenin in the Style of Jackson Pollock," part I, from the LP *Kangaroo?* by Art & Language and the Red Crayola, Rough Trade Records, 1981; re-released on CD by Drag City Records, Chicago, 1995.

21 P. Leider, "Literalism and Abstraction: Frank Stella's Retrospective at the Modern," *Artforum*, vol. 8, no. 8, April 1970, p. 44.

22 In conversation with T. J. Clark in the TV program, "Greenberg on Pollock," made for the course *A315: Modern Art and Modernism*, the Open University, Milton Keynes, 1982.

23 Bank, as quoted in *Everything Magazine*, issue 3.3, September 2000, p. 56.

24 "When I am *in* my painting, I'm not aware of what I'm doing. It is only after a sort of 'get acquainted' period that I see what I have been about. I have no fears about making changes, destroying the image, etc., because the painting has a life of its own. . . ." From a statement published in R. Motherwell and H. Rosenberg, eds., *Possibilities*, New York, 1947/1948. Reprinted in O'Connor, *Jackson Pollock* (see note 18 above), p. 40.

25 "A picture lives by companionship, expanding and quickening in the eyes of the sensitive observer. It dies by the same token. It is therefore a risky and unfeeling act to send it out into the world. . . ." From a statement published in *Tiger's Eye*, vol. 1, no. 2, December 1947, p. 44; reprinted in Harrison and Wood, *Art in Theory 1900–1990*, Oxford (Blackwell), 1992, p. 565.

4 On Painting a Landscape

1 This essay has its origins in three papers provoked by Art & Language's paintings on the theme of landscape. The first was published as "'Form' and 'Finish' in Modern Painting," in *Filosofski Vestnik*, 1, 1991, Slovene Academy of Arts and Sciences, Ljubljana; the second as "On Painting a Landscape," in *Kunst & Museumjournaal*, vol. 5, no. 2, Amsterdam, 1993; the third originated in a lecture given at the Galerie National du Jeu de Paume, Paris, in November 1993, during the course of an exhibition of work by Art & Language, and was published as "Art & Language Paints a Landscape" in *Critical Inquiry*, Chicago, March 1995.

2 "The Rhetoric of Temporality," in *Blindness and Insight: Essays in the Rhetoric of Contemporary Criticism*, Minneapolis (University of Minnesota Press), 1983, p. 207.

3 For illustration of these works see *Essays*, plates XIV and XVII.

4 Michael Baldwin and Mel Ramsden, "We Aim to be Amateurs," in Institut für soziale Gegenwartsfragen, Freiburg i. Br./Kunstraum Wien, eds., *Art & Language and Luhmann*, Vienna (Passagen Verlag), 1997, pp. 164–165.

5 We had by then exhibited the *Incidents* in Brussels. They had, like everything else, turned into catalogue illustrations. The form of the insertion was the plan of a museum. The illustrations were the contents of these insertions. Instead of Art & Language early work appearing fictionally installed [as it was in the *Incidents*], the fictional sites of installation themselves appear as the graphic content of a museum plan which the *Unit Cure, Unit Grand* image itself reflects. Allegory eats allegory. (Michael Baldwin, MS note, October 2000)

6 *Courbet's Realism*, Chicago and London (Chicago University Press), 1990. My interest in this work was expressed at more length in a review published in *The Art Bulletin*, vol. 74, no. 2, June 1992, pp. 341–344.

7 Cf. "I doubt if I have ever been present when a speaker did something like shout 'water!' as a warning of fire, knowing what 'water!' means and knowing that his hearers also know, but thinking that they would expect him to give to 'water!' the normal meaning of 'Fire!'" Jonathan Bennet as quoted by Donald Davidson in "A Nice Derangement of Epitaphs," from *Truth and Interpretation: Perspectives on the Philosophy of Donald Davidson*, Oxford (Blackwell), 1986, p. 433 fn. Cited by Michael Baldwin in "Artist's Language 2," *Art-Language*, new series, no. 3, September 1999, p. 56.

8 It is not entirely irrelevant that, though reflections have tended to reenter the work of painters in the twentieth century in response to the photograph, classically reflections tended to serve painting as metaphorical devices by means of which to set the facticity of the contingent beside the insubstantial and immutable perfection of the eternal. I have in mind such canonical works as Titian's *Venus with Mirror* in Washington and Ingres's *Portrait of Madame Moitessier* in London. Less exotically and more recently, Michael Baldwin worked with mirrors in 1965 (see *Essays*, p. 20, plate 12), and Ian Burn in 1967 (*No object . . . Mirror*). Mirrors and mirrorlike surfaces have also featured in the work of Robert Morris (*Mirrored Cubes* of 1965), Robert Rauschenberg (*Commissioned and Carnal Clocks*, shown at the Castelli Gallery, New York, in 1969), Gerhard Richter (*Double Glass* of 1977 and *Mirror Painting* of 1991), and others.

9 See T. J. Clark, "Preliminaries to a Possible Treatment of *Olympia* in 1865," in *Screen*, vol. 21, no. 1, London, Spring 1980, pp. 18–41. In discussing Manet's painting, Clark asks, provocatively, ". . . whether what we are studying here is an instance of subversive refusal of the established codes, or of a simple ineffectiveness. . . . Would it be helpful to say . . . that *Olympia* failed to signify in 1865?" See also P. Wollen, "Manet, Modernism, and the Avant-Garde," *Screen*, Summer 1980; M. Baldwin, C. Harrison, and M. Ramsden, "Manet's *Olympia* and Contradictions; apropos T. J. Clark's and Peter Wollen's recent articles," *Block*, no. 5, Middlesex, 1981; and "Olympia's Choice," in Clark, *The Painting of Modern Life: Paris in the Art of Manet and His Followers*, London (Thames and Hudson), 1985.

10 See chapter 10, "The Simple Life: Pastoralism and the Persistence of Genre in Recent Art," in Thomas Crow, *Modern Art and the Common Culture*, New Haven and London (Yale University Press), 1996.

11 "Retrospective Exhibitions and Current Practice," in *Art & Language 1966–1975*, Museum of Modern Art, Oxford, summer 1975, p. 3.

12 See chapter 3, "The Spectator in the Picture," in Wollheim, *Painting as an Art*, Princeton (Princeton University Press) and London (Thames and Hudson), 1987.

13 I intend an echo of T. J. Clark's impatience at the normal alternatives adopted in study of nineteenth-century art history: "The history of an heroic *avant-garde*, and the movement away from literary and historical subject-matter towards an art of pure sensation. . . . What a bore these two histories have become!" See "On the Social History of Art," in Clark, *Image of the People: Gustave Courbet and the 1848 Revolution*, London (Thames and Hudson), 1973, p. 18.

14 On the "contemplative account of knowledge," see chapter 1, "The Problem of Knowledge" in Barry Barnes, *Interests and the Growth of Knowledge*, London (Routledge and Kegan Paul), 1977.

15 I am aware that to conjoin the idea of a critique of Modernism with the critique of "vision" is to be driven into the margins of what has grown into a large theoretical preserve. Stephen Melville has associated "a relatively well-developed and secure notion of 'the postmodern'" both with a critique of Greenberg and with reference to the emergence "of those whom the Western tradition has cast as 'other.'" Within this "general picture of the postmodern" he draws attention to "the critique of vision," referring specifically to the volume *Vision and Visuality* edited by Hal Foster, which includes contributions from Rosalind Krauss, Martin Jay, and Jonathan Crary. According to Melville:

> The critique of vision as an art historical project gained its initial impetus from the theoretical formulations worked out in critical encounter with the work of Cindy Sherman, Laurie Andersen, Barbara Kruger, Sherrie Levine, and others; these formulations were themselves explicitly indebted to French "poststructuralist" writing – the writings of Jacques Derrida, Michel Foucault, Jacques Lacan, and Georges Bataille.

See Melville, "In the Light of the Other," in *Whitewalls* 23, Chicago, fall 1989, pp. 10–11. While Melville's account is no doubt apt to the American circumstance he principally addresses, it should be stressed that, even in the terms in which he glosses it, the "critique of vision" has another and longer

"art history," both pursued in and impelled by other artistic practices, and drawing on similar and other theoretical resources.

16 "Art has its history as a sheer phenomenon, and it also has its history as quality," in Greenberg, "Complaints of an Art Critic," *Artforum*, vol. 6, no. 2, October 1967, pp. 38–39.

17 On malapropism, see chap. 1, note 41, above.

18 David Batchelor, ed., "A Conversation in the Studio about Painting: An extract from an interview with Art & Language," in *Art & Language: Hostages XXV–LXXVI*, Paris (Galerie de Paris), London (Lisson Gallery) and New York (Marian Goodman Gallery), 1991, p. 9.

19 For discussion of these works see *Essays*, chap. 4, "The Conditions of Problems."

> In the first panel of a typical work from the series, a number of indices signifying points of depth is mapped onto a configuration taken from a sample of Constructivist graphics. Certain areas of the same configuration are designated as "surface" and are marked out as such by reiterations of the abbreviation "Surf." The second panel displays a printed text. This addresses the nature of Art & Language work and dialogue, questions of ideology, learning and language. The separate sections of text are variously marked with those indices which appear on the graphic panel alongside. The suggestion made in this work is that there is a possible "reading" of the dialogical text which is a kind of picture; i.e. which amounts to a mapping of its surface and depth upon one synchronous surface. The work will also sustain the corollary that there is a possible "viewing" of the graphic image which quantifies its formal ingredients by reference to a linguistic text.

In the landscape *Hostages*, the configurations to which the letters S-U-R-F are made to conform are taken from canonical examples of abstract art, from the graphic idealizations of town-planners, from the ground-plans of would-be postmodernist museums, and from other such attempts to give modernity a proper *shape*.

20 Jacques Derrida, "On the Gift," The Carpenter Lectures, 1991.

21 Marcel Mauss, "Essai sur le don," *Année Sociologique*, 1923–1924.

22 See note 6, this chapter.

23 This is where "vision" becomes an inescapably psychoanalytical property and encroaches on the theoretical territory of "the Gaze." However, I do not wish to lose the sense that the possibility of *seeing* himself seeing through a woman's eyes was probably ruled out for Degas for reasons that were at least as much sociological – i.e., matters of social decorum – as psychoanalytical. After all, the imaginary position involved is not one that an artist would nowadays have much difficulty in adopting, given that some degree of self-conscious concern for the relativities of "gender" has become virtually mandatory both in avant-garde practice and in academic discourse.

5 Fascinated by Glass

1 I tried to address this problem in my paper "The Effects of Landscape," contributed to W. J. T. Mitchell, ed., *Landscape and Power*, Chicago (University of Chicago Press), 1994.

2 For a discussion of Pissarro's *Hoarfrost – The Old Road to Enery* in terms of this problem, see *Essays*, chap. 7, pp. 200–202.

3 "I was originally alerted to the glories of glass-plus-painting in Rome in 1974 when the guards at Contemporanea combed their hair in front of a Reinhardt which had been glazed so as to become a) a sort of mirror, b) nearly invisible as a painting." Michael Baldwin, MS note, October 2000.

4 R. Krauss, from the original English typescript (pp. 12–13) of "Art & Language Turns to Painting, A Strange Quirk in the Fate of Conceptual Art," published as "Art & Language se met à la peinture; étrange aléa de l'art conceptuel," *Art Press*, hors-série, no. 16, 1995, pp. 54–58. A response by Michael Baldwin, Charles Harrison, Mel Ramsden, and Paul Wood was published in abbreviated form as "Rosalind Krauss: un pétard mouillé," in *Art Press*, hors série, no. 17, 1996, pp. 174–178, and in full as "Northanger Abbey," in *Art-Language*, new series, no. 2, June 1997, pp. 50–64.

5 In David Batchelor, ed., "A Conversation in the Studio about Painting: An Extract from an Interview with Art & Language," in *Art & Language: Hostages XXV–LXXVI*, Paris (Galerie de Paris), London (Lisson Gallery) and New York (Marian Goodman Gallery), 1991, p. 20. The reference is to Michael Fried's essay "Art and Objecthood," first published in *Artforum*, vol. 5, no. 10, June 1967.

6 I have in mind here Michael Fried's essay "Shape as Form: Frank Stella's New Paintings," first published in *Artforum*, vol. 5, no. 3, November 1966, reprinted in Fried, *Art and Objecthood*, Chicago (Chicago University Press), 1998. In this important statement of late-Modernist aesthetic principles, Fried considers the relationship between literal shape and pictorial form a crucial issue for the preservation of quality in modern painting. For Fried, as for all critics in the mainstream Modernist tradition, the sine qua non of aesthetic achievement is the victory of the noumenally "present" over the physically "literal." In considering form as both a more practical and a more *provisional* concept than Fried allows it to be, I mean to modify the terms of his argument and rather to suggest that it is the persistence of a *dialectic* between the (meanings of the) figurative and the (meanings of the) literal that secures the continuing possibility of painting as a form of art. This would accord the work of Donald Judd the critical pertinence to recent *painting* that Fried denied him in the development of art as a whole.

7 First given as a broadcast over the Voice of America in 1960; printed in *Arts Yearbook IV*, New York, 1961; reprinted in C. Harrison and P. Wood, eds., *Art in Theory 1900–1990*, Oxford and Cambridge, Mass. (Blackwell), 1992/1993.

8 First published in *Studio International*, London, vol. 180, no. 928, December 1970; second version included in Wollheim, *On Art and the Mind*, Cambridge, Mass., 1973; edited version in Harrison and Wood, 1992.

9 In a spirit of heightened skepticism, one might look for some causal connection with the popular acclaim accorded to Tate Modern in London, and with the present adoption of British avant-garde art as *successful* state culture.

10 "A Conversation in the Studio about Painting" (see note 5 above), pp. 14 and 17.

6 Tasteless Experience

1 See Wollheim, "On Drawing an Object," in *Art and the Mind* (London, 1973 and Cambridge Mass., 1974). See also "What the Spectator Sees" in *Painting as an Art*, Princeton (Princeton University Press) and London (Thames and Hudson), 1987:

> . . . the painter places himself as he does because he paints with, that is partly with – his eyes. It isn't that he paints first, and looks afterwards. The eyes are essential to the activity. But the problem is that, if this answer is right, . . . the same goes for, say, driving a car. . . . Like the driver, the artist does what he does *with* the eyes. Unlike the driver, he also does it *for* the eyes. (pp. 43–44)

2 See Schier, "Painting after Art? Comments on Wollheim," in N. Bryson, M. A. Holly, and K. Moxey, eds., *Visual Theory*, New York (Harper Collins), 1991.

3 The reference is to T. Crow, *Painters and Public in Eighteenth-Century Paris*, New Haven, Conn. (Yale University Press), 1985.

4 Published in *Art & Language: Now They Are*, Brussels (Galerie Isy Brachot), 1992, pp. 81–85.

5 [Courbet's] *L'Origine du monde* is a voyeuristic picture of the female sexual parts; its history has been one of concealment, of seclusion. Consider the possibility that it is or has become thereby the object of increased voyeuristic interest, the sexual parts of a nun perhaps: a nun's cunt. The letters of nun's cunt are rearranged to form the Latin words "nunc sunt," which translates back into English as "now they are" . . . which would be a literal possibility if we were looking at *L'Origine du monde*. (From a lecture given by Michael Baldwin and Mel Ramsden at the Jeu de Paume, Paris, in December 1993, published as Art & Language, *La Conférence du Jeu de Paume: L'Origine du monde*, Paris [Flammarion 4/Galerie de Paris], 1996, p. 63)

6 "When I remember the puzzlement and insecurity of one's first confrontation with his work, along with his name, which was just as new. And then for a long time nothing, and suddenly one has the right eyes. . . ." R. M. Rilke, *Letters on Cézanne*, ed. Clara Rilke, London (Jonathan Cape), 1988, p. 43 (letter of October 10, 1907).

7 I am committed to expanding this inquiry into a full-length study. I have published some preliminaries in "Cézanne: Fantasy and Imagination," *Modernism/Modernity*, vol. 4, no. 3, September 1997, and "Degas' Bathers and Other People," *Modernism/Modernity*, vol. 6, no. 3, September 1999.

8 Note to author, November 2000.

9 From "Preliminary Digression" to "Art & Language Paints a Picture (VI)" (see note 4 above).

10 See S. Faunce and L. Nochlin, *Courbet Reconsidered*, New York (the Brooklyn Museum), 1988.

11 See "Sexuality in the Field of Vision" by Jacqueline Rose, originally written for the catalog of the exhibition "Difference: On Representation and Sexuality," New York (Museum of Contemporary Art), 1984–1985; reprinted in Rose, *Sexuality and the Field of Vision*, London (Verso), 1986.

12 These are two of three paintings of women subject to acts of violence that were first exhibited in "Aspects of British Art Today" at the Metropolitan

Museum, Tokyo, in 1982. The third was *Attacked by an Unknown Man in a City Park: A Dying Woman; Drawn and Painted by Mouth* (see *Essays*, plate V).

13 See chap. 4, this volume, note 9.

14 *La Conférence du Jeu de Paume* (see note 5 above), p. 58.

15 It may be that the differences in question can be made out in ethical, political, psychological, or social terms, and that they are the conditions of other kinds of distinctions, such as those we intend in talking of a work's "originality," of its "being interesting" or "worthwhile," etc.

16 *L'Origine du monde* was for a while in the Hatvany Collection in Budapest, from which it seems to have disappeared during the Second World War.

17 Nochlin (*Courbet Reconsidered,* note 10, p. 178) refers to an account of Courbet's painting and of Masson's "hiding device" in Lacan's study, as given in E. Roudinesco, *La Bataille de cent ans: Histoire de la psychanalyse en France. 2: 1925–1985,* Paris, 1986, p. 305.

18 "Allegories of Identity: Notes on a Selection of Art & Language Paintings 1968–1992," in *Art & Language: Now They Are,* (see note 4 above), p. 80.

19 Art & Language, "The Utterance of Painting," in "On Conceptual Art and Painting and Speaking and Seeing: Three Corrected Transcripts," *Art-Language,* new series, no. 1, June 1994, pp. 56–57.

20 See, for instance, *Essays,* p. 204. In fact, following its installation in the Centre Pompidou, *The Deep* initially entertained Michael, who took a sadistic pleasure in making Mel and myself regard it in a similar light. See the TV program "Beaubourg" made by Michael Baldwin for the course *A315: Modern Art and Modernism,* Open University, Milton Keynes, 1983.

7 Reflections on the Nude

1 From Klein's "Sorbonne Lecture," delivered in 1959; transcript published in C. Harrison and P. Wood, eds., *Art in Theory 1900–1990,* Oxford and Cambridge, Mass. (Blackwell), 1992/1993, p. 803.

2 Honoré de Balzac, *Le Chef d'oeuvre inconnu (The Unknown Masterpiece),* 1832, first published 1845. The relevant excerpt is reprinted in C. Harrison, P. Wood, and J. Gaiger, eds., *Art in Theory 1815–1900,* Oxford and Malden Mass. (Blackwell), 1998, pp. 89–93.

3 At the close of his "Art as Art," originally published in *Art International,* vol. 6, no. 10, December 1962; reprinted in Harrison and Wood, *Art in Theory 1900–1990,* 1992, p. 809.

4 From a talk "Art as Art Dogma," given at the Institute of Contemporary Arts, London, in May 1964. Transcript published in *Studio International,* December 1967.

5 P. W. Bridgman, "The Paradoxes of Absolute Zero" in *The Nature of Thermodynamics,* New York (Harper Torchbooks), 1961, p. 204. *Two Black Squares: The Paradoxes of Absolute Zero* is the title of a black painting made by Mel Ramsden in 1966.

6 See de Duve, chapter 4, "The Monochrome and the Blank Canvas," in *Kant after Duchamp.* De Duve's is a compelling and highly developed thesis, which has the merits of acknowledging the arguments of Greenberg and Fried without needing to reduce them to caricatures. While the book is

predicated on an estimation of Duchamp's primary status that I cannot share, de Duve is certainly successful in demonstrating that various (mostly American) kinds of "going beyond" modernism were actually attempts to go beyond *Greenberg*, attempts that nevertheless remained firmly within the conceptual range of Greenberg's Modernist theory. From the perspective of the present study, the most regrettable weakness in de Duve's work is that though his dismissal of Kosuth is in itself well argued, it leads him to dismiss the Conceptual Art movement as a whole on inadequate or inappropriate grounds. (Some encouragement is to be drawn from the inclusion of an early work by Michael Baldwin in "Voici," an exhibition curated by de Duve at the Palais des Beaux-Arts, Brussels, in January 2001.)

7 Ibid., p. 238:

> Once even a blank canvas can be called a picture anything visible can be called art, in which case art has lost its aesthetic import and taste is not called for. The sentence "This is art" is a convention. Historical knowledge alone is required to make and judge art, some intellectual curiosity or interest for the "logic" of modernism, some strategic desire or interest to see it further extrapolated and tested on mere institutional grounds. Art fades into "art theory." Such is the left branch of the alternative. It is all too easy to see that minimal art and the movements that were to follow, conceptual art especially, chose the left branch, expressed in a nutshell by Judd's famous assertion from "Specific Objects": "A work needs only to be interesting."

8 "We were prepared to countenance the Hegelian possibility. But only as *teachers* perhaps. I tried to force the administration to name the Fine Art course at Coventry 'Romanticism' for this very reason. Art vanishes into theory at its most Romantic according to Hegel" (note to the author from Michael Baldwin, November 2000). Between 1969 and 1971 Terry Atkinson, Michael Baldwin, and David Bainbridge, all three then associated with Art & Language, were teaching at Coventry College of Art on a course with a marked "Art Theory" component. In 1971 the course was dismantled by arbitrary exercise of administrative power.

9 In his "Preface to Stripe Painting," written to accompany the exhibition of Stella's work at the Museum of Modern Art in 1959. See Dorothy Miller, ed., *Sixteen Americans*, New York (Museum of Modern Art), 1959, p. 76.

10 There are curves and curves. This is de Duve: ". . . I have yet to see the 'ultimate' blank canvas. While I am not enthralled at the prospect, I am not ready, as is Michael Fried, to rule out a priori the eventuality of its being a successful painting, but on terms that are, of course no longer modernist, that is to say, utopian or apocalyptic." This passage is accompanied by a significant and endearing footnote: "Going over my text again, I realize that I have done exactly the same thing that Greenberg did in 1962, but in relation to today's dominant ideology. I just legitimized in writing a blank canvas that no one has actualized yet. I would be lying if I tried to hide that it is in hope that it will never be." *Kant after Duchamp*, pp. 262–263. The references are to Greenberg's essay "After Abstract Expressionism" of 1962: ". . . a stretched or tacked-up canvas already exists as a picture – though not necessarily as a successful one"; and to Fried's response published five years later in "Art and Objecthood":

> It is not quite enough to say that a bare canvas tacked to a wall is not "necessarily" a successful picture: it would, I think, be more accurate

to say that it is not *conceivably* one. It may be countered that future circumstances might be such as to *make* it a successful painting; but I would argue that, for that to happen, the enterprise of painting would have to change so drastically that nothing more than the name would remain.

It is deserving of note that de Duve speaks of a "canvas" and Greenberg of a "picture," while Fried appears to conflate "picture" and "painting."

11 Neil Hertz, *The End of the Line: Essays on Psychoanalysis and the Sublime*, New York (Columbia University Press), p. 211. Maxime du Camp, writing of Courbet's *L'Origine du monde* (in *Les Convulsions de Paris*, Paris, 1889), suggested sarcastically that the painter's exclusion of all but the sex, belly, and breast of his model was due to his having catered to the tastes of a wealthy Moslem.

12 See the letter quoted in chap. 4, this volume, pp. 106 and 108.

13 "The Romantics were prompted," first published in *Possibilities*, New York, 1947, p. 84; reprinted in Harrison and Wood, 1992, p. 564.

14 Lecture at the Pratt Institute, New York, 1958, as cited from a transcript in the Rothko archives in J. E. B. Breslin, *Mark Rothko: A Biography*, Chicago (University of Chicago Press), 1993, pp. 394–395.

15 "Art and Language's Doubt," in C. Harrison, ed., *Art & Language in Practice*, vol. 2, Barcelona (Fondació Antoni Tàpies), 1999, p. 252–253.

16 Art & Language, "The Utterance of Painting," from "On Conceptual Art and Painting and Speaking and Seeing: Three Corrected Transcripts," *Art-Language*, new series, no. 1, June 1994, pp. 49 and 53.

17 "If I must place my trust somewhere, I would invest it in the psyche of sensitive observers who are free of the conventions of understanding. I would have no apprehensions about the use they would make of the pictures for the needs of their own spirit. For if there is both need and spirit, there is bound to be a real transaction." Mark Rothko, from a letter to Katherine Kuh, 1954, printed in *Mark Rothko*, London (Tate Gallery), 1987, p. 58.

18 This is the concluding sentence to R. G. Collingwood, *The Principles of Art* (first published 1938), Oxford (Oxford University Press), 1970, p. 336.

19 Ludwig Wittgenstein, *Philosophical Investigations*, X1, Oxford (Blackwell), 1953, pp. 195–196.

20 Greenberg, "Complaints of an Art Critic," first published in *Artforum*, vol. 6, no. 2, October 1967, p. 38. In extension of his claim that "Esthetic judgements are involuntary," Greenberg asserts "You can no more choose whether or not to like a work of art than you can choose to have sugar taste sweet or lemons sour." This analogy is surely fallacious. It might be amended thus: "You can no more choose to like a work of art than you can choose to like the sweet taste of sugar or the sour taste of lemons." This makes it easier to grasp the connections he intends between immediacy, involuntariness, liking, and taste, but it does not establish those connections in the form of a secure argument.

21 I have attempted to apply a similar set of propositions to the contemporary and more recent reception of Degas's pastels of women represented, as he intended, in "moments of unselfconsciousness, as though they were not being observed." See my "Degas' Bathers and Other People," in *Modernism/Modernity*, vol. 6, no. 3, September 1999.

22 *Philosophical Investigations*, X1, p. 213.

23 For more detail on the distinction between fantasy and imagination as I understand it, see my "Cézanne: Fantasy and Imagination," *Modernism/ Modernity,* vol. 4, no. 3, September 1997.

24 See my "Degas' Bathers and Other People."

25 "The exhaustion was, as it were, *in* us rather than with the genre as such. We could think of nothing much further to do with the landscape-glass-rogering technicality. We gave up the struggle." Note to the author from Michael Baldwin and Mel Ramsden, November 2000.

26 See M. Fried, *Courbet's Realism,* Chicago (Chicago University Press), 1990, p. 211, where the two works are reproduced together. Fried quotes Werner Hofmann:

> What again and again draws Courbet's eye into caves, crevices and grottoes is the fascination that emanates from the hidden, the impenetrable, but also the longing for security. What is behind this is a panerotic mode of experience that perceives in nature a female creature and consequently projects the experience of cave and grotto into the female body. . . . This compulsive wish is the key that leads to the understanding of his women and landscapes. In this way both themes end up on a common level of meaning. (From "Courbet's Wirklichkeiten" in W. Hofmann, P-K. Schuster, et al., *Courbet und Deutschland,* Hamburg [Hamburg Kunsthalle], 1978, p. 610)

27 Note to the author, November 2000.

28 We shall . . . uncover the *avant-garde* only if we criticize it, see the point of an art of pure sensation only if we put back the terror into the whole project. In other words, explain Mallarmé's words to Villiers de l'Isle-Adam: "You will be terrified to learn that I have arrived at the idea of the Universe by sensation alone (and that, for example, to keep firm hold of the notion of pure Nothingness I had to impose on my brain the sensation of the absolute void)." (T. J. Clark, "On the Social History of Art," in *Image of the People: Gustave Courbet and the 1848 Revolution,* London [Thames and Hudson], 1973, p. 19)

29 From "An edited Transcript of a Tour of the Exhibition with the Artists"; photocopied sheet to accompany an exhibition at the Lisson Gallery, London, June–July 1994.

8 Painting and the Death of the Spectator

1 My sense here is close to what Wollheim calls "expressive perception," which in his account follows from "seeing-in." (See especially *Painting as an Art,* Princeton [Princeton University Press] and London [Thames and Hudson], 1987, pp. 80–89.) "Expressive perception stands to expression in much the same way as seeing-in stands to representation" (p. 85). For Wollheim, successful recovery of the meaning of a painting depends on its being looked at in a manner conforming to the artist's intention – allowing intentions to be possibly, indeed importantly, unconscious. "Intentions must be understood so as to include thoughts, beliefs, memories, and, in particular, emotions and feelings, that the artist had and that, specifically, caused him to paint as he did" (p. 86). Wollheim gets around the traditional objection to expression theories – that we have no means of con-

firming that what we experience conforms to what the causal conditions in question have produced – by stressing the spectator's obligation to look at the painting in the right way; that is to say, by looking at it as it is *made* to be looked at. I follow Wollheim in holding that if a work of art is not made so as to produce a *relevant* response in a competent spectator, then it is an incompetent work of art. But we might want to allow a work of art to be the occasion of some critical *exchange* between the competences at issue.

2 Cf. C. Greenberg: "Whereas one tends to see what is *in* an Old Master before seeing it as a picture, one sees a Modernist painting as a picture first. This is, of course, the best way of seeing any kind of picture . . . but Modernism imposes it as the necessary and only way . . ." ("Modernist Painting," 1960; in Harrison and Wood, 1992, p. 756). Greenberg tended to use the term "picture" in a sense conforming more closely to the French "*tableau*" than to the standard sense of picture as "picture of. . . ." Fried has drawn attention to the critical significance of the concept of *tableau* – to mean a composition that is unified technically, expressively and, as it were, *philosophically* – in "the thought and practice of French painters and critics of the eighteenth and nineteenth centuries." See M. Fried, *Absorption and Theatricality: Painting and Beholder in the Age of Diderot*, Berkeley, Los Angeles and London (California University Press), 1980, p. 212.

3 To be specific: a culture – or rather cultural formation – that can resist instrumentation and pacification and co-option to the interests of end-of-history capitalism, and that is therefore inherently worth pursuing.

4 Stella's testimony was given in an interview on "Front Row," BBC Radio, in 1999, at the time of an exhibition of his work at the Hayward Gallery, London.

5 For responses representative of this type of spectator, see the coverage of Conceptual Art published in Robert Hughes, *The Shock of the New*, London (BBC), 1980, pp. 387–390, and Norbert Lynton, *The Story of Modern Art*, London (Phaidon Press), 1980, pp. 329–336.

6 See Fried, "Art and Objecthood," *Artforum*, vol. 5, no. 10, June 1967.

7 *Essays*, pp. 176–177. The painting is illustrated on p. 176, plate 93.

8 Note to the author, November 2000.

9 See T. de Duve, *Kant After Duchamp*, chapter 4.

10 Note to the author, November 2000.

11 See E. Gombrich, *Art and Illusion*, London (Phaidon Press), 1960, pp. 206–207.

12 See, for instance, the chapter "Saturday Disasters: Trace and Reference in Early Warhol," in T. Crow, *Modern Art and the Common Culture*, New Haven and London (Yale University Press), 1996.

13 "I still find Mary Midgely's citation of Bill Shankly quite profound: 'Mr Shankly, football is only a game, but you seem to treat it as a matter of life and death'; 'Yes, it's only a game, and it's a matter of life and death.'" Michael Baldwin, in "Art & Language," interview by David Batchelor, *Journal of Contemporary Art*, vol. 2, no. 1, spring/summer 1989, p. 22. Bill Shankly was manager of Liverpool Football Club.

14 Note to the author, November 2000.

15 Said on the occasion of an exhibition of these works at the Juana de Aizpuru Gallery, Madrid, 1995.

9 Being Here

1 *Index 01* was made for exhibition at "Documenta 5" in 1972; development of the series "Dialectical Materialism" was encouraged by the prospect of exhibition at the Museum of Modern Art, Oxford, in 1975; "Portraits of V. I. Lenin" were originally developed in 1979–1980 as a means of filling the VanAbbemuseum at Eindhoven with color-photocopies; the first two Studio paintings were made with a view to exhibition at "Documenta 7" in 1982; development of the *Incidents in a Museum* followed an invitation to exhibit the series at the Palais des Beaux-Arts, Brussels, in 1987; work on the series *Index: Now They Are* was in part driven by the need to have new work for a show at the Jeu de Paume, Paris, in 1993; and the first 500 or so panels of *Sighs Trapped by Liars* were produced in 1996–1997 with "Documenta X" in mind.

2 The artist Antoni Tàpies established the foundation in the Casa Montaner i Simon, designed in 1884 by the Catalan architect Lluís Domènech i Montaner.

3 "The Artist Out of Work: Art & Language 1972–1980," PS1, New York, September–December 1999. The exhibition also included both the *Documenta Index* and *Wrongs Healed in Official Hope*.

4 When I was attempting to chronicle the early activities of Art & Language for *Essays on Art & Language* I cast about in search of relevant methodological precedents. The most useful came not from the standard literature of modern art history but from the discographies of some long-running rock groups.

5 Adolf Loos's "Ornament und Verbrechen" (Ornament and Crime) is a canonical early statement of the Modern Movement position that the elimination of ornament is to be associated with cultural progress. It was first published in French in *Les Cahiers d'Aujourd'hui* in June 1913, from a talk given in Vienna in 1910, and was reprinted in *L'Esprit nouveau*, November 15, 1920. There is now a substantial literature associating decorativeness with the dangerous "other" to high Modernist ambition.

> We're saying that the conversational and the decorative are connected. . . . A mark of the conversational is that it is liable to collapse into a pragmatic or concatenatory excess or emptiness – a practical resistance to theory – and that is a resistance to a hegemony of academic observance, protocol and closure. It could be that conversation is the criminality of theory just as decoration might be the forensic degeneration of sense. (Art & Language, "Making Meaningless" in C. Harrison, ed., *Art & Language in Practice Vol. 2*, Barcelona [Fondació Antoni Tàpies], 1999, pp. 243–244)

6 Michael Baldwin, "Artist's Language 2," in *Art-Language*, new series, no. 3, September 1999, p. 49.

7 Ibid., p. 54. See Kafka, "A Problem for the Father of the Family," in *The Transformation and other Stories*. "Odradek" was also the title of an exhibition curated by Thomas Mulcaire, Liam Gillick, and Paul Sztulman and held at Bard College, New York in 1998. A work by Art & Language was included.

8 Matisse was brought specifically to mind by the exhibition "L'Envers du décor," organized by Joelle Pijaudier at the Musée d'art moderne, Villeneuve d'Asq, in 1998, where two *papiers collées* from the *Océanie* series were

hung in the same room with Art & Language's *Documenta Vitrine* and some striped sails by Daniel Buren.

9 It could be argued – as it implicitly was by Robert Morris – that this was a triumph of a kind. For example, the work of Don Judd, Carl Andre, and Sol LeWitt might be said to restore the critical connection between art and design that seemed to break with the failure of the European Modern Movement in the 1930s, and thus to impose a requirement of stylistic plainness and economy on its wider surroundings. But the ethical origins of the Modern Movement lay in the transcendental socialism of the late nineteenth century, and the movement collapsed as the prospect of transformation in everyday life was defeated in the world of practical politics. It would be idealism to suppose that that defeat is reversible through the agency of art. In fact, it is questionable how far the environmental conditions required by the geometrical phase of Minimalism are now practically attainable outside the world of powerful institutions and the super-rich – a constituency among whom Judd himself was certainly to be counted by the time he established his aesthetic control over the town of Marfa. We all have to live with contradiction, and the achievements of the three artists named are exemplary and considerable. The point is that they have not been matched by any of those who have sought to build on the *generic* character of their work. The work of these three artists still serves to make much subsequent sculpture or three-dimensional work look overfabricated, arch, and small-town.

10 B. Newman, "Art of the South Seas," first printed in English in *Studio International,* vol. 179, no. 919, February 1970, p. 70. The essay was written as a review of an exhibition held at the Museum of Modern Art, New York, in 1946. It was originally printed in Spanish in *Ambos Mundos,* June 1946, as "Las Formas Plasticas del Pacifico." Newman's evident concern at the time was with the possibility of an abstract art expressive of the concerns of "the modern mind." "All life is full of terror," he wrote:

> The reason primitive art is so close to the modern mind is that we, living in times of the greatest terror the world has known, are in a position to appreciate the acute sensibility primitive man had for it. . . . In Oceania, terror is indefinable flux rather than tangible image. The sea and the wind . . . approach metaphysical acts. . . . The terror they engender is . . . one that arises before abstract forces. The Oceanic artist, in his attempt at an explanation of his world, found himself involved in an epistemology of intangibles. By coping with them, he developed a pictorial art that contained an extravagant drama, one might say a theatre, of magic.

11 M. Fried, "An Introduction to My Art Criticism," in *Art and Objecthood,* Chicago (Chicago University Press), 1998, p. 15.

Index

Page numbers in bold indicate the locations of plates

abstract art, 6, 24, 35, 68, 74, 115, 120, 132, 158, 173, 186, 203, 211 n25; *see also* Abstract Expressionism

Abstract Expressionism, 19, 37, 40, 50, 52, 67, 69; *see also* Newman, Pollock, Rothko, Still

Academy, Académie, 7, 64

Adorno, Theodor, 40

advertising *see* publicity

aesthetic, aesthetics, 117–118, 155, 163, 181, 202: and Conceptual Art, 25, 42; criteria, 39; effect, 13; experience, 96–97, 160; failure/success, 15; intuition, 159; judgment, 158, 225 n20; Modernist, 40–41, 221 n6; production, 163; protocols, 11, 117; value, 39, 45, 47, 98, 162; *see also* self-criticism

Allais, Alphonse: *Première communion . . .*, **145**

allegory, 52, 57, 79–81, 140, 164, 207, 218 n5

amateur, amateurishness, 89, 93, 101–102, 113; *see also* competence

Andre, Carl, 126, 147, 228 n9

Antoni Tapies Foundation *see* Tapies Foundation

Art & Language: **exhibitions:** "Art & Language in Practice," **68,** 70–75, **72,** 192–194, **196, 197;** "Artist out of Work," 192–194, **197, 198;** plan for Barcelona wall, **194–195:** Painting by mouth/PBM, 10–11, 52, 56, 58, 179; **texts by:** "Art & Language Paints a Picture," 50–52, 60, 67, 71–75; "Art & Language Paints a Picture (VI)," 125–126, 130, 136–137, 138, 140–141; *Victorine,* 58–60, 134–135, 216 n 11; "We Aim to be Amateurs," 51; **works by:** *Artists' Studios,* 57–60, 134–135, 136–137, 164, 179, 228 n1; *Index: the Studio at 3 Wesley Place . . .,* 50, 52, **53,** 129, 196–198; *Attacked by an Unknown Man in a City Park . . .,* 9–11, **10,** 60; "Dialectical Materialism," 102, 228 n1; *Documenta Index* (see *Index 01*); *Documenta Vitrine,* 30–**33;** *Down to the Stone,* **208;** *Exit: Now They Are,* **128;** *Hostage and a People's Flag,* 83–84, 91–92, 198; *Hostages,* 81, 84, 86–122, 130, 135, 164, 198, 220 n19: *Hostage (Views of Immensity),* 4–5; *Hostage XIX,* 89–92, **90,** 100–101; *Hostage XXIV,* 86–88, **87;** *Hostage XXV,* **100;** *Hostage XXIX,* **83;** *Hostage XL,* **105,** *Hostage LIV,* **114;** *Hostage LXVI,* **120,** 122; *Hostage LXXIII,* **121,** 122; *Hostage LXXIV,* **107,** *Hostage LXXV,* **116;** *Incidents: Now They Are,* 126, 142, 164–167, **165;** *Indexes,* 95: *Index 01,* **26, 27,** 30, 58, 129, 196–197, 200, 203, 228 n1; *Index 11: Background, Incident, Foreground,* **188, 189;** *Index: Incident in a Museum (Madison Avenue) XIV,* 80; *Index: Incident . . . XXV,* 80, 82; *Index:*

Incident . . . XXVI, 80, 82; *Indexes: Now They Are,* 125–167, **144,** 198, 222 n5, 226 n1; *Index: Now They Are,* 141; *Index V: Now They Are,* **139;** *Index XIV: Now They Are,* **158, 159;** *Index XX: Now They Are,* **149, 150;** *Index: Wrongs Healed in Official Hope,* 74, 75, 198–203, **201, 202;** *Man Battering His Daughter to Death as she Sleeps . . .,* **134;** *Map for Portrait of V. I. Lenin . . .,* **67;** *Material Slang II,* **206;** *Model for Lucy Grays,* **193;** *Portraits of V. I. Lenin . . .,* **136,** 228 n1: *Portrait of V. I. Lenin in Disguise . . .,* 65; *Portrait of V. I. Lenin . . . V,* **66;** *Raped and Strangled by the Man who Forced her into Prostitution . . .,* **134;** *Sighs Trapped by Liars,* 30–34, 195, 206–207, 278 n1: *Sighs Trapped . . . 651,* **31;** *Sighs Trapped . . . 373–391, 413–508,* **32;** *Sighs Trapped . . . 510–520,* **200;** *Study after "L'Origine du monde,"* **138;** *Study for Hostage 40,* **104;** *Study for Hostage 74,* **106;** *Study for Impressionism Returning . . .,* 180; *Study for Incident, Foreground 1,* **183;** *Study for Index: Incident in a Museum 26,* **24;** *Study for Museum of the Future (I),* 82; *Study for Museum of the Future (II),* 82; *Surf 40,* **104;** *Surf 74,* **106;** *Title Equals Text No. 15,* **94;** Unfinished/abandoned paintings, *129, 130, 131;* *Unit Cure, Unit Ground,* 82, 218 n5; *"What remains of the Theme of Nature. . .,"* **92–95;** *see also* Art-Language, Baldwin, Ramsden

art as idea, 97

Artaud, Antonin, 12

"art context," 22, 28, 63, 64

art criticism, 5–6, 24, 34, 37, 39–40, 46, 204–206

art history, 6, 112–113, 134–135, 137, 173, 211 n27

Art in Theory, 6–7

artist's studio (genre), 57–59, 62

Art-Language, 18–19, 147–148, 194; cover for *Victorine,* **59**

Art News, 6, 52

Atkinson, Terry, 38, 176, 213 n10, 214 n16: *Title Equals Text No. 15,* 94

author, 5, 43, 63–64, 195

automatism, 85, 100, 102, 103–104

autonomy, 193: and "art context," 64, 71–72; ethical, 14; formal, 117; history, 136–137; vis-à-vis language, 17; of vision, 98; *see also* "other"

avant garde, avant-gardism, 6, 13–14, 20, 43–44, 63–64, 69, 71, 97, 175, 194

Bacon, Francis, 132, 177

Bainbridge, David, 213 n10